The Entrepreneurial Journalist's Toolkit

Today's journalism and communication students need the tools to develop and maintain their own media businesses and freelance careers. In addition to mastering the basics of converged journalism practice, they need training in business entrepreneurship, mass communication and business law, and career and reputation management. *The Entrepreneurial Journalist's Toolkit: Manage Your Media* provides a solid foundation of multimedia journalism and also teaches readers to create business plans and develop funding proposals while maintaining high legal and ethical standards. This book details the process of pitching and working with clients, managing multi-platform communication campaigns to maximize reach, keeping the books, and filing taxes. It provides everything a new or experienced journalist needs to get started as a media entrepreneur.

Key features:

- Includes all aspects of entrepreneurial journalism in a single volume—you won't need to turn to multiple texts to learn the business skills alongside the fundamentals.
- Each chapter includes a summary, application exercises, discussion questions, and sidebars directing readers to further information. In-depth practitioner interviews provide insights into the lives and careers of entrepreneurial journalists and those who work with them.
- A companion website includes student exercises and sample text, video, images, and other media content for student practice. It will maintain current links and updated resources so you can keep up with the latest developments.

Sara Kelly, Ed.D., is chair of the Department of Journalism, Film and Entertainment Arts at National University in San Diego, where she serves as lead faculty for the BA in Digital Journalism and adviser to the online student newspaper, *The National University Herald* (thenuherald.com). Kelly also holds an MBA and an MFA. While at NU, she has helmed programs in journalism and strategic communications, as well as the integrated marketing communication specialization of the MBA. Previously, Kelly served as the longtime executive editor of the *Philadelphia Weekly* and the editor of *In Pittsburgh Newsweekly*. Her professional publications include *Salon, Mother Jones, The New York Times Book Review, Men's Health, Town and Country*, and *Utne Reader*.

The Entrepreneurial Journalist's Toolkit

Manage Your Media

Sara Kelly

Focal Press
Taylor & Francis Group

NEW YORK AND LONDON

First published 2015
by Focal Press
70 Blanchard Road, Suite 402, Burlington, MA 01803

and by Focal Press
2 Park Square, Milton Park, Abingdon, Oxon OX14 4RN

Focal Press is an imprint of the Taylor & Francis Group, an informa business

Library of Congress Cataloging-in-Publication Data
Kelly, Sara.
 The entrepreneurial journalist's toolkit : manage your media / Sara Kelly.
 pages cm
 1. Journalism—Management. 2. Journalism—Vocational guidance. I. Title.
 PN4784.M34K47 2015
 070.4068—dc23
 2014040155

ISBN: 978-1-138-81648-0 (pbk)
ISBN: 978-1-138-81647-3 (hbk)
ISBN: 978-1-315-74606-7 (ebk)

Typeset in Giovanni
By Apex CoVantage, LLC

Printed and bound in the United States of America by Sheridan Books, Inc. (a Sheridan Group Company).

Contents

Preface

We're living in an entrepreneurial world—all of us, whether we're journalists or not. Global transformation brought by technology and years of economic retrenchment has fundamentally changed the way we work and live. While technology has made it easier for individuals to produce and create without significant overhead or infrastructure, economic realities have underscored the need to do just that.

Perhaps no profession has been more dramatically transformed by the dual forces of advancing technology and tightening budgets over the last decade than journalism. Likewise, no other field stands to gain more from these changes.

Journalists have always been guided by a sense of right and purpose. They are compelled to tell stories, and in the digital age they don't need gatekeepers like editors or news directors to determine whether they can. Not only can journalists create the stories they find meaningful, but they can distribute them to their target audiences.

Journalists have more options today than ever before. And while they've been freed of the need for editorial approval, they've also taken on many of the responsibilities of their former editors, news directors, and publishers. The most significant of these—and traditionally the most uncomfortable for journalists to consider—is financing the enterprise. Specifically, they've had to answer this question: How do you live off of journalism without necessarily working for someone else? Answering that can be a job in itself.

Many journalists today enjoy more professional freedom because they don't have a single full-time job. While some have struggled to find one, others don't want to work long hours for a single employer on someone else's terms. Happily, journalism has always been a profession of freelance and contract work, so taking on individual assignments or clients isn't new.

Now more than ever, entrepreneurial journalists can create their own livelihood in their own way, sometimes doing the same kind of work they'd do

on staff at a publication or broadcast outlet, and sometimes doing something completely different. There are infinite possibilities.

Even for those who hadn't planned to go it alone, entrepreneurial journalism has real appeal. It is journalism on your own terms. It is seeking out the stories that matter to you, and finding ways to get them to your audiences. It's about solving every piece of the puzzle yourself.

While it's an exciting time to be a journalist, it's also a demanding time. Not only do entrepreneurial journalists need to know how to produce great stories, but they also need to know how to promote and monetize them without compromising their high ethical standards. Entrepreneurial journalists need to know how to make the best use of technology, as well as how to use that technology. In addition to writing, researching, and taking pictures, they need to know how to capture and edit audio and video, how to fact-check their own stories, and how to get them out there.

On top of all this, they also need to know how to run a business and protect themselves from lawsuits. And they need to anticipate coming developments in technology and the law. The job of the entrepreneurial journalist is truly never finished, and that's what keeps it interesting.

Quickly advancing technology also presents obvious challenges to those who dare to write books about it. Since specific software, tools, and technology come and go, this book attempts to discuss each in more foundational terms, presenting universal skills and concepts that aren't tied to any one piece of software or hardware.

That said, the companion website for this book will provide new information on the subject matter as updates become necessary. It will be revised on a regular basis to reflect the latest changes to tools, rules, and technology. It will also include hands-on exercises and the opportunity to apply what you learned. Like with most skills, the best way to learn is by actually doing the work.

Remember there are more ways than ever for an entrepreneurial journalist to craft a sustainable career. As long as you're willing to work hard, be creative, and keep your eyes on the horizon, your future is limitless. Enjoy the journey.

Journalism's New Frontier

All of us now live in a world of media on demand. We receive the news we want, how and when we want it, in whatever degree of depth we prefer, on the devices of our choice. In the days of traditional mass media, when there were few ways to learn about news, information was published and broadcast with the idea that the audiences who needed it would seek it out. Households subscribed to daily newspapers. Commuters listened to drive-time FM radio in their cars on their way to and from work. Families tuned in to six o'clock and eleven o'clock local news broadcasts. With the advent of a public Internet, new mobile technology, and to some degree years earlier, the non-legacy news outlets created in the early days of cable TV (specifically CNN, and later, CNN's Headline News, which introduced the twenty-four-hour news cycle), viewers were liberated from the fixed time slots and delivery methods of the old mass media model. Although in the pre-Internet days of the early 1980s, the kind of multimedia journalism we think of today was not possible, CNN's cable news experiment was among the first to change the viewer's relationship to the media. More significant changes evolved slowly with the development of cable and satellite television, and the proliferation of channels throughout the 1980s.

Beginning in the 1990s, widespread Internet access made convergent journalism truly possible for the first time by allowing the Web to serve as a new platform for the dissemination of news and information that was accessible to consumers on their own schedules. The Web-based news model did two important things: It allowed news consumers to pick and choose which stories they wanted to follow and in how much depth, and it freed consumers from the limitations of TV time slots and newspaper press deadlines. It was not quite yet what we now think of as news on demand, but it was a radical departure from the traditional mass media model.

Convergent journalism has come of age. It is now at a point of maturation. Indeed, most news has been converged for years. Most print and broadcast outlets have websites and blogs. Many routinely post photos, videos, and slideshows. Some boast podcasts. Others host live online events. Most are

Figure 1.1

A newsstand at the Minneapolis–St. Paul International Airport exhibits true convergence. Photo by Rae Whitlock, Columbus, OH / Wikimedia Commons.

active on social media. Some even curate social media content, occasionally covering breaking stories half a world away. This is good news for those with roots in traditional journalism who lament the end of the field as they know it. The truth is that the only people predicting the end of journalism are those still living in a pre-converged world—which is to say not many. Thanks to smartphones and the global networks that connect them, even the developing world is quickly converging. Passionate, dedicated journalists adapt and learn the new tools and practices instead of mourning the old ways. In fact, flexibility and the desire to perpetually retrain to stay on top of the latest changes and developments in technology may be the single most important characteristic of an entrepreneurial journalist.

HOW WE GOT HERE

Journalism's professional orientation has long united its practitioners and students. Journalism is rare among academic disciplines in that it, in a way perhaps similar to forensics (debate) and sports programs, allows students ample opportunities for real world practice while still enrolled in college. There are few collegiate activities outside of sports that routinely send enthusiastic students to conferences and trade shows. Anyone harboring doubts about the future of journalism need only attend a college journalism conference to have their faith renewed for good.

Journalism has always been more than a job for those who do it. Journalists share a strong culture. Until the 1970s, journalism ran like a medieval guild

where young men who started as copy boys rose slowly through the ranks over years to become reporters, editors or copy chiefs. The vast majority of reporters were male and lacked formal education. They learned on the job by immersing themselves in their news beat over decades. This now-obsolete model of the hard-bitten journalist was similar to Raymond Chandleresque gumshoe stereotypes.

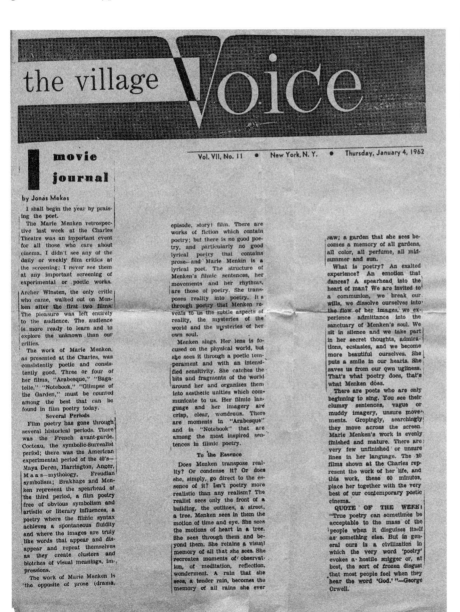

Figure 1.2

The Village Voice *remains the first and most famous alternative newsweekly.* Photo by Bigjoe5216 / Wikimedia Commons.

The image of the hard-drinking, hard-living journalist who made his bones by becoming a political insider with connections across the city began to fade in the mid-1950s, with the advent of the alternative press. The earliest and still best-known alternative newspaper is New York's *Village Voice*, a weekly tabloid that covered the counterculture that was beginning to coalesce (at least in large coastal cities) during Eisenhower's famously conservative postwar 1950s. For the first time in hundreds of years, the alternative press changed the newspaper's business model by running the kinds of advertisements the mainstream dailies refused to print—mostly for pornography and prostitution (advertised as escort services or massage parlors). Although the *Voice* initially charged a cover price, it eventually sold enough ads to support the distribution of copies throughout New York City for free. Other alternative weekly newspapers ultimately followed the *Voice*'s lead and offered free circulation instead of paid subscriptions. Circulation continued to grow as newspaper companies installed honor boxes (which allowed readers to take copies without putting coins in a slot) on city sidewalks alongside the dailies' coin-operated boxes. As young people started moving back to the cities following the suburban exodus of the middle class in the postwar years, alternative weeklies enjoyed a surge in readership and popularity. By the 1990s alternative weeklies had themselves become the mainstream, largely eschewing the kind of extensive investigative reporting they had become famous for a generation earlier in favor of expanded arts and entertainment coverage, and lifestyle features. Instead of picking up the paper to read about political corruption or pressing social issues, most people browsed alt weeklies for their extensive events calendars, arts reviews, and movie times listings. Although they did not much resemble *Voice* co-founder Norman Mailer's vision for alternative journalism, the weeklies were selling ads and doing well through the 1990s. But the alt weekly renaissance would also ultimately end.

For the alternative press, the end began with an early Web browser called Netscape and the funny-sounding search engine Yahoo! Within a few years, Craigslist, a peer-to-peer online marketplace, went national, and soon those ads for pornography and prostitution that had previously been the exclusive domain of alt weeklies began moving online. In 2000, when Craigslist expanded nationally from its local San Francisco Bay Area home, the ad-supported alternative weekly business model began to falter. It would take several years for alt weeklies to feel the full effect of Craigslist's classified domination, but eventually, just like their peers at daily newspapers, journalists working at weeklies began expressing legitimate worry about their futures. It was at this time that talk of alternative models not just for reporting news but also for financing it emerged. At first hope came from strange places—namely philanthropists.

Although it would be decades until the converged newsroom would become a reality, way back in 1975 an old-time Florida newspaperman known for his

starched white oxford shirts and natty bowties changed the future of journalism in ways he could never have imagined at the time of his death in 1978. Nelson Poynter's legacy, now known as the Poynter Institute, began its existence as Modern Media Institute, a school for journalists that owned controlling stock in Poynter's St. Petersburg Times Company, which publishes the *Tampa Bay Times*. Poynter's dream was two-fold. Not only did he want to protect his newspaper from marketplace demands, but he wanted to help train working journalists to improve their craft.[1]

Poynter's experiment has endured, enjoying years of success as a training ground for journalists. Today, the Poynter Institute and its extensive website Poynter.org are among the best-known resources in journalism. Every day new and experienced journalists turn to Poynter for onsite and online training, webinars, tutorials, news, tips, and job leads. After years in the spotlight and consistent Pulitzer Prizes, the future may not be so bright for the *Tampa Bay Times*, which remains one of few news entities owned by a nonprofit organization. Toward the end of 2014, high-profile media blogger (formerly for Poynter.org) Jim Romenesko wrote about the *Times*' precarious finances. Quoting from an email he received from an anonymous staffer, Romenesko blogged about a "crisis situation" in which the paper was "on the brink of doom" over financial shortfalls.[2]

Although the *Times*' unusual business model remained a curiosity for the first couple decades after Poynter's death, it became a topic of serious consideration in the early years of the millennium, when those in the news business started seriously looking at alternative business models to keep print journalism alive. "[B]eleaguered industry veterans longingly turn their collective gaze to the *Times* and Poynter for inspiration," *Times* veteran Louis Hau wrote in *Forbes* in late 2006.[3] At around the time of the *Forbes* article, desperation over the decline of the traditional for-profit newspaper model led some to cling to the nonprofit model like a lifeboat. But the news industry was about to become much more complicated. Soon it was not just the business model but the platform itself that would undergo unprecedented change.

By 2005 the concept of the "Web-first" newsroom had taken hold in traditional newspaper offices everywhere. The radical new idea—that instead of an online regurgitation of the exact contents of the print edition, a newspaper's stories would break on the paper's website, *then* get the full treatment in print—was not winning over many fans. The paper's writers and editors remained convinced that print contained the paper's most exclusive real estate, and that no one would go online to read a story that was also available in print. In this pre-smartphone era with the introduction of Apple's first iPhone still a couple years off, few used mobile devices to access the Internet, and no one used them to read newspaper stories. But newspaper and

magazine publishers were becoming increasingly aware of the need to publish online. The big question was *what* to publish. Breaking news stories such as trial coverage opened the door to a new kind of reporting, as journalists were for the first time free of rigid deadline pressures and were newly liberated to post content before an editor could read it. This simple alteration in workflow flipped the newsroom power dynamic. Writers and reporters rejoiced while editors wondered how they could maintain quality control (or simply control) in the twenty-four-hour newsroom.

At the *Philadelphia Weekly*, an alternative weekly newspaper, the move online was straightforward. Like at many newspapers and magazines in the early days of online publication, the exact contents of each issue were simply duplicated online. Then in 2003, when senior writer Steve Volk covered local rapper Beanie Sigel's murder trial *from right outside the courtroom*, reporting on the latest revelations via a blog, both the newsroom and Volk's readers were energized by the speed of coverage. After posting to the blog with his wifi-enabled laptop, Volk would email or call the office. The copy was then printed for interns to fact-check and editors to edit. An editor would then log into the paper's blog account and make any necessary changes—*after* the story was published. It was a process that made editors who lived and died by the formal fact-checking process a little crazy. Risking the momentary publication of errors—or worse—did not endear copy editors to the process. Over time the process would get more efficient and easier to manage, but the copy desk has not been the same since.

THE "WEB-FIRST" REVOLUTION

Back in winter 2006, Michael Riley, editor of the *Roanoke Times* and a 1995 fellow at the Nieman Foundation for Journalism at Harvard, wrote presciently about the Web-first model in the foundation's journal. Journalism's future survival, he wrote, would

> rest on attracting more innovators into our midst and finding ways to
> give them the freedom and the backing they need to experiment and
> help us move into a new realm in which we can preserve the journalism
> and make a robust business model work.[4]

Among many ideas for reinvigorating the news business Riley wrote about (including using video to supplement the reporting of news stories and developing websites that reach beyond the terrestrial readership), he also made a suggestion that seems quaint (and impossible) in retrospect. Citing Google and Yahoo!, he suggested newspapers take control of local search data before others had a chance to. He instructed journalists to "take a crash course in how to gather up this information, pour it into a database, offer a dynamite

search function, and become the best source of local information."[5] This was before Yelp was ubiquitous. Twitter had just launched. Although Riley could not have known it at the time, it was, at the time of his writing, already too late for most urban daily newspapers to claim online access to the readers they were losing in their markets. While he had been right about the coming emphasis on hyperlocal and community news, he was wrong in thinking that the staid traditional news outlets that had spent the last decade fighting the online invaders would be the ones to lead the charge toward the new journalism frontier. The news model had changed, and changing seasoned newsroom minds to embrace a whole new way of doing things would prove far less efficient than training new journalists in new methods.

AN EARLY MODEL

One of the first success stories of early Web-first journalism, the investigative news site *Voice of San Diego* (*VOSD*) is still going strong, although it looks a little different than it did in the early days when print still ruled and investing in online journalism seemed a risky bet at best. In 2004, San Diego was a large but conservative media market defined by a right-leaning newspaper, the *Union-Tribune*, owned by the Copleys, a famous local family of developers and contributors to Republican causes.[6] Soon after San Diego's only big daily newspaper dismissed columnist and editor Neil Morgan, he and local venture capitalist and entrepreneur Buzz Woolley started plans to launch the all-online news site *Voice of San Diego*. According to the publication's "About Us" page, both men thought the city needed more news voices, analysis, and reporting.[7] Although Morgan and Woolley never discussed it publicly, there was a clear subtext to the claim that the city needed more voices: The right-leaning *Union-Tribune*, Morgan's former paper, shouldn't be the city's main news source. Woolley anted up the site's first-year funding—$354,399— out of frustration that the local news media neglected to report on major issues involving the highest levels of local government. One story in particular, the city's pension scandal, which made national headlines when it broke—no thanks to local media—underscored the many lapses in San Diego's news coverage at the time.[8] Woolley's donation was generous, but it would not last long. *Voice of San Diego* would quickly have to garner additional funding if it were to remain a going concern.

VOSD's writers and editors were young. The staff was small. The mission was simple: essentially, to bring investigative journalism to a region that lacked much serious news reporting.[9] Investigative reporting remains the most expensive kind of journalism, regardless of the medium or the platform. It requires skilled and well-trained journalists who are granted the kind of long deadlines that in-depth reporting requires. For *VOSD*, this meant that other

reporters would have to be hired for daily coverage that investigative reporters would not have time to produce. But with limited competition from other local news outlets and no printing costs, it was clear that if the *Voice* remained independent and reported on important stories that had been largely ignored by the mainstream press, it could go far. *Voice of San Diego* would have to enjoy early success if it were to remain financially viable. And it did.

Much of *Voice of San Diego*'s early success has been credited to current CEO Scott Lewis and former editor Andrew Donohue (now senior editor at the Center for Investigative Reporting), both twentysomethings at the time who were fairly new to journalism. Unlike more seasoned journalists who had years or even decades of traditional newsroom experience to overcome, they were young, eager, and willing to work for less money than the average midcareer union reporter (although established urban dailies had already begun buying out their reporters' contracts in the previous years, as revenues declined and unions began losing their leverage). A 2008 *Christian Science Monitor* story posited *Voice of San Diego* as a model of nonprofit journalism that was spreading across the industry. Noting a number of new entrants into the nonprofit sphere, *Monitor* reporter Randy Dotinga reminded readers of his own paper's nonprofit status as well as that of the Poynter Institute's *St. Petersburg Times* (now the *Tampa Bay Times*).[10]

There are now several nonprofit news sites in the United States. These include the *Texas Tribune*, an online local news site established in 2009 and supported by grants from financier T. Boone Pickens and the John S. and James L. Knight Foundation among others, and *MinnPost*, a Minneapolis-based nonprofit news site established in 2007 and supported by the Knight Foundation and several local foundations. The Manhattan-based investigative news site *ProPublica* was established in 2007 and has received funding from the Knight Foundation, the MacArthur Foundation, the Ford Foundation, Pew Charitable Trusts, and the Carnegie Corporation among others. *ProPublica* has won several high-profile awards, including Pulitzer Prizes for investigative reporting.

What *Voice of San Diego* pioneered in the earliest years of the twenty-first century hardly seems revolutionary today, but no other news outlets were doing it at the time. Most had hardly even established websites by the time *VOSD* made a routine of reporting daily news online. In the early years of the site, it offered long (by Internet standards) reports with embedded video and links. It also ran short blog-type postings by regular columnists. Again, not that different from most online news sites today, except these days online stories tend to run shorter. That *VOSD* offered more original local content was a welcome change for news buffs who had watched the news holes in their local dailies shrink precipitously in recent years. Readership took off, though there

were never as many daily hits on *VOSD* as there were once daily readers of the *Union-Tribune*. Even in its diminished state, *U-T San Diego*, as of 2007, was just shy of 300,000.[11] It would lose some 50,000 daily readers over the next six years,[12] but while the *U-T* counted readers in hundreds of thousands, *Voice of San Diego* continues to log just several thousands of daily hits[13]—a respectable showing for today's fragmented media environment.

By publishing the kind of investigative journalism that had not been seen in San Diego for years, and publishing it *online*, where editorial space concerns were not an issue, *VOSD* won early recognition from a new and growing online news community—specifically, the Online News Association (ONA), which awarded *VOSD* a first-place Online Journalism Award for "Online Topical Reporting/Blogging, Small Site" in 2010.[14]

Voice of San Diego CEO Scott Lewis sat for a brief interview inside the *VOSD* offices at the San Diego Foundation in Liberty Station, an old Navy training center.

INTERVIEW: A Conversation with Scott Lewis, CEO, *Voice of San Diego*

What did the founders hope to accomplish with **Voice of San Diego?**
Neil Morgan and Buzz Woolley wanted to come up with something new. They decided they had made enough money in life and wanted to find a way to save the cost of print but also still pay professional journalists. That's where they came up with the nonprofit online model. They just wanted to create something that people liked and that did investigative news in San Diego around important topics like quality of life, the economy, quality schools, government efficiency, all that.

Figure 1.3
Scott Lewis.

You were among the first news outlets to use an unusual funding model.
There had been nonprofit journalism before. Obviously there was public radio. And there had been online journalism before, like *Salon* and *Slate*. But nobody had combined the two. We were the first to do that. We've had dozens of news organizations write stories about us, but often they get it wrong because they assume we were in response to the decline of the news industry and the problems of local journalism. But remember that was 2004, and in 2004 things were doing quite well in the newspaper business. People were selling newspaper companies for a lot of money, and revenues did not seem to be that worrisome. With the credit bust and other crises in the financial markets, that changed that. That we were in response to a local challenge and

not a national one was why we came up with the model that we did, and why it ended up becoming a model for the country.

Describe the model and how it works.

It's not a new model. Public radio has been using a similar system for decades. But the difference is we don't have any of the high costs of transmission, antennas, control rooms, that sort of thing. One of the sites that followed our lead was the *Texas Tribune*. They followed our lead, but now they're so big and important, we actually learn a lot from them. The founder of that organization calls it revenue promiscuity where they just try to get as many types of revenue and as many sources within those types as possible to create a sustainable organization.

What would someone need to create a similar organization somewhere else?

It's not unlike too many other kinds of business. Every engine needs a spark, so there needs to be a capacity investment of some kind. Building it out of nothing would be difficult. But there are some who have built pretty cool things out of nothing. *Texas* really set the standard for investing at the beginning in quality leadership and corporate sponsorship directors and in a nice website that really set the standard for how an operation like this should be started. One thing to keep in mind is we're not talking about a lot of money. *Texas Tribune* is now held up as this giant model, but its budget this year is at $6 million. Compared to other cultural institutions, that's really not that much money.

What advice do you have for someone looking to create a news site like Voice of San Diego?

Make as much of an investment in the business model as they make in the editorial design. There are a lot of former journalists who just want to do editorial work, and that's fine, but they need to make investments in sustainability to be able to keep doing it.

I was just a writer and an editor, and I evolved into somebody who was getting grants and recruiting donors, and then we went through some crises here and there, and emerged from that with the determination that we needed some more support. I recruited our VP, Mary Walter-Brown, who has added a lot of sophistication and professionalism to the business side. Throughout the whole process, we've had to learn to be entrepreneurial, to create events and products that people like and at the same time make sure we haven't drifted from that mission to explain and investigate the news.

How have changes in local news affected what you do?

We were always a response to the local news climate. We were always a creation of it. Frustration about there being only one newspaper in town was at the heart of our origination. That's not necessarily a knock against them. No one institution can do the job of filling a community's information needs

completely. So there needs to be pressures. There needs to be rivalries. There's plenty of room for more sources of information. Some changes at the *U-T* highlighted the need for an alternative source of information. Particularly, of course, when Doug Manchester purchased the *U-T*, there was a lot of concern on the left and right. People wanted to make sure there were strong alternatives. So we benefit from time to time from worries about the *U-T*. But we want the *U-T* to be a strong and thriving institution. It doesn't do our community any good if they fall apart and die. Any criticisms we have of them are in the vein of wanting them to be stronger and better. We don't see anyone in town as a competitor. As a nonprofit, we see every outlet in town as a potential partner. We learn from other people trying. There are editorial rivalries among our staffs, but our model doesn't put us into competition with any other organization.

Have you partnered with other news organizations to expand your reach or leverage your strengths?
We have several thriving partnerships. Our biggest one is with NBC. We work in tandem with them on several projects, but also two segments a week that themselves have gotten national news coverage. We have a partnership with [local public radio station] KPBS. We share a reporter. We pay one-third of her costs, and they pay the rest. We have a partnership with [local AM radio station] KOGO. We do a radio show each week with them and a podcast. And we have a partnership with *San Diego* magazine. We think partnerships are key because our website is really just one tool that we have in our quiver to reach people, and as long as we reach them we don't really care that it has to be through our website. So social media, for example, doesn't have to be a way to get people to our website. It can be a way to just get the work done itself, as long as people recognize it's from this service. A lot of us, from TV stations to radio stations and others, recognize that there's no need for many of us to fight because we don't have competing business models. So we might as well supplement each other's work, and we can all thrive.

What does Voice of San Diego *deliver that others don't?*
Our staff is mandated to only pursue stories that, (a) no one else is doing, or (b) that we think we can do better. So our entire approach to news, our entire approach to investigations, is about maximizing our impact and reducing the possibility that we will be redundant. That means, by definition, we will always add value to the news ecosystem. Our mission is two-part. It's one part to do investigative work that uncovers realities or inefficiencies or corruption or malfeasance or complexity that needs to be cleared up, and the second part is to explain the news in a way that's conversational and approachable so that people can follow major issues really well. We believe there's been a lack of explaining going on in news, and we think we've done a good job of approaching that so that budgets and elections are understandable.

How can students prepare for the future of journalism?

I think the future of journalism has to do with skills and deep occupational information. For example, I think there are going to be huge opportunities for people who understand accounting, who understand science and engineering, and who understand more technical subjects, and are able to write about them. I think that our industry will covet them as we get more and more involved in data, in particular computer science and statistics, and math and forensic accounting, and things like that. Those professions pay more than journalism does, but over time I think we will learn the value of those skills. I urge younger students to make sure they're good at math, make sure they understand concepts like that.

How can professional journalists distinguish themselves from casual bloggers?

I use that as a motivating factor for the staff. I say, "Look. Anybody can write these days, so you have to prove to the community that you're worth paying for it." It's become clear to me that finding people who are actually talented at it and who can really generate enthusiasm and sharing and engagement about what they've written are few and far between. They need to remember they're on top of a pyramid of people who would love to do this for a living, so they need to show why they're the ones to trust with it.

Where did you go to school and what did you study?

I went to the University of Utah, and I studied history and Spanish, but I worked at the school paper, the University of Utah's *Daily Chronicle*. It was at that paper that I got all my journalism training. I never thought I would stick with journalism, but I just kept doing it, and it worked out.

What advice do you have for independent journalists these days?

I would focus on a particular niche. Anyone who tries to be a mile wide and an inch deep is just not going to get attention these days. But somebody who's a mile deep on one particular topic can really own it. So if you just focused on the impact of climate change on San Diego, or if you wrote about one particular kind of science happening in San Diego or surfing or something in particular that you own, you would very quickly rise to the top of that if you did it well.

What advice do you have for journalists just starting out?

The key for a lot of journalists starting out is to freelance and to pitch editors relentlessly. Even if they don't pay well, once you start to gain a presence in the discussion marketplace, it's a lot easier at that point.

What skill sets do today's journalists need?

There's a lot of emphasis on being able to code and do computer programming, and I think that is valuable. More important is to have a healthy respect for what can be done, and then to have the personality skills to be able to pull things off, to be resourceful, to be open to partnerships, and I think a

lot of that has to do with being able to articulate your vision, to be able to speak well in public. Again, I think there's going to be a real high value on people who understand math and science and accounting. Another area that's important is graphic design and information visualization. If you're a good reporter and you can also design graphics and images that go into your posts, you will be really well appreciated. We have to respect the sciences and math. It's kind of embarrassing that [journalists] didn't for so long.

How do you keep up with changing technology and prepare for what's to come?
I try to consume all of the new gadgets. The Nieman Lab is an invaluable source of information for me. Twitter has proven to be a great mechanism for finding out what's going on in our world. Journalists are well represented on Twitter, so following the latest trends and crises and ideas from that is pretty easy. *Voice* has never had a major investment budget for our technology platform, so this year we hope to do more than we've ever done before to professionalize it and get it up to speed.

What's next for **Voice of San Diego***?*
Our goal is to figure out just how big an institution like this should be in a town like this. We're going to try to expand, but also do it strategically and in a sustainable way, and figure out where our limits are.

NOT A UNIVERSAL MODEL FOR JOURNALISM

Despite a growing reputation for delivering high-quality news using a nonprofit business model, *Voice of San Diego*'s formula could not be easily translated to other news outlets. While *Voice of San Diego* remained a shining bright spot in an industry beset by bad news and declines in recent years, when some grant funding it had relied on for operations expired two reporters and a photographer were laid off in 2011.[15] Although the site would survive and continue to do good work, *Voice of San Diego*'s financial struggles came as sobering news to an industry increasingly pinning its hopes on the nonprofit model. In early 2012, *VOSD* launched another experiment in journalism funding by creating a membership program along the lines of those run by public radio and television stations. But also like most supporters of public broadcasting, *Voice of San Diego*'s paying members skew toward the older and wealthier,[16] who are more willing to pay for news. Despite several news outlets' experiments with paywalls, few younger and less affluent Americans think paying for news makes sense when you can scan the Web for free on a smartphone. So while *Voice of San Diego* has improved the quality and diversity of news coverage in San Diego, it has done little to permanently alter journalism's business model. That means, for now at least, unless every city in America that needs more robust news coverage can find a well-heeled

benefactor to fund the local news, the nonprofit model remains just one vision for journalism's future.

On the editorial side, *Voice of San Diego* did help transform the way news is reported by proving to its early critics that a news outlet could keep up with—or, as is increasingly the case, outpace—the mainstream outlets that had dominated local news for decades. Most important, *Voice of San Diego* rendered the Web-first concept that traditional newsrooms were just learning about a rather quaint notion. Instead of convincing reporters that publishing their stories online was just as important as publishing them on newsprint, *VOSD* proved that important news stories did not need to be in print at all. Online publication was faster, less expensive to produce, and easier to update, augment or change. While few these days question the merits of online publication, in the first years of the twenty-first century, print news still ruled. Much has changed since 2005. The versatility and depth of reporting possible online has in many ways revolutionized the industry.

A SPECIAL CASE

San Diego is a crucible of media transformation. In many ways it is a unique market. Not only is it home to the pioneering *Voice of San Diego*, but the current owner of its storied daily newspaper, a local developer and hotelier, freely admits his desire to use the paper to promote development and advance his own interests in the city. When "Papa Doug" Manchester spoke to local media about his reasons for buying the *U-T* in 2011, the local media (many of whom were on Manchester's payroll) were notoriously quiet about the unprecedented development. By late 2012, private equity groups had gobbled up many of the region's daily newspapers. Besides, a pro-business bias was nothing new for the *Union-Tribune*. But not since the early days of Pulitzer's and Hearst's empires had newspaper owners exercised such direct control of the editorial process. Since Manchester took over in late 2011, the *U-T* has run front-page editorials and special sections to promote Manchester's business associates. Bloggers and journalists made apt comparisons to Citizen Kane. Andrew Donohue, then the editor of *Voice of San Diego*, told *American Journalism Review*, "The scary part of it is, the price of buying a newspaper has gotten so cheap … you could just buy a newspaper and emerge as a player."[17]

Manchester was already well known in San Diego, as was the future of print journalism. However, the unique demographics of the paper's readership (an older readership that has largely prevented the degree of steep circulation declines experienced by other big city dailies) perhaps led *U-T* management

to stumble in its first forays into convergence. Its news website, SignOn-SanDiego.com, debuted in the first years of the new millennium, and featured mostly online versions of stories from the print edition. In the early years, there was limited evidence of convergence. Then in 2012, years after the debut of convergent journalism, the recently renamed *U-T San Diego* launched its own experiment in convergence by creating its own cable TV news station, like a local CNN. Few were able to tune in since Manchester could not secure a carriage agreement with Time Warner Cable, and Cox, the other local cable company, offered the channel only to its digital subscribers.[18] The channel was hard to find, and the programming was notoriously dated, reminding some of another infamous San Diego TV news broadcast brought to life by Will Ferrell and his sexist 70s anchorman Ron Burgundy. A scathing *Voice of San Diego* review from early 2013 cited an episode in which a U-T TV interviewer asked San Diego's female district attorney whether she wore a thong and another in which a male host taunted his female co-host with unwelcome sexual comments while introducing a segment about a food truck called Mastiff Sausage Company.[19] In February 2014, *U-T San Diego* announced it would no longer broadcast on cable, and that it would lay off some of the station's forty-five employees so that the news outlet could focus instead on bolstering its online offerings.

SUMMARY

Beginning in the 1990s, widespread Internet access made convergent journalism possible for the first time by allowing the Web to serve as a new platform for the flexible dissemination of news and information. Convergence has since matured. Indeed, most news has been converged for years. Most print and broadcast have websites and blogs. Many routinely post photos, videos, and slideshows. Some boast podcasts. Others host live online events. Most are active on social media. Some even curate social media content, occasionally covering breaking stories half a world away.

As the success of the converged newsroom has shown, journalism is not dying. It is simply in a state of flux. With more ways of getting news these days and much greater access to the distribution tools, there is more demand for journalism than ever. But the journalist's job has changed. For most who hope to make a career of journalism, it is no longer sufficient to simply write solid stories or take good photos. In the converged newsroom, journalists need to do everything. While most will specialize, depending on what skill set or personality trait drew them to the field to begin with, now writers need to know how to take a decent photo, shoot and edit a short video, post their work online, and use social media to draw audiences to their stories.

JOURNALIST'S TOOLKIT

Most news organizations today deliver a multimedia product and require their journalists to possess a wide skill set. They may require their reporters to use specific tools or may ask them to choose their tools in whichever way will best get the job done. Today's multimedia journalist, whether experienced or just starting out, whether working for an established media outlet or for herself, needs to make sure she has the following skills and tools.

Skills

Writing

Self-editing, including copy editing and proofreading

Basic photography

Photo slideshows with audio

Video skills

Video editing skills

Interviewing skills

Audio editing skills

Basic Web development

Social media for distribution and promotion.

Tools

Video camera

Still camera

Digital audio recorder

Laptop or tablet computer.

Sites

Archive.org/web: Home page of the Internet Archive's Wayback Machine.

Craigslist.org: Home page of the local online marketplace.

Philadelphiaweekly.com: Website of the *Philadelphia Weekly* alternative weekly newspaper.

Poynter.org: Home page of the Poynter Institute, a resource for journalists.

Voiceofsandiego.org: San Diego's nonprofit investigative news site.

Application

1. Find a news site that has existed for a decade or longer. Compare the home page from one day ten years ago to a home page from one day seven years ago, to one day five years ago, to one day two years ago, and today. You can use the Internet Archive's Wayback Machine (archive.org/web) to find snapshots of websites as they existed on various dates all the way back to the 1990s. For each date, make sure to discuss the layout and graphic elements, media types used, headlines, type treatment, use of advertising, navigation, story lengths, tone, and any other significant differences.

2. Interview a journalist who has been working since before 1994. Ask them how their job has changed since they entered the field. *Optional:* Create an online story package about this person, using various media to illustrate and explain how the Internet has transformed the practice of journalism. Create a social media plan to maximize your story's reach.

3. Analyze the business and funding structure of a nonprofit news site. Compare its business and funding structure to that of a legacy news organization.

Review questions

1. What kind of mindset or attitude does a journalist need to succeed in the field today?
2. Why is it important to understand the evolution of journalism business models?
3. What are the strengths and weaknesses of the nonprofit journalism business model?
4. How would you characterize the future of nonprofit journalism?

REFERENCES

1. "A Brief History of The Poynter Institute," *Poynter.org*, http://about.poynter.org/about-us/mission-history.

2. "'Crisis Situation' at Poynter's *Tampa Bay Times*," *Jim Romenesko.com* (blog), September 18, 2014, http://jimromenesko.com/2014/09/18/crisis-situation-at-poynters-tampa-bay-times/.

3. Hau, Louis. "Why Newsrooms Pray to St. Petersburg," *Forbes.com*, December 4, 2006, http://www.forbes.com/2006/12/01/newspapers-poynter-st-petersberg-tech-media_cx_lh_1204stpete.html.

4. Riley, Michael. "Newspapers and their Quest for the Holy Grail: Putting the Web First Might Be 'The Most Difficult Transformation in Our Mindset, but We Should Go Ahead and Flip Our World on Its Head,' " *Nieman Reports*, Winter 2006, http://niemanreports.org/articles/newspapers-and-their-quest-for-the-holy-grail/.

5. Ibid.

6. "San Diego Loses a Newspaper Scion, David Copley," *NYTimes.com*, November 26, 2012, http://www.nytimes.com/2012/11/26/us/san-diego-loses-a-newspaper-scion-david-copley.html?pagewanted=2&_r=0.

7. "About Us," *Voice of San Diego*, http://voiceofsandiego.org/about-us/.

8. Meyer, Michael. "Part of the Club," *Columbia Journalism Review*, May 1, 2014, http://www.cjr.org/feature/part_of_the_club.php?page=all.

9. "About Us," *Voice of San Diego*, http://voiceofsandiego.org/about-us/.

10. Dotinga, Randy. "Nonprofit Journalism on the Rise." *Christian Science Monitor*, February 12, 2008, http://www.csmonitor.com/USA/2008/0212/p03s01-usgn.html.

11. "Top Media Outlets 2007," *Burrelles Luce*, http://www.burrellesluce.com/top100/2007_Top_100List.pdf.

12. "Top Media Outlets June 2013," *Burrelles Luce*, http://www.burrellesluce.com/sites/default/files/Top_Media_June_2013_FNL%281%29.pdf.

13. "Voiceofsandiego.org Traffic and Demographic Statistics," *Quantcast.com*, https://www.quantcast.com/voiceofsandiego.org.

14. "2010 Awards," *Online News Association*, http://journalists.org/awards/past-winners-2010/.

15. Meyer, Michael. "Part of the Club," *Columbia Journalism Review*, May 1, 2014, http://www.cjr.org/feature/part_of_the_club.php?page=all.

16. Ibid.

17. Spivak, Cary. "Are These Guys Crazy?" December 2012/January 2013, http://ajrarchive.org/article_printable.asp?id=5458.

18. City News Service. "U-T San Diego Pulling Plug On UT-TV After Less Than 2 Years," February 19, 2014.

19. Libby, Sara. "I Watched U-T TV So You Don't Have To," *Voice of San Diego*, March 6, 2013, http://voiceofsandiego.org/2013/03/06/i-watched-u-t-tv-so-you-dont-have-to/.

Build on Tradition

Communication shapes human culture. Since human beings developed speech, communication has driven civilization. It is the vehicle we use to navigate our world. The fundamentals of communication have remained the same through time, and despite endless changes in form and the delivery systems we use to convey our words and thoughts, they will never change.

In ancient Greece, public heralds called out the day's news, and messengers famously delivered it great distances. Even then, people wanted to know what was happening in other places, with other people. Traders and merchants were the first to carry information about faraway places back home, along with exotic goods and spices. Religious pilgrims and missionaries returned to Europe speaking of newly discovered civilizations in Asia and the Americas. Anyone who traveled outside the community became a conduit of information, an early journalist long before journalism was a formal profession.

Back home in England in the Middle Ages, the Catholic Church maintained the crown's political power by controlling access to information. Monks worked as scribes, diligently copying religious texts by hand. Literacy rates were low, and printed matter was often read aloud in public. Before German metalsmith Johannes Gutenberg invented movable type in the middle of the fifteenth century, news traveled mostly by word of mouth. The development of print had a democratizing influence on the people, and literacy became a mark of education and social status.

People had long relied on the Church to provide them guidance through oral readings of the Bible. Once Gutenberg's invention allowed mass printing of the Bible, those who were literate could read it on their own, without having to wait for a reading in church. This sparked widespread interest in education. It also led to a shift in the power balance between the people and the Church. If people could read the Bible on their own, church leaders worried, would they drift away from the Church?

Printing would have tremendous global repercussions for an institution that was then largely dependent on the public's contributions for its survival.

The successful growth of Protestantism in the fifteenth century, for example, is largely due to the printing press. When Martin Luther, a Catholic priest, nailed his *Ninety-Five Theses* to a church door in Wittenberg, Germany, he also made printed copies available to the public. That Luther could distribute his message far and wide made his religious movement unstoppable in ways previous movements had not been.

Now everyone with a smartphone or a tablet computer has their own personal printing press. In much the same way movable type shifted power balances and changed history in the late Middle Ages, the Internet has once again democratized and globalized communication. Instead of the Catholic Church resisting the inevitable change to a system that had long served it well, for a time at the turn of the twenty-first century the mass media resisted technological changes that would fundamentally alter their business model. However, most mass media companies, after years of waning audiences and subscription bases, began to realize that the Internet—and the global changes it has brought—was too great a force to resist. Although they did still have something to offer readers and viewers, if they wanted to survive into the twenty-first century, they would have to change with the changing times. Resistance was futile.

It is worth noting that legacy news organizations represent decades of success in investigating, reporting, and distributing on the part of their veteran staff. In other words, newspapers and broadcast stations still have much to contribute to an information-hungry world. But so do many new and independent news organizations, as well as individual reporters, analysts, and bloggers. But now, like in the fifteenth century, most residents of the developed world, and increasing numbers in the developing world, have access to an electronic printing press and the networks needed to spread their words far and wide. Not everyone will have as much to say as Martin Luther did, and most won't gain as large an audience, but in the days of the democratic Internet, we are all publishers. The old gatekeepers—newspaper editors and broadcast news directors—are still there, but the gates have been flung wide open.

The question, then, is how can journalists use their special skills and training to help readers and viewers make sound choices when consuming news and information? In many ways the journalist's job is more complicated today, when a large new part of their responsibilities entails educating the public in media literacy. In other words, in today's media saturated world with limited gatekeeping, journalists not only need to help their audiences understand the stories they tell, but they also need to establish the credibility of their stories through consistent transparency and professionalism. Journalists must establish the highest journalistic standards for themselves, and deliver on everything they promise. Over time, thorough reporting guided by established

journalism principles, along with solid presentation and distribution skills, will win over audiences who, with help from skilled and ethical journalists, will learn to differentiate high-quality professional reporting from the endless pages of poorly reported and just plain erroneous information posted online every day.

WHY DO JOURNALISM?

Although these days it can be less obvious than in times past, journalism lies at the heart of democracy. It is for this reason that it remains a protected practice in most developed Western nations. Since the fifteenth century, many political movements and most revolutions have been powered in part by journalism. This is clear from the earliest days of colonial America through the political upheaval that launched the Arab Spring. Because so much of the reward of journalism is the work itself, it is important to remind ourselves every so often of the noble origins of the field and why—beyond financial concerns—it remains so important today.

Of course, not everyone who enters journalism does so for the same reason. Not everyone plans to be the next Woodward or Bernstein, blowing the lid off of corruption at the highest levels of government. But even for those who do not plan to be career investigative reporters, it is important to understand the connections between journalism and democracy. In most democracies, the work of journalists is protected because, it is widely understood, journalism upholds the public's right to information. Journalists are charged with delivering news and information to the people as widely and from as many perspectives as possible, with the goal of ensuring the people are well informed and capable of conveying to their audiences what their government's leaders are doing and saying. This, in theory, keeps politicians honest and governments functioning transparently. With skilled, well-trained journalists doing their job, governments can't hide corruption for long. This is key to a democracy's proper functioning.

In the days before social media, when traditional gatekeepers (such as editors and news directors) managed the public's access to information, journalists alone held the power to uncover wrongs and corruption. There are many famous stories of journalists changing the world through their work. Perhaps most well known in the United States is Bob Woodward and Carl Bernstein's exposure of a break-in at the Democratic Party's Watergate complex headquarters in Washington, DC, as part of then-President Richard Nixon's re-election effort. Working for the *Washington Post*, Woodward and Bernstein changed the course of history by exposing the illegal actions of Nixon and his men. Their reporting led to Nixon's resignation in disgrace and indirectly

influenced the fates of both major American parties for years to come, as voters began to post their ballots in protest of the corruption Woodward and Bernstein exposed.

A century earlier in the United States, an enterprising young female journalist who called herself Nellie Bly went undercover in a New York City asylum to uncover terrible conditions and inhumane treatment of those deemed insane. Her 1887 work, reporting for Joseph Pulitzer's *New York World*, led to a grand jury investigation of the Women's Lunatic Asylum, and later, widespread reform of the nation's nascent mental health industry. Another early investigative reporter, Ida Tarbell, filed a series of damning reports on business practices at Standard Oil for *McClure's* magazine in the first years of the twentieth century. Through interviews and exhaustive research of public records and court filings, she exposed unsavory business practices at what was at that time one of the United States' largest, most influential companies. Tarbell's reporting led to the breakup of the Standard Oil monopoly.

In the 1950s, broadcast journalist Edward R. Murrow helped expose the corrupt tactics of Joseph McCarthy, a U.S. senator from Wisconsin who created a

Figure 2.1

CBS newsman Edward R. Murrow speaks to reporters on a stop in Germany in 1956 on his way to Tripoli.

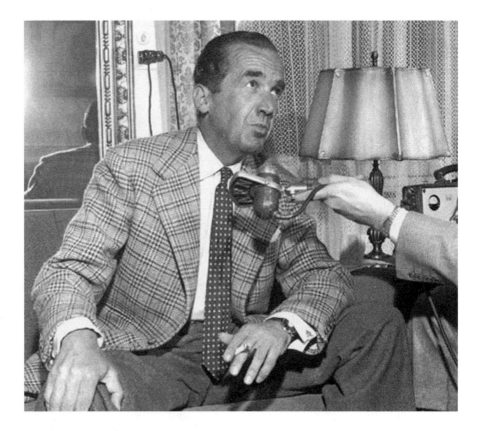

climate of widespread fear in the postwar United States by launching a witch hunt for those Americans he branded Communists in the early days of the Cold War between the U.S. and the U.S.S.R. Through his investigative reports, Murrow helped end McCarthy's political career and made his name synonymous with demagoguery.

Independent journalist Seymour Hersh won a Pulitzer Prize for investigative reporting in 1970 for his work exposing the horrors of the My Lai Massacre in which American troops fighting the Vietnam War slaughtered hundreds of unarmed civilians—mostly women, children, and the elderly. After researching Army files, Hersh documented the attack by U.S. troops in unflinching detail. When the *St. Louis Post Dispatch* published his report, massive public outrage helped expedite the end of the Vietnam War. In the 1990s crusading Irish journalist Veronica Guerin fearlessly reported on her nation's drug kingpins for the *Sunday Independent*. When her investigations led to her murder in June 1996, massive outrage brought policing reforms and a crackdown on drug dealing that resulted in dozens of arrests and led to declining drug crime rates in Ireland for years to come.

THE FIRST AMENDMENT AND AMERICAN PRESS FREEDOM

The First Amendment to the United States Constitution—the first of ten initial constitutional amendments called the Bill of Rights—is the basis of press freedom in the United States. It is a single sentence, but it accomplishes much. Here's the entire text:

> Congress shall make no law respecting an establishment of religion, or prohibiting the free exercise thereof; or abridging the freedom of speech, or of the press; or the right of the people peaceably to assemble, and to petition the Government for a redress of grievances.

Although courts and most Americans take press freedom quite seriously, the First Amendment was written so broadly, it leaves much up to interpretation. Since its passage in 1789, the First Amendment has been cited to protect the rights of individuals to practice the religion of their choice, speak freely (even about their leaders—an act that wasn't often tolerated in the new Americans' countries of origin), and publish even news and information that was not particularly flattering to the government and its leaders. It is probably the best known of the amendments because it is frequently cited in court cases and used by journalists as a defense against charges of libel.

Without the protections they are afforded by the law in the United States and a few other developed countries (not including England, where the burden

of proof in libel cases rests on the defendant, not the plaintiff, as is the case in U.S. courts), journalists would not be able to do their jobs legitimately, reporting fairly, uncensored and without fear of retaliation. In the United States, the First Amendment serves as the basis for journalists' legal protections. Journalists in other countries are offered some protections, but few outside of the developed world enjoy legal rights nearly as robust as those within the First Amendment. There are some notable exceptions in Western Europe—namely Sweden. Swedish law is highly protective of journalists. Taking a step further than the First Amendment and American shield laws that allow journalists to protect their sources, Swedish law forbids journalists to reveal confidential sources. In a 2010 story about WikiLeaks founder Julian Assange's legal trouble in Sweden (to which he had avoided extradition as of this printing), local journalist Anders Olsson told the *Columbia Journalism Review* why Swedish law is so pro-journalist. Olsson said, "It's a rather old tradition of making sure that people can trust the press."[1]

In the United States, press freedom, as guaranteed by the Constitution, is sacred. It is closely connected to such deep-seated American values as freedom of speech and freedom from censorship. These values are so engrained in the American consciousness that even those far outside the media understand and embrace them. They define the job of journalists and their treatment in courts of law. Even so, public attitudes toward things like privacy and access to information that are central to the journalist's job change with shifting political and economic conditions as well as major news stories. In the wake of 9/11, the surprise terror attacks in New York, Washington, DC, and Pennsylvania came as such a shock to the United States and its allies that the people and their lawmakers proposed legislation that infringed on people's privacy to a degree that would not have been widely acceptable before the tragedy. In late 2001, just weeks after 9/11, Congress passed the USA PATRIOT Act that allowed the U.S. government to pry into its citizens' private affairs, including their phone calls and library records. Several years later, after the international nonprofit organization WikiLeaks released secret government communications to the public revealing that, among other offenses, governments around the world were engaged in covert investigation of their own citizens. WikiLeaks supported private government contractor Edward Snowden, who gained international fame in 2013 for leaking classified information about the U.S. National Security Agency, the NSA. The revelations of both WikiLeaks and Snowden brought a near complete reversal of the public's prior attitudes toward privacy.

Like the public itself, the courts, whose job it is to interpret the law, can shift their orientation fairly radically based on their makeup and the prevailing attitudes of the general public. Precedent is a keystone of legal interpretation, as courts draw upon the resolution of previous court cases to determine how

current cases are decided. Although precedents are sometimes overturned, which people and cases ultimately prevail has much to do with current attitudes and events. In the weeks and months after 9/11, great restrictions were placed on the media in terms of access to transportation centers, utility plants, and other sensitive infrastructure. Although it still sometimes happens today, routinely in the months after 9/11, journalists were banned from shooting photos or video near airports, train stations or power plants. The restrictions have since loosened as the public has become less tolerant of their government's quiet violation of individual privacy.

The rise of WikiLeaks and the subsequent uproar over what many considered spying by the NSA ushered in new questions about who is a journalist and what are the rights and responsibilities of journalists. The last time the media had experienced such an identity crisis was after the 1971 release of the Pentagon Papers, revealing covert U.S. government activities in Vietnam. Military analyst Daniel Ellsberg released secret documents to *New York Times* reporters and was initially charged with conspiracy. The Pentagon Papers revealed that President Lyndon Johnson's administration had lied about the Vietnam War to the American public and knew it was not winnable.

The Nixon administration sued to keep the *Times* from publishing classified information and pushed for Ellsberg's conviction. They initially won an injunction to keep the *Times* from publishing. The *Times* appealed the decision, and *New York Times Co. v. United States* went all the way to the Supreme Court, which ruled in favor of the *Times*. The Pentagon Papers soon appeared in newspapers across the nation. The case was a milestone for press freedom as it showed that the presidency was not untouchable, but rather, that the press could report information powerful enough to unseat a president. Two years later, the Watergate scandal would further underscore the power of the press. The early 70s was a great time to be a journalist in the United States. Enrollments in journalism programs across the country soared as young people committed to changing the world with the power of the pen and the typewriter prepared to enter the field.

JOURNALISM IS STILL SPECIAL

It is an interesting time for journalism. In fact, times have been interesting for journalism for many years now. But the only people who fully understand are those who remember journalism's more stable era. Younger people and those new to the industry may not recall a time when journalism was stable, when jobs were relatively fixed and technological changes took place at a glacial pace. The media industry was turned upside down in the first years of the twenty-first century, and it has been in flux ever since. But the only people

struggling with these changes are older mid- or late-career journalists with a significant investment in maintaining the old ways of doing things. Those who started their journalism careers in this century, who know only flux in their profession, are that much better prepared for success in the field than those who came before them.

Despite the upheavals of recent years, the fundamentals of journalism haven't changed. Journalism has always been a professional discipline that unites practitioners and students in a common cause. It has its feet in the real world and, for this reason, is uniquely responsive to its environment. Journalism does not exist outside its environment or the community it serves. Unlike academic disciplines such as history or the social sciences that depend on broad concepts and theory, journalism has been, since its very inception, evolutionary and adaptable. It has no purpose without an audience.

Journalism has a proud storied history. It is a challenging craft that offers rewards much more often personal than monetary. Although plenty of smart and talented people have stumbled into journalism indirectly, most who enter the field do so for good reason: They are passionate about finding the truth and sharing what they learn with others. Although journalists are now better able than ever to manage their careers and determine their own salaries, journalism has never been a field people enter for the money. Journalists tend to identify with their careers more than some in other professions. Anyone who has been around journalism students and journalists who are early in their careers recognize a kind of vocational passion that is almost unique to the field. Most would agree there is something special about journalism.

On its most basic level, journalism exists to inform. Journalists do the hard work of researching and gathering information, making sense of that information, packaging it in the best way they can to ensure their audiences will understand the information, then getting it out to their readers and viewers. This may sound simple, but without journalists, who dig beneath the surface, ask questions, and make connections for their audiences, most people would have an incomplete understanding of the news at best.

Until the late 1950s, print journalism in the United States had remained largely unchanged since colonial days. In eighteenth-century Philadelphia, then the center of government and politics in the New World, statesman and early media entrepreneur Ben Franklin published his newspaper of political criticism and essays, the *Pennsylvania Gazette*. In the following 300-plus years, most large cities claimed their own daily newspapers, which ran as for-profit ventures owned by media moguls with names like Pulitzer and Hearst. Paper

Figure 2.2

A 1729 issue of Ben Franklin's Pennsylvania Gazette. From the Project Gutenberg archives.

Numb. XL.

THE

Pennfylvania *GAZETTE*.

Containing the frefheft Advices Foreign and Domeftick.

From Thurfday, September 25. to Thurfday, October 2. 1729.

THE Pennfylvania Gazette *being now to be carry'd on by other Hands, the Reader may expect fome Account of the Method we defign to proceed in.*

Upon a View of Chambers's great Dictionaries, from whence were taken the Materials of the Univerfal Inftructor in all Arts and Sciences, which actually made the Firft Part of this Paper, we find that befides their containing many Things abftrufe or infignificant to us, it will probably be fifty Years before the Whole can be gone thro' in this Manner of Publication. There are likewife in thofe Books continual References from Things under one Letter of the Alphabet to thofe under another, which relate to the fame Subject, and are neceffary to explain and compleat it; thefe taken in their Turn may perhaps be Ten Years ------, ------ ------, ------ lefire to acquaint themfelves with any particular Art or Science, would gladly have the whole before them in a much lefs Time, we believe our Readers will not think fuch a Method of communicating Knowledge to be a proper One.

However, tho' we do not intend to continue the Publication of thofe Dictionaries in a regular Alphabetical Method, as has hitherto been done; yet as feveral Things exhibited from them in the Courfe of thofe Papers, have been entertaining to fuch of the Curious, who never had and cannot have the Advantage of good Libraries; and as there are many Things ftill behind, which being in this Manner made generally known, may perhaps become of confiderable Ufe, by giving fuch Hints to the excellent natural Genius's of our Country, as may contribute either to the Improvement of our prefent Manufactures, or towards the Invention of new Ones; we propofe from Time to Time to communicate fuch particular Parts as appear to be of the moft general Confequence.

As to the Religious Courtfhip, Part of which has been retail'd to the Publick in thefe Papers, the Reader may be inform'd, that the whole Book will probably in a little Time be printed and bound up by it felf; and thofe who approve of it, will doubtlefs be better pleas'd to have it entire, than in this broken interrupted Manner.

There are many who have long defired to fee a good News-Paper in Pennfylvania; and we hope thofe Gentlemen who are able, will contribute towards the making This fuch. We afk Affiftance, becaufe we are fully fenfible, that to publifh a good News-Paper is not fo eafy an Undertaking as many People imagine it to be. The Author of a Gazette (in the Opinion of the Learned) ought to be qualified with an extenfive Acquaintance with Languages, a great Eafinefs and Command of Writing and Relating Things cleanly and intelligibly, and in few Words; he fhould be able to fpeak of War both by Land and Sea; be well acquainted with Geography, with the Hiftory of the Time, with the feveral Interefts of Princes and States, the Secrets of Courts, and the Manners and Cuftoms of all Nations. Men thus accomplifh'd are very rare in this remote Part of the World; and it would be well if the Writer of thefe Papers could make up among his Friends what is wanting in himfelf.

Upon the Whole, we may affure the Publick, that as far at the Encouragement we meet with will enable us, no Care and Pains fhall be omitted, that may make the Pennfylvania Gazette as agreeable and ufeful an Entertainment as the Nature of the Thing will allow.

The Following is the laft Meffage fent by his Excellency Governour Burnet, to the Houfe of Reprefentatives in Bofton.

Gentlemen of the Houfe of Reprefentatives,

IT is not with fo vain a Hope as to convince you, that I take the Trouble to anfwer your Meffages, but, if poffible, to open the Eyes of the deluded People whom you reprefent, and whom you are at fo much Pains to keep in Ignorance of the true State of their Affairs. I need not go further for an undeniable Proof of this Endeavour to blind them, than your ordering the Letter of Meffieurs Wilks and Belcher of the 7th of June laft to your Speaker to be publifhed. This Letter is laid (in Page 1. of your Votes) to inclofe a Copy of the Report of the Lords of the Committee of His Majefty's Privy Council, with his Majefty's Approbation and Order thereon in Council; Yet thefe Gentlemen had at the fame time the unparallell'd Prefumption to write to the Speaker in this Manner; You'll obferve by the Conclufion, what is propofed to be the Confequence of your not complying with His Majefty's Inftruction (the whole Matter to be laid

boys delivered an evening edition to every household in the coverage area. Daily newspapers provided all that most people knew about what was happening in the world beyond their front door. For this reason, newspapers were essential reading, and their owners were able to significantly influence public opinion and both national and international events. In the late nineteenth century, competing newspapermen Joseph Pulitzer, who owned the *New York World*, and William Randolph Hearst, who owned the *New York Journal*, sensationalized the news in an effort to boost circulation.[2] Both men were blamed for helping push the United States into the Spanish-American War[3] by publishing stories that pandered to Americans' patriotic desire for acquisition and imperialism.

Although readers grew more sophisticated and demanding of their news media, with the rise of the mass media came a standardization and limitation of viewpoints and stories. The mass media, which dominated the news and information game for most of the twentieth century, provided limited perspectives to consumers by providing few variations on the stories of the day, produced and distributed not for specialization or customization (as news is packaged today), but to reach the largest number of consumers possible for the smallest investment in time and resources. It was a one-size-fits-all news model, wholly controlled by gatekeepers including editors, publishers, and news directors, and it defined journalism practice for most of the twentieth century.

From World War I to Operation Desert Storm, the journalist's realm was limited mostly to print (newspapers and magazines) and, later, broadcast (radio and television). Journalists in training decided which medium they wanted to work in, and often entered the field directly, starting at the bottom of the organization as an intern or, in the early days, a "copy boy." In the mass media decades of the twentieth century, journalism ran largely like a trade, mirroring the medieval system through the years-long apprenticeship of young aspirants and even a union dubbed a "guild." Like the medieval trades, journalism had its own way of doing things. New members learned on the job over a period of years, internalizing the expectations and rules unique to their trade. The profession even enjoyed its own unspoken expectations for coverage that did not always embrace the call for objectivity, transparency, and accountability we hear more than ever today. While for decades the mass media gatekeepers kept certain kinds of stories out of the news, including stories about the personal lives of public figures, the media began reporting on the foibles and often unsavory personal details of even U.S. presidents' lives in the early 1970s. Some news critics have pointed to the Watergate scandal and its effect on public trust as a turning point in American media. The Watergate scandal not only exposed Nixon's wrongdoing, but it also opened

the door to similar scrutiny of future presidents. Journalism would never be the same.

The media would experience their next seismic shift some twenty years later with the advent of the Internet. Despite the expressed concerns of some who have recently warned of journalism's demise, transformation and change is nothing new for the news media. Unusually dependent on consumer demands, journalism boasts a unique capacity for transformation, and although practitioners' memories are short, it is worth recalling that the media, by their very nature, are always in flux.

JOURNALISM AT A CROSSROADS

In 2008, as the American economy tanked and housing values plummeted in response to the collapsing mortgage market, the pace of layoffs in traditional journalism outlets quickened significantly. The following year was particularly tough for journalists. In 2009 the American Society of News Editors (ASNE) canceled its annual convention "because of the challenging times we face" that would lead to low attendance, as reported by Poynter.org's Jim Romenesko.[4] In early 2009, the Online News Association (ONA) faced similar challenges as it planned for its fall conference in San Francisco. Working journalists who had agreed to volunteer in the student newsroom or in some other capacity changed their plans to attend the conference in response to layoffs or other economic factors. By the time of the fall conference, some struggled to remain positive when talking with students about the news business. It was a tough time for traditional print and broadcast journalism, and online news had yet to really take off. But the bad news was short-lived. By the time the ONA started planning its 2010 conference, a new online journalism model was in full bloom. The previous year, America Online (AOL) had purchased a network of hyperlocal online news sites called Patch.com. Following its community journalism mandate, Patch launched online news sites in small towns and cities across the United States, refusing to enter large markets that were beyond the scope of community journalism and where it could not successfully compete. For a while, the formula—like the nonprofit news model before it—seemed uniquely promising. In an industry feverishly exploring answers to plummeting circulation numbers and declining viewership, the news that AOL would be investing at least $50 million into developing the Patch network and that in 2010 it planned to hire more full-time journalists than any other media outlet was almost beyond belief. By the time of the 2010 ONA conference, journalists were almost giddy about Patch. Although some expressed concern about the apparent irony that a giant media company like AOL would support the hyperlocal news model, many were just happy that journalists were once

again in demand. At that fall's ONA conference in Washington, DC, many of the promising journalism students who were poised to graduate were offered jobs at Patch.

Like the others that had come before it, Patch.com commanded serious attention for some time as journalism's much anticipated future. By keeping expenses down with low wages and little infrastructure (most employees worked at home), Patch was able to expand quickly. The idea was that if Patch could expand into 500 small communities with minimal startup costs and use low-cost labor (mostly freshly minted journalism graduates) to post photos, videos, and short items about happenings in their own communities every day, the business model would be sustainable. Key to the model's success would be tech-savvy young reporters and first-hand community knowledge. With a consistent and growing readership, Patch could sell highly targeted ads to business owners in the communities they served. This proved a good alternative for some small businesses that were no longer seeing much response to their print ads in community newspapers.[5]

Within three years, what was once the solid Patch foundation began showing cracks. The limited experience of most of its writers put them in direct competition with local news bloggers, then a fast-growing group. By 2013, Patch had begun consolidating its network, reducing the number of its sites by several hundred from 900, and laying off writers and editors.[6] In January 2014, AOL sold Patch to Hale Global. Within a couple months, the newsroom reductions had become noticeable on Patch sites that ran mostly stories reposted from other news sources.

Although the once hugely popular term "hyperlocal" had largely fallen out of favor by 2014, readers' demand for hyperlocal news coverage remained. However, instead of navigating to websites on their laptops, more readers were looking for content on their smartphones and tablets. This meant that if news entrepreneurs wanted to deliver news to readers wherever they were, they would have to use global positioning technology to develop highly customized, localized mobile apps. While websites and laptops were the technology of early days of convergence, smartphones and tablet computers would be the technology of its maturity phase.

Smartphones and mobile media have largely globalized the developing world in recent years. In some of the world's most remote areas, cell phone reception is often more reliable than electricity transmission. Norwegian journalism professor Kaare Melhus spoke via Skype about his work helping to train investigative reporters in Uganda. (The power went out in Melhus' room several times during the interview.) Melhus' experience is a useful reminder that technology alone is not enough to guarantee a free and democratic press.

INTERVIEW: A Conversation with Kaare Melhus, Associate Professor, NLA University College, Kristiansand, Norway (via Skype from Uganda)

What do you teach in your journalism classes in Norway?
I teach production of radio news, journalism ethics, and crisis journalism.

What are you doing in Uganda?
We are starting a new program on Monday. It's a master's degree in journalism and media studies at Uganda Christian University.

What is your background?
Before I started teaching, I was a reporter with the Norwegian Broadcasting Corporation, which is a similar setup to the BBC in England. I worked there for thirteen years in various capacities. I started out in regional broadcast in the south of the country, then I worked on the national desk, and I did national news and also for a period worked on the foreign news desk. I was one of those parachute reporters that flew into all sorts of hot spots all over the place. I was in Sarajevo during the Bosnian War. I covered the aftermath of the genocide in Rwanda. In 1999 I came to work at NLA University, and I've been there teaching basically practical, hands-on courses.

Figure 2.3
Kaare Melhus.

How is the European media different from the American media?
My impression is that the European market isn't all that different from the United States. I follow quite a bit of BBC World News and CNN International, and it's pretty much the same. Compared to my own background with the Norwegian Broadcasting, I think the BBC is far superior in their coverage primarily because they have so many more resources. They have reporters all over the place, whereas we had just a handful of reporters. When I was out with BBC and CNN covering something, I was by myself and those two had thirty people working the story.

What did you study as a journalism student that remains essential for journalism students to know today?
The reason why I went to the States in the first place in the '70s was that at that time Norway did not have journalism or media studies at the university.

In those days journalists studied either languages or political science, and then they learned the trade on the job. But I was interested in studying journalism, and at that time the only option was to go to the United States. I also wanted to learn to speak reasonable English. So I spent six years in the States.

What skills are essential for all journalists today?

You have to have creative story ideas and the necessary insight and connections in your field in order to produce good journalistic content. This has always been the case. The newsrooms are looking for creative people with ideas. I spent most of my time teaching journalism students in Norway, which is an environment similar to the United States. The most important skill or ability is to have ideas. Journalism students in Norway, at least on the undergraduate level, seem to not be living in the real world. They have their Facebook friends and they live in a bubble, and when we send them out on assignments to cover city council, they have no idea what that is or what to do. We just throw them into it. They learn by crashing. The other thing is to be engaged in society because if you are not engaged with other people, you won't get any ideas. Journalists need to have an area of expertise in terms of a beat because that is also what the newsrooms and media houses are looking for—people who know something special. It is very hard to be an all-around reporter with no areas of expertise. One of my former students spent two years in China learning Chinese. She will create interest.

Are there any essential personality types or characteristics that journalists need to be successful? Have these changed over time?

A successful journalist is curious and outgoing. This has not changed over time.

What kinds of work are your students getting after graduation?

The best of them end up as reporters and editors in local and national media, and in leading media houses. Recently I learned that one female student is now the spokesperson for UNICEF, Norway.

What career advice do you give your students?

Learn foreign languages and develop a field of specialization.

What skills are you teaching your journalism students in Uganda?

The skills courses are pretty basic. But we require that students have an undergraduate degree in something so they are not fresh out of high school. The common denominator and the most important thing we do besides teaching them the basic skills in reporting and editing and putting together television documentaries and whatnot, the basic thing that we emphasize and have various courses in is the role of the media in a democracy. In the areas where we work, the students have no concept of that. I am going to teach a course in investigative journalism here, and I did some research last time I was here

to see if there was anything done like that in this country. What I understood after having talked to a few people is that investigative journalism is anything beyond printing a press release directly from an agency or from the government. If you ask questions and do some more reporting than just passively printing the stuff, that is investigative journalism. Most of the reporting here and in Ethiopia has been pretty much subservient to the government, and there is a reason for that. The laws of the land prohibit any sort of probing—particularly into government affairs. So the people do it with considerable risk. This is a very slow process for us. We try to introduce Western ideas of a free press, free speech, democracy-building, that sort of thing, and we don't expect to see any immediate results. We're trying to build this from within. Some of our critics say this is naive. Maybe it is, but at least we're trying.

How long will you be there?
I am here for the first two weeks. I'm teaching three hours in the afternoon every day. When we're finished with that, we will divide the people—about twenty—into groups of two, and they will do an investigative project of some sort. We will use these two weeks to sort out what that is and make them ready for it. And then I will mentor them via email or Skype or whatever, and then I will come back in the beginning of November and go through it in person with them. They will finish their projects by the end of the year. This is very much a hands-on course. The first two projects we had, we built up a network of people. We were working with the University of Nebraska and people from the BBC and *Time* magazine, various people from contacts everywhere. We flew them in. They were there for three weeks or so, and taught their courses full time. We do it that way because we can't bring people to the States for extended periods of time.

Do the students have access to multimedia tools?
All of these projects have been funded by the Norwegian government, and there has been some money to buy state-of-the-art equipment, and also generators so that when the power goes we can continue. We have brought in our own gear. It's all digital. We use digital cameras. We have layout programs for newspapers. We have digital voice recorders. Some of that stuff is a bit more advanced than what they will be using in local newsrooms, although over the last few years this digital equipment is pretty much everywhere. But we have figured we would show them the future rather than the past. I have toured some of the newspapers here in Uganda, and they are all digitalized and computerized, so that has pretty much reached everywhere. There is power trouble, but they run decent generators.

What are the biggest challenges to teaching journalism in Uganda?
The hindrance is not technical here. It is censorship and to a large degree self-censorship because the students are afraid to say something that will get

them in trouble. This is the first time I am teaching investigative journalism here, so I'm not exactly sure what is going to happen, how far we can go. We'll also have local lawyers to explain to us the surroundings and the environment in which students will work, so we're not exactly sure what this will bring. It's walking a fine line. On the one hand we want to encourage students to be bold and speak out. On the other hand we don't want them to land in jail or worse. In all these places we have had local partners. We are not coming in from Europe and stirring up something. We are working with serious local partners. In Kosovo, we worked with the Ministry of Education. But all of that also creates its own problems.

Why do you do this?

The watchdog role of the media is important in emerging democracies and even in dictatorships. What is new is that it is now more difficult for authorities to silence oppositional voices inasmuch as the Internet is all over the place. But the Internet itself changes nothing. A strong democracy depends on competent and knowledgeable critique of the ruling authorities. Technology does not change classic journalism. There are now many new channels and possibilities, but the craft is the same.

SUMMARY

Journalism is a vehicle for individual empowerment and democracy. A nation with a strong press has an informed citizenry that makes decisions based on actual facts and information reported by trained journalists. These journalists are not afforded any special privileges, though some enjoy legal protections to ensure that they can continue to work in their communities without fear of retaliation or coercion. Few would want to live in a society without investigative journalism, where those with the most money, power, and influence could impose their will upon those in a lesser position completely without public knowledge or scrutiny.

The First Amendment allows American journalists to do the important job of reporting on corruption and malfeasance without fear of lawsuits, retaliation or worse. Without the protections they are afforded under the law, American journalists may not be able to publish stories that revealed illegal or immoral activities. They may not be able to conduct the type of research required to reveal and right wrongs. Without the First Amendment, American journalists could be silenced as journalists are in many non-democratic nations where the government more or less determines news coverage.

Because of its profound ability to empower people and keep governments from overstepping their authority, journalism is a protected practice in most

developed Western nations. Despite charges of sensationalism that have been leveled since its earliest days, journalism keeps citizens informed and governments honest. There are protections for journalists working in other parts of the world, though few legal systems protect reporters and content producers to quite the same extent that they do in the United States. With that in mind, a few nations, including Sweden, make American press freedom look weak in comparison. In contrast, many nations in less developed parts of the world (including several in Africa) still offer limited press freedom despite claims to the contrary.

Technological advances have brought the greatest changes to journalism in recent years. But as journalism instructors are quick to point out, the fundamentals of journalism practice haven't changed. It is important to not lose sight of that fact. Without a doubt, technology has changed the way reporters research and deliver stories, requiring them to learn new skills. However, the new skills have not replaced the old skills. Rather, journalists must ensure that their skills remain current through continuous training while mastering and maintaining the foundational skills that journalists have always needed to know.

JOURNALIST'S TOOLKIT

Journalists working today, like the journalists who worked decades before them, must master and maintain certain fundamental skills that will not change even as technology does. These foundational journalism skills include the basics you probably learned in your first journalism classes. Successful journalists of any era must develop impeccable research skills. They must learn how to find the answers to the critical questions raised by the stories they report. Successful journalists need stellar communication skills. They need to know how to conduct interviews, as well as how to find, approach, and maintain sources.

After gathering information, journalists need to know how best to assemble the facts of their stories, to create coherent stories, and to make logical connections and clear points. They need to get to know their audiences and the purpose of their reporting. They need to learn how to deliver compelling stories that are relevant to their audiences but do not pander, distort facts or otherwise compromise the integrity of their reporting or themselves. Above all else, they must be ethical, fair, and neutral in their reporting. They need to understand their role, their rights and privileges, and their responsibilities as reporters. That many contemporary journalists now work primarily online does not diminish the importance of their mastering these foundational journalism skills.

Skills

Data-driven research and computer-assisted reporting

Oral and written communication

Interview technique

Source development

Storytelling and narrative story structure

Working command of libel law.

Tools

Computer with Internet access and word-processing software

Digital voice recorder

Libraries, archives, and databases.

Sites

Asne.org: The American Society of News Editors' (ASNE) site.

Journalists.org: The home page of the Online News Association (ONA).

Patch.com: The home page for a network of hyperlocal news and information sites.

Application

1. Interview a veteran journalist who worked before the widespread adoption of the Internet. Ask the journalist how they researched stories, solicited interviews, and checked facts without online resources. Create a story (in any media form or on any platform) about the journalist you interviewed, utilizing all the foundational journalism techniques you've learned.
2. Interview a journalist or student journalist who works or studies in another country. Create a story (in any media form or on any platform) comparing press freedom in your country to press freedom in the subject's country.
3. Fact-check a published news story without using Internet sources. Print a double-spaced text copy of the story or story transcript and highlight each number, name, and fact. Verify all facts and spellings by visiting a library or talking with primary sources. Change any incorrect information and note the source of the correction.

Review Questions

1. What are the rights, privileges, and responsibilities of journalists working in your country?

2. What qualifies people to call themselves journalists? Does everyone who produces content today qualify as a journalist? If not, who does not and why?

3. How does someone establish himself as an independent journalist today?

4. Why is reputation so important to journalists today? Can a journalist's bad reputation be repaired? If so, how?

5. How does a journalist maintain a good reputation as a journalist?

REFERENCES

1. Hendler, Clint. "A Swedish Shield, Unraised," *Columbia Journalism Review*, September 2, 2010, http://www.cjr.org/campaign_desk/a_swedish_shield_unraised.php?page=all.

2. Blackbeard, Bill, and Williams, Martin. *The Smithsonian Collection of Newspaper Comics* (Washington, DC: Smithsonian Institution Press, 1977).

3. Campbell, W. Joseph. *Yellow Journalism: Puncturing the Myths, Defining the Legacies* (Santa Barbara, CA: Praeger, 2001).

4. Romenesko, Jim. "ASNE Cancels 2009 Convention 'Because of the Challenging Times We Face,' " *Poynter.org*, February 27, 2009, http://www.poynter.org/latest-news/mediawire/94381/asne-cancels-2009-convention-because-of-the-challenging-times-we-face/.

5. Stewart, Ain. "Patch.com, a Year-Old Online Community Newspaper, is Competing with Local Papers for Ads," *Long Island Business News*, November 3, 2010.

6. Carlson, Nicholas. "AOL CEO Tim Armstrong Fired Patch's Creative Director in front of 1,000 Coworkers," *SFGate.com*, August 9, 2013, http://www.sfgate.com/technology/businessinsider/article/AOL-CEO-Tim-Armstrong-Fired-Patch-s-Creative-4720914.php.

A Converged World

"Convergent journalism" is by now a fairly old term. Because what it describes is so commonplace now, its definition may not make sense to younger people who cannot easily recall a time when newspapers were exclusively printed on newsprint, radio stations were exclusively on the AM or FM band, and television stations were either part of one of the major broadcast networks (ABC, NBC or CBS) or on the UHF dial. Even seasoned journalists are quite familiar with converged media because most people now live in a converged world. We don't get our news and information from just one medium. During the course of a typical day, we move seamlessly from one medium to another. We increasingly use our smartphones and other mobile devices to interact with the world and learn what's going on around us. Most of the time we don't even think about the way news and information reach us. We are nimble consumers with multiple devices and options for communication.

We discussed the history of convergence and some early models of convergent journalism in a previous chapter. Here, we discuss convergence itself, its uses, and the choices journalists face when reporting and distributing their stories. Because journalists now have so many media and tools available to them for telling stories, the temptation to take advantage of all those options can lead to poor decision-making and confusing stories. One of the main challenges for journalists today is deciding the best media and tools to use for reporting certain kinds and parts of stories. The decisions can be overwhelming, particularly for journalists working on their own. Just because you have access to a decent still or video camera doesn't mean you should use video to report a story. The inverse of this is also true: A lack of familiarity with certain hardware or software should not prevent a journalist from using these tools when they are the best means by which to report a story. Although they should not feel the need to show their expertise in all areas at all times, journalists should not be limited by a lack of training or a deficiency in skills.

Not all stories lend themselves to reporting in all media, but what follows are the most appropriate media to use for various kinds of stories or reporting demands. These are just guidelines, as there are no set rules regarding right or

Figure 3.1

In a converged media world, rarely does a journalist do just one thing. Photo by Jonut / Wikimedia Commons.

wrong ways to report a story. Sometimes stories reported in unexpected ways can be unexpectedly powerful.

THE CONVERGED JOURNALIST

In the converged newsroom, journalists need to know how to do at least a bit of everything. While most will specialize, depending on what skill set, interest or personality trait drew them to the field, now writers need to know how to take a decent photo, shoot and edit a short video, post their work online, and use social media to draw audiences to their stories. This does not mean that journalists need to be experts in every skill and tool used in the newsroom. But it does mean they need to know the journalism fundamentals, starting with how to tell a story regardless of the tools or platforms. The journalist's first consideration is always the story. Only after he understands the story he needs to tell should he consider the best tools to tell it. This does not mean journalists need to be particularly technologically advanced. With the variety of Web-based software available and more than one way to create most kinds of media, problem-solving is now among the journalist's most important skills. If he does not know how to do something he needs to do, he simply

Figure 3.2
Most newsrooms, like this one in Moscow, have long since been converged. Photo by Jürg Vollmer / maiak.info / Wikimedia Commons.

learns it. The best journalists understand that the only way they can stay on top of their field is by knowing or learning how to execute their vision.

Not all converged stories are equal. Complex stories that may not have compelling images but that require lots of numbers and other facts may require text and informational graphics. An example would be a story about changing housing prices or recycling patterns across your city. Another story that might offer more visual interest would logically include photos or video (that's better to show action than audio). An example might be a story about a local marathon or a march for civil rights. Still another story with highly emotional content may call for an audio slideshow. An example might be a story about the funerals for gunshot victims over the course of a hot summer in the city. Regardless of the content, as has always been the rule in journalism, the story comes first. It is the journalist's job to choose the best complement of tools to tell it.

TEXT

Text has long been the basis of most news and reporting. Most of us have been reading text for most of our lives. It is familiar. It is accessible. It is the storytelling tool with which we have the most experience. But in the digital world where more text is read on screens instead of on paper, readers tend not to want to wade through long blocks of text. For the most part, they want

Figure 3.3
Newspapers are still published, but readership has long been in decline. Photo by Ulrich Lange, Dunedin, New Zealand / Wikimedia Commons.

information fast, in bite-sized chunks that can be read on a small screen without excessive scrolling. Of course, not all stories must be short. People still enjoy reading long-form feature stories in magazines like the *New Yorker*, but for news, shorter is almost always better.

Best For

All stories in a limited capacity, but especially stories that require analysis, explanation or description.

Qualities

In journalism, text is usually analytical and straightforward. It provides explanation and logical connections among ideas. In longer-form journalism, word choice and sentence length can set the tone and determine pacing.

Examples

- An investigative report following the money trail in a political campaign.
- An extended profile of a little-known politician who is suddenly poised to beat an incumbent in an upcoming election.

Worst For

While text is essential for news reporting, large blocks of type are not ideal for reporting breaking news, spot news, and news briefs. Minimal type should be used for content delivered via mobile device or online.

Challenges

Long blocks of text can easily overwhelm readers, most of whom don't want to have to scroll to decipher long, involved stories. While investigative stories and personality profiles are, by necessity, long, they also need to offer readers room to catch their breath between sections. That means long stories should not run at length without photos, illustrations, explanatory text sidebars or information graphics to break up the text and add context in logical places. Explanatory sidebars and other graphic items are particularly important in helping to explain complicated concepts without overloading the main story. Whenever possible, detailed figures or computations should be kept out of the main story narrative where they can slow—and possibly even lose—the reader. Removing this information from the story's main body serves two purposes: (1) encouraging readers to continue by removing potential distractions from the story's main body, and (2) making challenging information easier to understand.

IMAGES

Best For

Stories heavily dependent on imagery and scenes, including personality profiles and feature stories about meaningful locations and weighty events. Images are ideal for reflection and in-depth consideration of context and setting. Since viewers can spend more time with images than they can with specific frames of video (unless they freeze the image, which is unlikely to produce a clear picture), slideshows or even audio, strong images tend to resonate more deeply and longer with viewers.

Qualities

Images bring emotional weight and empathy to story. They also help illustrate ideas while helping to establish tone.

Examples

- A story about a large march on Washington would be much more compelling with an image to convey the enormous size of the march and how it affected traffic near the Washington Mall.

- A personality profile of a local established politician featuring photos from throughout her long career.
- A slideshow documenting a number of funerals for gunshot victims in a particular community during the course of a single summer.

Worst For

Meetings and press conferences—any event in which the main action takes place behind a podium. An appropriate image always helps frame a story and makes it more appealing to potential readers.

Challenges

Appropriate images may not always be available. Photos that run large or in a slideshow must be extremely high quality. While images should accompany stories beyond a couple hundred words, it is better to not include an image than to include a poor-quality image. If an image relevant to a story is not available, these days it is easy to find a stock image that may work well as an illustration if not as an image from the event or story itself. Stock images can be found through Web-based subscription services such as istockphoto.com or shutterstock.com, although because licensing these images can be expensive, it is always preferable to take your own pictures when possible.

VIDEO

Best For

Long, elaborate multimedia stories with visual elements, drama, and—most important—action. Also for interviews or sidebars to accompany stories running online, and for tours or explanatory items.

Qualities

Video is informational, explanatory, factual, and demonstrative. It captures breaking news and action, and provides an overview of or introduction to a scene or event. It also gives viewers a better sense of a source or subject's personality. Video can supplement a feature story online by providing a quick visual reference that adds context to the main story. It captures a tone or a mood. It can also be used in an explanatory capacity online to demonstrate a process for readers who are unfamiliar with the process.

Examples

- Brief man-on-the-street video interviews with people camping overnight outside a ticket office embedded in a Web or broadcast

story about a popular band or major event coming to a local venue. Use video to show the enthusiastic dances of elaborately costumed fans, trash piling up on the sidewalk near their sleeping bags, and the chaos that erupts when the band finally arrives.

- Edited video excerpts from an interview with an outspoken local politician on the subject of the main story embedded into the Web version of the text story. Use video to reveal the politician's charismatic personality or his curious expression as he discusses a sensitive topic.
- Short video showing downtown flooding after a water main has ruptured. Seek out dramatic images such as people stranded on roofs or canoeing down an otherwise busy street.

Worst For

Long interviews, meetings or entire press conferences in a single fixed location. People lose interest in on-camera interviews—especially online—after a few minutes or even just thirty seconds. Journalists should make sure to keep these kinds of interviews short—ideally edited down to one or two minutes at a time or in a particular setting. Unless there are compelling events or locations to feature, long videos can exhaust the viewer or make the story seem less interesting than it is.

Challenges

Journalists with access to video equipment and editing software should resist the temptation to overuse video since it is often readily available, and can be easier and more fun to produce than explanatory text. When video is used, individual clips should be only a few seconds long, and the entire video itself should be no more than three or four minutes long. Video featuring unedited static shots that run at length will bore or turn off the viewer.

AUDIO

Best For

Long-form stories, chronological narratives, but also short breaking reports from the scene of news events.

Qualities

Audio is emotional, harking back to the earliest oral traditions. It is informational, but also warm and intimate. It conveys a strong sense of the speaker's personality.

Examples

- A report from the front lines of fighting in Gaza. Capture quotes from soldiers, witnesses or fleeing families.
- A first-person account of the trek from Guatemala, through Mexico and into the United States by a teenager in search of parents who have settled in North Carolina. Capture the teen's audio diary, then intersperse excerpts with quotes from a later interview with the reunited family.

Worst For

Stories reliant on specific images that may be difficult to describe or stories that rely on complex analysis and detailed explanation, numbers or computations.

Challenges

Audio can be a difficult medium for stories that are highly reliant on visual elements or are analytical and fact-based, requiring much of the listener's concentration to comprehend. It can also be a challenging stand-alone medium for stories dependent on specific visual details that are not easily described.

Figure 3.4

A treemap shows Uganda's exports. Graphic by R. Haussman, Cesar Hidalgo, et al., Economic Complexity Observatory, MIT Media Lab and the Center for International Development at Harvard University / Wikimedia Commons.

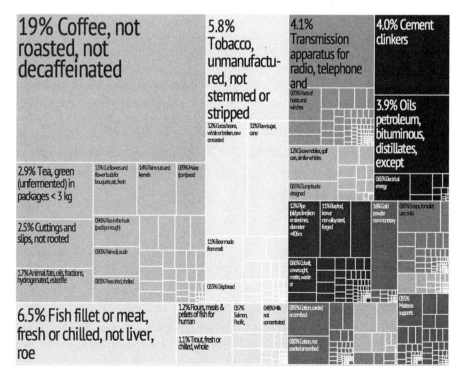

INFORMATION GRAPHICS

Best For

Complex facts that would require hundreds of words to explain. Almost always used as a supplement to larger stories in different media.

Qualities

Information graphics are factual and generally devoid of emotional content.

Examples

- For a story comparing property taxes across a few nearby communities, use an information map to visually display where taxes are higher and lower. The graphic may allow readers to click on various sections of the map to reveal property tax history in various locations.
- Produce an illustration of an accident scene that allows readers to hover a mouse over hotspots to expand on audio clips from witnesses describing what happened at a particular place at a specific point in time.
- Create an interactive calculator that allows online readers to compute the amount of money they need to have saved if they retire at various ages.

Worst For

Descriptive or highly emotional stories that are not analytical or numbers-based.

Challenges

Not all journalists can create professional-quality information graphics. Effective graphics may require contributions from those with special analytical or artistic skills. However, there are now many computer applications and free websites that allow journalists to create attractive graphics without possessing strong drafting or artistic skills.

SUMMARY

Convergent journalism is no longer an exotic term. Although it may still seem exotic or strange to some, its concepts have become commonplace. All of us now live in a world of ubiquitous media on demand. We receive the news we want, how and when we want it, in whatever degree of depth we prefer, on the devices of our choice. All of us are converged. Journalists working today are expected to know how to use various media and platforms to tell their stories. But instead of working in a favored medium or avoiding

tools with which they are less familiar, journalists who are committed to high-quality, effective, engaging storytelling must choose the best tools available for the job. Which tools they use to tell various aspects of a story depends on their understanding of the story's most important elements. Some media are better for setting tone or setting a scene. Others are better at explaining concepts. Some create emotional gravity. Still others help readers access challenging or highly sophisticated content. Each tool has different strengths and weaknesses, and journalists should consider the best way they can use each together to produce the most effective stories.

The most important thing to keep in mind when it comes to multimedia storytelling is that there is no one right form for reporting every story, and most longer stories now require a complement of different media to create the complete picture today's readers, viewers, and listeners expect. There are several great websites that feature high-quality multimedia storytelling. These highlight longer explanatory stories rather than short updates or breaking news items. The Online News Association's Interactive Narratives site (interactivenarratives.org) features extraordinary multimedia storytelling that informs without relying heavily on text. Some stories are anchored by video. Others surround a photo slideshow. At least one requires readers to click through on-screen options to reveal each new section of the story. Years ago *Guardian* technology correspondent Bobbie Johnson started an open Google Doc to track multimedia stories across venues. You'll find the link in "Sites."

JOURNALIST'S TOOLKIT

Among the entrepreneurial journalist's most essential skills is the ability to switch effortlessly among media to tell the best story. While many journalists—particularly photographers and other shooters, as well as those who are quite well known for a particular kind of work—may tend to specialize, most journalists today must be able to access a wide range of reporting skills using various hardware and software.

Skills

Writing

Photography

Recording and editing audio

Shooting and editing video

Creating informational graphics.

Tools

Desktop or laptop computer

Tablet computer or smartphone

Digital audio recorder

Audio editing software such as Garage Band or Audacity

Video camera

Basic or better video editing software.

Sites

Interactivenarratives.org: The Online News Association's (ONA) collection of interactive narrative reports.

Istockphoto.com: An online stock photo site.

Shutterstock.com: An online stock photo site.

Tinyurl.com/ktu2pgx: *Guardian* technology correspondent Bobbie Johnson's open Google Doc to track multimedia stories worldwide.

Application

1. Compare a print publication to its website. Review the similarities and differences between content, design, type treatment, advertising, tone, and any other significant differences. Look for convergence.
2. Select the essential journalism skill listed in the Journalist's Toolkit about which you know least or you would most like to learn more about. Use reliable online sources to teach yourself the skill, then explain what sites you visited and what you learned.
3. Find a breaking news event on your campus or in your community to cover. Draft a coverage plan that lists what aspects of the story you plan to report and the media you will use to report them. *Optional:* Report the story and pitch it to a relevant news outlet.
4. Find a meeting, speech or other presentation to cover. Draft a coverage plan that describes how you will use various media to make a story with potentially dull visuals more appealing to your audience. *Optional:* Report the story and pitch it to a relevant news outlet.
5. Conceive a feature story to report on a complex issue. Draft a coverage plan that describes how you will use various media to explain, elaborate on, and highlight various aspects of the story.
6. Find an existing news or feature story in a print publication. Report a follow-up of the story taking full advantage of the strengths of various media.

Review Questions

1. Are any stories these days best presented in text only? If so, what kinds of stories are these?
2. Can a journalist use too many media to tell a story? Provide an example and explain why the use of various media is problematic in this case.
3. Can a journalist today succeed without having developed skills in one of the major areas of multimedia journalism? Why or why not?
4. Has the Internet changed news consumers' habits and expectations of journalists? If so, how?
5. How much should journalists think about the ways they reach their audiences with their stories? Should they consider producing different versions of the same story for different audiences (i.e., mobile or offline) using different combinations of media?
6. What does it mean to think visually about a story? Does that fundamentally change the nature of the story for the journalist?

Tools Are Tools

When the concept of convergence hit newsrooms and classrooms in the first years of the new millennium, veteran journalists, editors, and educators were concerned. They wondered how the changes would affect the way they had done their jobs for years—or even decades. Some wondered if the changes would make their skills and experience irrelevant. Retraining was possible, but it seemed daunting to most.

Most newsrooms and classrooms at the time were led by people who had learned their jobs in the pre-Internet era and were not eager to transform themselves into multimedia whizzes. Many seasoned professionals wondered whether journalism was even the same profession it was when they entered it. Very few who became journalists before the mid-1990s (aside from maybe technology columnists) entered the field for their love of technology. They became journalists for the same reasons generations of their predecessors had. The old expression: "To comfort the afflicted and to afflict the comfortable" may come to mind, but in actuality, many journalists entered the profession to write stories about people that other people could relate to.

After reporters and editors recovered from the initial shock of the Web's gradual dominance over print, those with open minds realized that tools are, in fact, just tools, and that technology should never overshadow the true goal of journalism: to report true human stories that can make an impact on others. Now that the term "convergence" is quite familiar across the industry and newsrooms have adapted to the new ways of doing things, the early panic may seem a bit overblown. But back in the first years of the new millennium, particularly as an economic downturn exacerbated existing pressure on a struggling economy, print seemed particularly vulnerable. With the events of 9/11 exposing the Western world's vulnerability to terrorism as well as the need for real-time news coverage, the case for digital media grew stronger by the day. A change was, indeed, coming, and it would soon be unstoppable.

Well into the first decade of the new millennium, many college journalism programs still offered exclusively print-based instruction. Most offered courses in broadcast journalism, but there was little or no mention of multimedia or the Web until both were fairly common elements of mainstream media. By the middle of the decade, curricula at the world's best journalism schools began to reflect a new paradigm. For the first time, universities required courses in Web development or even the HTML editor Dreamweaver. There was a rush to provide both students and faculty training in specific software quickly. Universities offered supplemental summer classes to help students and faculty get up to speed in basic Web development or video editing. Often, in the rush to train everyone quickly, students and faculty worked side by side as students in the same classes and a new crisis of confidence descended upon professors who wondered if what they had been brought to the university to teach would still be relevant in five years—or in one. It was an uncomfortable time for many. There was also a real concern that the fundamentals of journalism would be lost amid the rush for technical training. Journalism faculty who brought with them decades of newsroom experience suddenly found themselves in the uncomfortable position of reminding their students and supervisors why they were there. Although it was sometimes difficult for them to realize it at the time, journalism faculty during this era were actually more important than ever. However, it would take some time for their institutions to embrace their claims that during this transitional time for the profession, teaching journalism's foundations was still essential. Many institutions learned the hard way, after investing huge amounts of time and money in software and hardware that would soon be obsolete. Although it took some time for university curriculum committees to realize their mistake, now journalism students, professors, and practitioners are secure in their assertion that tools are just tools. They come and go, but the real work of journalism never changes.

Bernard "Barney" McCoy is a veteran journalist who has worked as a print reporter, television news producer and anchor, and has produced and directed documentaries. He won six Emmy awards along the way. McCoy transitioned to teaching full-time in 2006. He is now Associate Professor at the University of Nebraska-Lincoln, where he teaches digital, mobile, multimedia, and broadcast journalism, and journalism ethics. In summer 2014, the newsletter for the Association for Education in Journalism and Mass Communication (AEJMC) published preliminary findings of a study McCoy conducted on the most important skills for graduating journalism students today. For the study, McCoy asked journalism faculty and professionals about what skills graduating journalism students need most to succeed in the current job market. He received responses from 665.

INTERVIEW: A Conversation with Associate Professor Bernard "Barney" McCoy, Veteran Journalist and Journalism Educator at the University of Nebraska-Lincoln

What did you learn from your study?

Accuracy, ethical principles, and good news judgment remain the foundation skills college journalism graduates must possess. *But* digital reporting, good mobile skills, and social media reporting skills are definitely increasing in professional demand. News professionals and journalism educators agree that newer technology skills are increasingly important for graduating journalists.

Figure 4.1
Bernard "Barney" McCoy.

Based on your findings, does it seem that working journalists and journalism educators have similar ideas about the kinds of training new journalists need for the current job market?

They're in general agreement on most skill sets such as accuracy, ethical principles, and accountability, but there are a few areas where they disagree. For example, educators place a greater emphasis on having good mobile, social media reporting skills, while news managers and news employees place slightly greater emphasis on digital reporting skills.

Does the term "job market" still apply to journalism today, when so many journalists are working outside of traditional channels?

Yes, the traditional job market still supplies most of the post-graduate jobs, but that is quickly changing to include journalism post-grads who are working in a growing number of online-only venues that demand a greater understanding and use of multimedia content, Web analytics, story display, mobile apps, and search engine optimization.

What do you teach in your journalism classes today, and how do the skills taught today differ from what you learned in school?

The content basics are still priority number one (good writing, proper attribution, diverse sourcing, accuracy, etc.) and should always be so because they dictate the reporter's and the organization's credibility. I make sure there is also training involving multimedia journalism content production,

Web analytics for content feedback, and the use of social media for content research, promotion, and distribution.

What can experienced journalists do to remain competitive?
They must keep evolving in every area. Today's journalists must have broader (multimedia, social media) technical skills to go with their legacy (accuracy, attribution, ethics, writing) reporting skills. They must pay closer attention to content and audience feedback to it. Audiences are less captive and can appear and disappear faster than ever. The number of people who read, listen, watch a reporter's story has always mattered. It matters more today because the content competition is increasingly global. Journalists who use Web analytics to effectively tailor content have the greatest opportunity to succeed.

Are there any essential personality types or characteristics that journalists need to be successful? Have these changed over time?
Curiosity, integrity, perseverance, and getting facts right have always been important. Today I would add being willing to work with new reporting tools and technology—being willing to look for new reporting tools and technologies that can make your reporting more effective and meaningful.

We all know how journalism has changed in recent years. In what ways has it stayed the same?
Integrity, accuracy, hitting deadlines, accountability, thinking outside the box—these remain hallmarks of good journalism.

What kinds of work are your students getting after graduation?
Broadcast reporters, producers, directors, videographers, print writers, photographers, editors, digital content producers and writers, management, employee training, public relations, advertising, sales.

What career advice do you give your students?
Information is power. Those with the ability to gather it, confirm it, and communicate timely, effective messages will always be in demand.

ESSENTIAL SKILLS ARE STILL ESSENTIAL

Journalism education is more complicated today than it was when most programs offered training only in research, reporting, and writing. Yet like with society at large, technology is quickly becoming more seamlessly integrated into journalism. This is due to two significant and ongoing trends: (1) the improvement of technology and increasing ease of its use; and (2) the greater comfort of younger people with technology. In other words, most traditional-age students today grew up using technology and face fewer challenges

learning and adopting new technology than those in older generations. This is due in part to improvements in the way technology works and its increasingly ubiquitous role in daily life. Despite—perhaps even *because of*—technology's central role in our lives today, journalism foundations are more important than ever. While there is no master list of essential journalism skills, most educators and professionals would agree about the importance of the following.

ESSENTIAL LEGACY SKILLS FOR JOURNALISTS

Integrity

Although integrity is an essential legacy skill, some could argue that it is even more important in the digital era. Just like in the past, a journalist is only as good as his sources. Especially when reporting sensitive or high-profile stories, journalists must earn the trust of potential sources. No one will be willing to speak with a reporter—much less reveal secret or potentially damaging information—unless they trust that reporter. A reporter must prove himself trustworthy by keeping his word (for instance, not revealing a source, as promised), reporting fairly, and not allowing cowardice or the pursuit of personal gain to alter the outcome of his reporting. A reporter (particularly a reporter following a beat) relies heavily on sources for information he would not be able to learn through other channels. A good source is like a good relationship. The more a reporter invests in the relationship by keeping his word and acting ethically, the more likely the source will be to reveal even more sensitive information as it becomes available. If a reporter develops a good reputation with a source, other sources are likely to trust the reporter with whatever sensitive information they may want to convey. In some cases, for instance, in which there are serious problems within an institution, a single reporter who has built trust within an organization may find himself in a position to break a major news story about a corrupt official or other hidden problem with great potential to impact the public.

In the online world, reputation is even more important because with increasing numbers of media platforms and people with access to information, more information about people is available to the public than ever before. Not only does the general public now have more access to information about each other, but many people post information about themselves online. This means a journalist's professional reputation can be—and has been—ruined with the click of a "send" button.

In summer 2014, CNN correspondent Diana Magnay was removed from her reporting of Israeli–Palestinian conflict in Gaza after she fired off an angry

tweet after being threatened by Israelis. She tweeted: "Israelis on hill above Sderot cheer as bombs land on #gaza; threaten to 'destroy our car if I say a word wrong.' Scum." The tweet was quickly deleted, but the damage was done. It had been retweeted more than 200 times.[1]

The widespread use of digital—and particularly mobile—technology has rendered mistakes journalists have always made more clearly and widely apparent. Although this example shows poor professional judgment on social media, a far more common problem for journalists is showing poor personal judgment on social media by posting, for instance, bigoted comments or drunken selfies. Because our digital lives are so much more accessible than our analog lives were, journalists in particular have to work hard to personify integrity and credibility across all media.

While in years past objectivity was essential to a journalist's credibility, there is now more room for opinion even among hard news and investigative reporters. As the opinion-heavy Internet has influenced all aspects of life in the developed world, news journalism has become less rigid about its complete objectivity dictum.

Interactive, on-demand news has allowed consumers greater access to the thoughts and opinions of journalists than they had in the days of mass media dominance. For some prominent journalists, that has come to mean more scrutiny and accountability to their audiences. Regardless of what audiences value most in journalists, it is clear that they expect those who bring them news and information to be honest and open with them. Transparency is a must. That said, objectivity—or the appearance of objectivity—remains a key requirement of journalists at many of the largest mainstream news organizations, CNN among them.

Accuracy

Accuracy is a legacy skill for journalists who now have more fact-checking tools to draw upon than ever before but also more erroneous or deliberately misleading information to assess across various media. While in the past some news organizations had fact-checking staffs, interns or other resources to support their work, today's lean budgets often mean that reporters are left to check their own facts. As anyone who has checked facts in their own stories knows, it's difficult to find errors in a story you have read countless times. If reporters are left to check their own facts, there will likely be errors. Another threat to accuracy in the digital era comes from the 24/7 news cycle and the need to instantly report breaking news. Reports made from the field on mobile devices will inevitably contain errors. Even if errors are eventually corrected, sometimes, as was the case with CNN correspondent Diana Magnay, the correction comes too late.

How do journalists working in the field or without reliable access to editors to check their work ensure accuracy in their reporting? For starters, they have to balance the urgency to report the story quickly with the need to get the story right. Without the luxury of staff, they need to find new ways to check their own reporting. Documenting facts in multiple places, via various media, will help reduce the chance of error. For instance, when conducting recorded interviews it is good practice to have subjects say and spell their name into a digital voice recorder or on video. Ask them for a card if they have one. Get contact information to follow up if you can. This is much easier than it used to be. Instead of stopping to write down a subject's name, shoot a quick video on your smartphone in which they identify themselves and spell their name. A smartphone is also great for taking quick photos of signs and documents on the fly instead of copying their contents with pen and paper. Take as many reference photos and videos as you can when reporting a story. These will help improve your memory of the scene and report on what happened there with a level of accuracy and detail exclusively print reporters never enjoyed.

Analytical skills

While it is now more important than ever for journalists to have numerical skills, analysis has always been a key component of the journalist's job. Today, like before, journalists need to be able to analyze a situation quickly, understand its implications, and determine what their audiences need to know about it. While these basic analytical challenges remain largely unchanged today, journalists now face infinitely more choices when it comes to both analyzing and reporting facts. One technique that has always helped reporters understand the true facts of the situation (instead of being swayed by the compelling appeals of biased participants) is determining the interests and motivations of each player in a story. As a reporter, you want to not only analyze the motivations of the central players in a political drama, for example, but you also want to ask yourself what has motivated a particular source to speak out, paying close attention to what that source may have to lose or gain from speaking to a reporter.

Analysis may also be more challenging for some reporters these days because many work alone and fewer have newsroom peers to help vet their ideas. Reporters covering in-depth stories less often return to crowded newsrooms rich with thoughts and ideas for the best way to tell the story—the most compelling lead, the most relevant angle, the most illustrative facts and quotes. Lacking other journalists to talk with, reporters may want to discuss their stories with a trusted friend who can relate to the reporter's target audience.

Written and Oral Communication

Even though the demand for news as it breaks has reduced the average length of reported stories, and most who get their news from print want the most complete news in the smallest number of words, written and oral communication skills remain essential for every journalist. In fact, as Twitter has proved, writing a clear, concise, accurate story with a limited word count is much more challenging than covering all the relevant facts in a long feature. Because more people are now reading news on the small screens of mobile devices, writing concisely is an essential skill, especially as competition for readers' attention becomes more fierce, and news consumers demand the greatest value for their limited time.

Oral communication skills remain essential for any journalist, in all aspects of their career. Journalists need to know how to effectively communicate with sources and others with whom they work, especially in the field, where the demands of covering breaking news stories can lead to confusion or worse. The scene of a breaking news story can be dangerous. Clear, concise oral communication not only saves time; in a conflict situation, it could also save lives. With increasing numbers of independent journalists recording video reports from the field, an ability to quickly and clearly articulate the facts of a story will make the difference between an amateur video and a professional news report.

Sound judgment

Sound judgment has always been a requirement for journalists. This is one aspect of the reporter's job that has actually become easier in the digital age. Just as a reporter's reputation can be either damaged or bolstered by information published about her online, sources and other people relevant to a story can more easily be checked on the Web. But beyond just checking an individual's reputation, sound judgment means a reporter has the ability to assess the veracity of a story based on the logic of the facts and the behavior of those presenting information as facts.

There's an old expression in journalism: "If your mother says she loves you, check it out." It's a funny saying, but it's an important reminder for journalists, regardless of their experience. No one should assume a story is true just because of the circumstances.

One might be tempted not to check out a death announcement. After all, why would someone request an obituary for someone still alive? Reporter Greg Toppo learned exactly why when he almost published a hoax obituary that had been part of a revenge plot by a jilted girlfriend. In his introduction to the tale, Poynter.org's Chip Scanlan wrote, "Careful journalism

requires a healthy dose of skepticism."[2] That has always been true. Without a healthy dose of skepticism, journalists risk embarrassment or worse by publishing false information. Journalists should keep in mind that if a story is hard to believe, or if an inner voice suggests something just isn't quite right, they need to check their facts—especially unverified facts in quotations. Just because someone says something doesn't mean it's true.

Ability to Tell a Meaningful Story

Storytelling, or building a narrative arc, is covered in more detail in another chapter. Being able to tell a good story may sound obvious, but it's not a skill all journalists have. In fact, particularly as news consumers become more used to receiving updates in very short blocks of type, the need for a strong narrative arc to lead the reader through a story's main ideas can easily get lost. Even though readers these days are less accustomed to longer stories that are well developed, they still look for narratives in everything they do read, listen to or view. A story doesn't have to be long—or even written—to follow a complete arc. Slideshows and videos should have narrative arcs. Even a well-framed photo can tell a story.

What is a narrative arc or thread, and how does it apply to journalism? First of all it's important to keep in mind that storytelling doesn't refer only to stories in the fictional sense. Fictional or non-fictional, stories use narrative techniques to engage readers (or listeners or viewers) and allow them to become invested in them just as they might become invested in a fictional story. At its most basic level, a story shows the world from a human angle. We discuss storytelling in more detail in another chapter, but at its most basic, telling a story is simply about answering the elementary questions every journalist tries to answer: who, what, when, where, why, and sometimes how. In other words, a story has to mean something. It has to prompt a feeling or reaction in the reader. It has to move the reader (or viewer or listener) to some kind of action or thought. This may sound more complicated than it really is. Most simply, telling a story is about making people care, taking the audience on a journey, no matter how small. A story without a narrative is just a collection of facts.

Ability to Make Logical Connections

A skilled journalist can make connections between the subject matter of an interview or a story she's reporting and other people or significant events. People pursue careers in journalism for a reason. They tend to be inquisitive, curious, and observant. These are natural qualities that aid in making important connections. Being able to make connections is a critical skill for investigative journalism. Without a clear understanding

of cause and effect, and how things fit together, it is difficult to conceive potential story angles or appropriate avenues to pursue when investigating a story. The ability to make connections also helps a journalist understand sources' motivations, which can aid reporters in answering cause-and-effect questions.

For example, when a businessman suddenly starts making large donations to local political campaigns, a skilled reporter will start asking the kinds of questions that will lead to investigations, answers, and ultimately the compelling stories behind the controversy. Making connections begins with an inquiry. For instance: Why has a local luxury auto dealer suddenly become so politically active? An inquisitive reporter will start checking campaign records for details about his campaign donations, including how much he gave to whom. The reporter may first investigate whether any pending or proposed legislation could have an impact on the dealer or his business. Does a particular lawmaker's proposal threaten his livelihood, or does another lawmaker's proposal stand to benefit the dealer? If these simple inquiries don't yield answers, the reporter may then try to schedule interviews with the dealer, his friends, associates or employees to learn more about his political and financial interests, and specifically why he made the campaign contributions. It can be a slow (but in some cases quick) process of thoughtful, logical questioning that, when done well, can lead to major investigative revelations and groundbreaking stories. Although not all journalists are expected to be—or even want to be—investigative reporters, an ability to see the "big picture" and help readers understand why some things that seem to defy clear logic actually happen will help any journalist develop a reputation for insightful reporting.

ESSENTIAL DIGITAL SKILLS FOR JOURNALISTS

Research and investigation

The ability to research and investigate a story has always been essential for journalists. The availability of digital archives and databases has made the research process easier in many ways. Simple investigations are easier now thanks to the Internet, although the Internet also allows reporters to cut corners while opening the door to more potential inaccuracies or errors in judgment. With much more information of all kinds now available to everyone with a reliable Internet connection, and nearly the same democratic access to Web-based publishing tools, journalists, like their audiences, must work harder to determine the veracity of the information they find online, as well as the sources who provided the information. Because of the sheer volume of information now available to the general public online, reporters face a

higher bar for accuracy and for making meaning. To prove their own necessity, they must add value to the information they relay to their audiences by ensuring an accurate report that they have verified as well as the story around the information that makes it relevant to readers, listeners, and viewers. In other words it is not good enough for a reporter to simply distribute what has already been distributed. She must also vet it and contextualize it to maximize its meaning and relevance to her audiences.

Writing

Writing ability is such an obvious requirement for journalists it almost defies mentioning. Journalists have always been required to concisely convey facts in writing. Writing clearly and concisely has never been more important than it is today, with limited character counts across social media and the fact that people increasingly get their news on their phones and on other mobile devices with smaller screens. Being able to write simple declarative sentences in subject–verb–object order may sound simple, but it takes some practice. There is a tendency—especially in social media—for people to write conversationally. While the writing style across social media is decidedly casual, journalists must take care to ensure that their writing, while fitting the conventions of social media, is also clear and does not suggest bias. The latter standard can be particularly difficult to uphold considering the highly opinionated nature of social media in general.

Journalists should use social media for breaking news coverage and updates. Their writing should be short and to the point, reporting only facts, not opinions. Blog entries should also be short. Not even those reading on laptops or other larger screens want to scroll through large blocks of text. Feature stories and other long-form pieces also require compression. As any reader will tell you, regardless of the genre, the best stories are those that say the most with the smallest number of words. When it comes to storytelling, less is more. A story that is powerful at 500 words won't get any better at 1,000. Make every word count, and delete any unnecessary words. Your stories will be stronger for it.

Editing

It's only logical to discuss editing after writing. Journalists—especially in these days of small staffs—need to be good editors, particularly of themselves. Although writers should always ask another person (if an editor is not available) to read their writing before they publish it, they should also be prepared to edit their own writing if necessary. While it may not be possible to find an editor for breaking news, writers should try to take at least a short break after writing and before editing so they can return to the work with

"fresh eyes" that will allow them to see problems they might not be able to catch when immersed in a story.

A Few Very Quick Edits

Good editors see what casual readers can't. They read word by word, sentence by sentence. They may read by isolating each line with a ruler or they may read aloud. They will consider the necessity of each word, and delete anything that does not add to the meaning of the story. When looking for ways to cut, you should seek out common words and phrases that usually add no meaning to a sentence. If you're not sure whether a word is necessary, simply delete it from the sentence and see if the sentence still makes sense. Here are just a few sample sentences with extra words that can be deleted without any loss of meaning:

"that" and "being"

Wordy sentence: She didn't know that the call was being recorded.

Edited sentence: She didn't know the call was recorded.

"to be" and other unnecessary words:

Wordy sentence: He believed it to be the consensus of the group.

Edited sentence: He believed it was the consensus.

Or: It was the consensus.

"the fact that"

Wordy sentence: She didn't like the fact that she had to watch what she said around him.

Edited sentence: She didn't like having to watch what she said around him.

"started to" and other unnecessary words:

Wordy sentence: He started to run away when he heard the phone ring.

Edited sentence: He ran away when the phone rang.

For complete editing exercises, please see the companion website for this text.

Basic photo manipulation

Contemporary journalists don't need to be expert at Photoshop, but they do need basic photo editing skills. Basic photo editors are built into much of the software journalists use frequently, making it easier than ever to distribute and share high-quality images. When sending images through social

media, Instagram, as its name suggests, is a great tool for making quick edits that can dramatically improve or add interest to your images. Instagram is made for sharing photos via smartphones or mobile devices. Sharing photos taken by digital cameras (like DSLRs) or other devices that can't run the Instagram app is more complicated (and not very "insta"), but it is still possible. The process can involve downloading photos from a camera to a computer, then emailing the photos to yourself, and opening the photos on your phone where you can access your saved photos for sharing. Like a lot of basic photo editors these days, Instagram allows users to alter their images by applying filters, adjusting brightness and orientation, cropping, and adding other effects. Such basic tools are also available in photo storage archiving software such as iPhoto, which comes installed on new Macintosh computers. Given that most images that run online these days are small and need not be of particularly high quality, journalists don't have to do much to make an image look good online. Cropping tightly around the subject helps—especially if the image will run small. Keeping the images bright and simple with clean backgrounds also helps. On the Web, small images with busy backgrounds are difficult to decipher. Abstract, involved, or complex images that do not immediately convey the intended idea should not be used. Like with writing online, images online need to be simple, clear, and quickly understood. If viewers are confused by an image, they are likely to stop reading.

Basic Web skills

Journalists need fewer Web skills than they used to. Because the available free tools are so much more self-explanatory these days than in years past, journalists need less training and fewer specialized skills to create a basic website. While learning some HTML and basic coding is a fine idea, these days a journalist can create a professional-quality website on her own with little to no coding abilities at all. The visual (not HTML) editors that are built into software like WordPress, Tumblr or Blogger have made creating Web pages and posts almost as easy as creating a Word document. Most of the big blogging tools also have extensive support communities that can provide quick answers to those who get stuck anywhere along the way. Unlike the old days before ready-made themes and templates, creating a professional-looking website today is almost as easy as cutting and pasting.

Knowing a little HTML may be a good idea for troubleshooting. Sometimes, for instance, spacing, or type placement may resist editing on a Web page. When simple edits don't seem to do what they are supposed to do, it can be helpful to view the code to see if some command is dictating that all text is centered or bolded. With a basic knowledge of how HTML works, you may be able to quickly remove erroneous code.

Figure 4.2

A few lines of HTML source code. AzaToth / Wikimedia Commons.

```
 1  <!DOCTYPE html PUBLIC "-//W3C//DTD
    XHTML 1.0 Transitional//EN"
 2  "http://www.w3.org/TR/xhtml1/DTD/
    xhtml1-transitional.dtd">
 3
 4  <html xmlns="http://www.w3.org/1999/
    xhtml">
 5    <head>
 6      <meta http-equiv="Content-
    Type" content=
 7        "text/html; charset=us-
    ascii" />
 8      <script type="text/
    javascript">
 9          function reDo() {top.
    location.reload();}
10          if (navigator.appName ==
    'Netscape') {top.onresize = reDo;}
11          dom=document.
    getElementById;
12      </script>
13    </head>
14    <body>
15    </body>
16  </html>
```

Decoding HTML

HTML is the language that is the framework for the Web. You don't need formal training to figure out how HTML functions on a basic Web page. These days visual (or WYSIWYG, meaning "what you see is what you get") editors make it easy to switch between lines of code and live views of how the code will display. Alternatively, Adobe's Dreamweaver application provides another way to view code live. The following are a few tips to help you quickly read HTML.

- Each command is surrounded by tags, or brackets, which dictate what happens in the space between the open and close tags. Following are some of the common tags you'll find in a document.

Tag	Meaning
<p>	Start paragraph
 	Line break
	Embed image
<html>	Introduces an HTML document
<body>, </body>	Defines the area in which text will appear

- When commands refer only to words or letters between brackets, an end tag is inserted. An end tag repeats the opening tag but adds a backslash at the beginning. Here's an example: <p>This is a complete paragraph.</p>
- Many text tags determine the size, look, and font in which text should appear. Here are some examples:

 o <h1>This text appears in the main heading type.</h1>
 o <h2>This text appears in the second heading type.</h2>
 o The list goes down to heading 6 (h6).
 o This text appears in boldface.
 o This text appears in italics.
 o Starts a bulleted list. ends the list.
 o Defines a line in a list.
 o Add a link with an anchor tag <a>, followed by the visible text that readers click on using a line of code that looks like this: Focal Press.
 o Embed an image and determine the size it should run with code that points to the URL of the image, then defines width, height, and alternative text, which is essential for accessibility. Here's an example of the code:

 Accessibility text is required for those who have impaired eyesight and use a reader to determine the content of a Web page. (Title II of the Americans With Disabilities Act, or ADA, requires that government websites in the United States can be easily interpreted by assistive technology. Although you may not be required by law to ensure that any websites you oversee are ADA compliant, it is a good idea that you do so that your content can be "read" by everyone.)

This is just a quick overview of some basic HTML tags and commands. For more information on reading and writing code, there is a huge selection of training available online, at sites such as www.codeacademy.com or www.lynda.com. But if all you need is a simple HTML command, you can usually find the line of code you need through a simple Google search.

Basic audio recording and editing

Although these days journalists often record audio along with their video, audio clips, podcasts, and even Internet radio remain great options for broadcast journalists and those who favor long-form storytelling. Unlike video, which should be no longer than a few minutes (and ideally less than two), stand-alone audio can run longer since listeners can be mobile. Just like traditional broadcast radio, recorded podcasts and streaming audio content can be played while driving, running, exercising or working. Like with every other technology skill set discussed so far, there are countless tools now available

Figure 4.3

A Zoom recorder will make high-quality digital audio recordings. Some models can be mounted to booms or DSLR cameras for video production. Photo by Ludovic Péron / Wikimedia Commons.

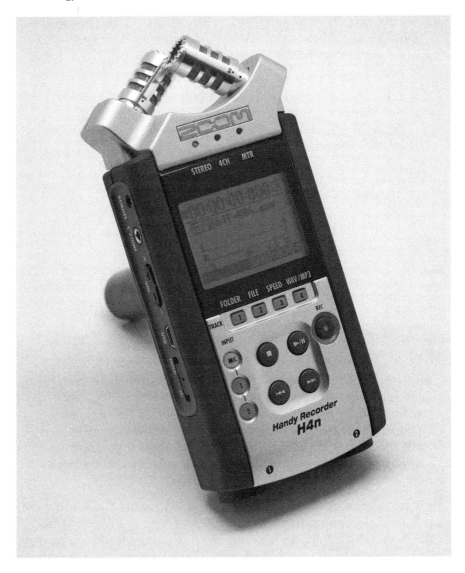

for recording high-quality audio. Even so, it is essential to keep in mind that audiences will tolerate low-quality video more easily than they will tolerate low-quality, scratchy or staticky audio.

In general, this means that you don't want to use video equipment to record audio. The built-in microphones on even pro-grade video cameras should not be used to record primary audio. If you are recording in the field, a cinema-quality portable digital audio recorder can be purchased for less than $100. (Search for "Zoom" digital recorders.) If you are recording at length—a podcast, for example—you may want to buy a professional recording studio setup with fixed microphones (for both the host and any guests) that you install in a small space lined with plenty of acoustic foam to absorb echo and improve the sound quality. However, podcasts are now often recorded from a Skype session and edited using a simple program such as Apple's Garage Band or the free, open-source Audacity. Even if you aren't able to invest in expensive microphones for your podcast, at the very least you want to record using USB headsets, which should produce decent sound. Always avoid using the built-in microphone and speakers on your computer because their quality is comparatively low, and recording without a headset can create echoes and feedback that may be impossible to fix in the edit. As with any time you record audio or video, make sure to find a quiet place without interruptions, including barking dogs, playing children or even the neighborhood ice cream truck. And don't forget to silence your cell phone.

Basic video recording and editing

For most journalists these days, video equipment is easier to access than audio equipment. This is partly because most of us now have a choice of personal mobile devices that record video. These can include our smartphones, tablets, computers, DSLR cameras, and video cameras. The average price points on this equipment have decreased dramatically in recent years, and it is now possible to get very high-quality equipment for a minimal investment.

If you will be using video in your reporting (and you should be), buy the best camera you can given your budget, although if you are new to video, you may want to start with a simpler, lower-end camera (or even an iPhone) before upgrading to a professional or "prosumer" camera. With proper lighting, the iPhone can produce surprisingly attractive video, and there are many attachments, including lenses and microphones, that can help improve the captured image. When you are ready to upgrade to a professional-quality video camera, keep in mind that you'll be able to afford a better model if you buy used. Of course there are risks involved in buying used equipment from unknown sellers. However, B&H Photo in New York has an extensive online catalog of both new and used equipment. They rank their equipment

according to condition, and allow for returns within a certain timeframe. B&H Photo has an excellent, well-deserved reputation. Every piece of used equipment the author has purchased through their website has arrived quickly and in better-than-advertised condition.

Shooting is only half the story. Everyone who shoots also needs to be able to do simple editing. There are several powerful tools now available for editing video, from higher-cost programs like Avid's Media Composer, Adobe's Premiere Pro to Apple's somewhat less expensive (but just as good) Final Cut Pro, to dozens of free or nearly free options such as Apple's iMovie or Windows' Movie Maker. Most video editing tools these days utilize the same basic functions, varying mostly in terms of how many additional features each offers. Not every journalist these days must be a highly skilled video editor; however, a reasonable expectation is that journalists now must know how to shoot stable, well-lit video (ideally with a tripod), cut that video into clips of a few seconds each, create effective transitions between clips that, together, create a logical narrative, and add music and voiceover. Of course there is much more to editing quality video, but consider these minimum expectations. When reporters have finished editing their short videos, they need to find the best way to share them with their audiences through a video streaming service such a YouTube or Vimeo. Since the interfaces of so many of these tools are so similar, and any number of them can be used with much success, there is no need to focus specifically on just one in this space. After all, tools are just tools. Like with all the skills today's journalists are expected to have, which tools they choose to do the work is much less important than getting the work done. There are industry standards, they change and evolve, but the bottom line is that the tools are getting better all the time. Whichever you choose to use, you will not go wrong.

SUMMARY

Despite the changes and advances in technology that have affected the way we do journalism over the last two decades, the fact remains that tools are just tools. Software and hardware come and go. We learn new applications, new platforms, and new ways of reaching and interacting with our audiences, but the journalist's job has not fundamentally changed. There are simply more ways to do that job today.

The essential skills for journalists remain essential, and should not be confused with the means of doing the job. Successful journalists still need—and may need more than ever—such foundational qualities as integrity, accuracy, analytical skills, written and oral communication skills, sound judgment, the ability to tell a meaningful story, and the ability to make logical connections. Journalists now also need a variety of new and multimedia skills, although they will most certainly not all use the tools at the same time to demonstrate those skills.

Arguably, journalists have always needed highly developed research and investigation skills. These are even more critical today. In fact, most traditional journalism skills remain essential as broad new skill sets have been added to the basic expectations of the position. The biggest difference between what a journalist once needed to know and what a journalist now needs to know is that, except in rare cases, those entering the field today cannot afford to restrict themselves to just one medium or type of journalism. They need to do at least a little bit of everything. This requires flexibility and a willingness to keep learning new technology and finding better and more efficient ways to do the job.

Research and investigation, writing, and editing are skills that should be familiar to journalists of all eras. Reporting has always required research and investigation, as well as writing, but the profession now requires all journalists to also learn how to edit their own work on the fly. Of course there are still dedicated editors, but with the growth of mobile reporting and journalists filing breaking news reports from the field using social and other instantaneous media, reporters may need to publish without an editor. It is essential that journalists know how to write clearly and concisely—or at least to edit their work for compression, information, and accuracy.

Social and mobile media are highly reliant on images—still photos and videos—to get their message out. The percentage of news consumers who get their information and updates on phones and other mobile devices has been steadily increasing for years. Because mobile devices have small screens, text must be short, and visuals must be quick and self-explanatory. Many apps are now available for on-the-fly photo and video editing, and for longer-form or Web-based stories there are countless software options for editing and distributing photos and videos. Again, hardware and software are just tools. Unless an organization or supervisor demands that a particular tool is used to create and distribute stories, most journalists can choose what works for them as long as the end result is high quality.

JOURNALIST'S TOOLKIT

It is assumed these days that journalists have the basic multimedia skills and access to the tools they need to competently report across platforms. Neither the ability nor an inability to use specific tools or to employ particular skill sets should determine what medium, platform or technique is employed in reporting. Rather, narrative needs should dictate the best way to tell the story.

Skills

Analysis

Written and oral communication

Sound judgment

Storytelling

Research and investigation

Writing

Editing

Basic photo manipulation

Basic Web skills

Basic audio recording and editing

Basic video recording and editing

Social media mastery.

Tools

Laptop or desktop computer, or Internet-connected mobile device

Digital audio recorder

Digital still camera or smartphone

Digital video camera or smartphone

Basic photo editor

Basic video editor

A content management system (CMS) for creating websites or blogs

Social media platforms.

Sites

Audacity.sourceforge.net/: Download page for Audacity's free open-source audio editing software.

Bhphotovideo.com: Main website for B&H Photo in New York, an excellent resource for new and used media and recording equipment.

Codeacademy.com: An interactive site for learning code.

Lynda.com: A paid subscription site with a vast selection of video tutorials on software, hardware, and various media skills and techniques.

W3schools.com: A site to guide readers in learning code. Includes resources for learning HTML, HTML5, CSS, JavaScript, PHP, and other languages.

Application

1. Thoroughly fact-check both a news story written by another journalism student and a story you wrote. Start by printing out the stories and underlining or highlighting every fact, spelling, and number in each. In the margin of each story, either correct any mistakes or make a check mark to show that the highlighted information is correct. Also note the reliable sources you used to check all highlighted information. When you are finished checking both stories, compare the number and variety of corrections made to each piece and consider whether any significant differences could be attributed to the fact that you were "closer" to the story you wrote than you were to the other story.

2. Interview a reporter about an investigative news story they wrote or produced. Ask the reporter to explain their work from the beginning of the investigation to the end, paying particular attention to how they analyzed the facts of the story and made connections among facts that helped advance their investigation. Create a story based on your interview using appropriate media, and pitch the story to a student publication or other relevant publication.

3. Swap story drafts with a classmate, and edit each other's work with compression and clarity in mind. Eliminate any unnecessary words or sentences, and share your edits with the writer.

4. Choose a breaking news story from Google or another news site. Create a plan for developing an online multimedia website that expands on the story using the appropriate mix of available media. (See the "Skills" list in the Journalist's Toolkit section.) Create a dummy layout for the home page and any additional pages, including summaries of each section. In no more than 500 words, explain why you chose to portray certain parts of the story using specific tools and media.

5. Produce a follow-up to your breaking news story that summarizes the news, then provides analysis of what happened as well as implications for your audience. Use an appropriate combination of media to present both highlights of the breaking news event you covered earlier as well as after-the-fact analysis. Pitch the story to a student publication or other relevant publication.

Review Questions

1. What are the minimum essential skills journalists need today?
2. How can journalists anticipate and acquire the skills they will need in the future?
3. What aspects of a journalist's writing, research, and investigation skills are specifically related to technology?
4. Why do the demands of new technology require journalists to be better editors— particularly of themselves?
5. List five entrepreneurial journalism skills you need now, and five skills you anticipate needing in the next five years. Explain why each skill is essential.
6. What does the phrase "tools are tools" in respect to journalism mean to you?

REFERENCES

1. Calderone, Michael. "CNN Removes Reporter Diana Magnay from Israel–Gaza after 'Scum' Tweet," *Huffingtonpost.com*, http://www.huffingtonpost.com/2014/07/18/cnn-diana-magnay-israel-gaza_n_5598866.html.

2. Scanlan, Chip. "If Your Mother Says She Loves You: A Reporter's Cautionary Tale," *Poynter.org*, April 17, 2003, http://www.poynter.org/how-tos/newsgathering-storytelling/chip-on-your-shoulder/10039/if-your-mother-says-she-loves-you-a-reporters-cautionary-tale/.

Find Your Own Way

Entrepreneurial journalists who have developed specialized skills and honed their brand identity so they can offer a unique product to a targeted audience are, in increasing numbers, choosing not to work for traditional employers. It's a smart move considering the decline of traditional media jobs in recent years. Instead, they, like Gayle Falkenthal, are opting to work independently for clients who hire them to perform specific jobs, or like *Times of San Diego* founder Chris Jennewein, they are forming their own online media enterprises.

A veteran journalist and public relations consultant, Falkenthal owns a consulting business and doesn't count any one client as her boss. Although she's been following an entrepreneurial job model for decades, there is now more interest than ever in doing the kind of work she does. Learning more about her job only makes it sound more appealing.

INTERVIEW: A Conversation with Gayle Falkenthal, Veteran Journalist and Public Relations Consultant

What do you call yourself and what do you do?
The job that really pays my mortgage is that I'm a public relations consultant, and I've got probably at any given time six to ten clients who for the most part provide some kind of professional service. They're an attorney. They are a professional association, of which I have two. An expert on green building. Green roofs and living walls are his expertise. A political pollster. That gives you a general idea. Those people pay me to position them in front of their potential clients so that when they're ready to do business or seek services in those areas, they're going to find my clients. Or in the case of the professional associations, it's building membership, and in one case there is a direct consumer. When I first started, 90 percent of my job was media relations. Placements. Very straight PR. Now that's maybe 10 percent of my job, tops. Now I'm the one producing the content.

Figure 5.1
Gayle Falkenthal.

What kind of content are you producing?

I'm producing content for their website. I'm managing blog pages. In some cases I'm ghost writing. For two of my ten clients I ghost write regular columns that are in traditional media, under their bylines. In one case I actually write the whole thing start to finish, under the byline of the client. I've internalized his voice so well that I just write it for him. He reads it, he approves it, and it's published under his name. On the websites, we're constantly looking for opportunities for more content. Several of my clients are fairly good, a little more self-sufficient about producing material.

What skill sets do journalists need today?

It really all comes down to being able to write and communicate well with your audience in mind. Here's a great example of a skill I learned literally thirty years ago that I'm putting to use now. I never in a million years thought it would have any use. I worked in radio news, at a station called KNX. It was a typical news station that was literally doing an hour of news every hour. All-news radio. You're churning out a lot of copy. And most of the people listening to you are in their cars. But you want to keep them listening as long as you can. Our goal was to keep them listening across two quarter-hours of the clock. That maximized your ratings, and maximized how much an advertiser would pay for commercials on the station. So you had to keep listeners there. How would you do that? By headlines that teased what was coming up. We ran headline sets eight times an hour, and I had to write those. So you're writing 240 or 300 headlines in an eight-hour shift. That's a lot of headlines, in addition to all the newswriting. I got to be wicked good at writing headlines. I'm now wicked good at writing headlines that turn into URLs that turn into search terms. I know how to draw somebody's attention. You learn what language keeps someone listening. Search terms, tricks. Now it's called "click bait."

How can those just entering the field get the work experience they need today?

You can intern in the PR department of a hospital and write articles for their website. If you really want to work for a magazine, unfortunately the magazines that used to churn copy like crazy are gone. But in their place are things like the *Red Bulletin*. It's the most beautiful, well-written, interesting, visually stunning glossy magazine you'll ever see in your life. I get it for free. I read it cover to cover. I have zero interest in action sports other than peripherally. But it's so well done, so well written. It is produced by a commercial corporation, but it's tying its product name—Red Bull, we all know it—to this whole lifestyle of living on the edge. They profile athletes I've never heard of who do extreme sports. They'll also do environmental articles because these people are going out to these remote areas. They cover travel. They do a lot of technology and gear reviews because their readers buy this stuff. You don't see an actual ad for a can of Red Bull in that whole magazine. You don't have to. It has the whole Red Bull lifestyle just oozing off the page.

What else do you do to pay the bills?

In addition to my so-called paying jobs, I am working as a copy editor and writing two regular columns for this online news organization started by someone who used to be a business editor at the *Washington Times*. I write on media. From that point of view, I'm writing about topics that demonstrate my subject area expertise. And because the site gets really good search pickup, I'm constantly feeding information about me and my byline into the "interwebs" so people can find me. I'm easy to find. If I write two or three columns a week, I've got all this material churning out there about myself.

What do you do that doesn't pay the bills?

I'm a boxing writer. I love boxing. It's my hobby. There is virtually no monetization for me in it. I get page views. In a good month I'll pay my utility bill. But it's an attention getter because being female and small, I'm not what they expect. Everyone says, "You do what?" And you only get good at writing by writing. It's so completely out of what I normally do. It's writing in a completely different voice and personality. It's not like anything I do for a client. But it's almost like cross-training. It is hard to figure out, "How do I make a decent living doing all of this?" It is super easy if you do it for free.

Why would a journalist write for free?

I'm thinking to myself, "Why am I doing this again?" Promotion for the site. Driving more page views. Eventually building the regular returning audience. It's convoluted, but I know for a fact that I have clients on the adult, paying side of my work life that found me because of this stuff. They see me out there and they assume, "If she's doing it for herself, she can do it for me." At the site [*Communities Digital News*, or commdiginews.com] writers with an

area of expertise monetize their interest and then make it into another job. On the other hand we also have people who have a subject matter expertise who are good writers and are talented. One of our most popular writers is a chef in Los Angeles. She writes about food and does recipes. People love her. This is absolutely free advertising for her restaurant.

How did you start your public relations career?
In the beginning, I took every client. That's how I ended up with clients I realized were a nightmare. I had to tell myself, even though they weren't the paying customer, my relationship with the media was just as important as—if not more important than—my relationship with the client. Clients come and go. My relationship with the media goes back way further than it does with any of the clients. That has to be maintained too.

Where are the jobs in the new media economy?
It used to be, at least at boxing events, the newspapers would have their own boxing columnists and send their own photographers. You would see a bank of photographers, and they'd all be from news organizations. Now probably 10 percent are from news organizations. AP will still send someone. Getty will still send someone. Our little news site doesn't have the budget to pay for AP or Getty, but it doesn't matter because the promoters who run these fights have hired professional news photographers who work for them full time. And faster than AP or Getty can turn me a photo, the promoters' photographers will post their photos for media use, and they are every bit the quality. All I have to do is credit them. Also, HBO and Showtime have their own photographers on staff, for sports or pay per view. So all I have to do is look on their Twitter account or Facebook for links, or HBO will send me a zip file in twenty minutes, and I open it, and all I have to do is provide credit. That's so incredible, and in a way so heartening about the profession. It isn't really collapsing. It's dispersing.

THE RED BULLETIN

Red Bull, the world's first and best selling energy drink,[1] isn't just a ubiquitous beverage with strong extreme sports associations. It's also a multiplatform media company called the Red Bull Media House. Through its magazines, Web, TV, and mobile media products, it promotes the Red Bull brand in a way simple advertising never could. Rather than merely promoting Red Bull, the Red Bull Media House is a concept that reinforces and extends the Red Bull brand, all without directly promoting the brand.

The Red Bull Media House, like the manufacturer of Red Bull, is headquartered in Salzburg, Austria, with a North American office in Santa Monica, CA. When *Red Bulletin* debuted in the United States, the media company was already publishing editions of the magazine in nine countries, Great Britain, Ireland, and Germany among them. At the time of its founding in 2011,

Figure 5.2a and 5.2b

The Red Bulletin.

Figure 5.3

Red Bull has long been a branding leader. Photo by Dan Smith / Wikimedia Commons.

Associate Publisher Raymond Roker told *USA Today* that the magazine was created "to have a rich conversation with our audience."[2] The magazine was initially available on newsstands, by subscription, and in the Sunday editions of five big city daily newspapers in the United States. Although the magazine features the familiar Red Bull logo, it does not overtly advertise the drink. Instead it accepts advertising from other companies just as any other lifestyle magazine would. It is image-focused and platform agnostic. With distribution in Europe, the Americas, the Persian Gulf region, and New Zealand, as well as plans for distribution in South Korea and China, *Red Bulletin* is an international brand that exemplifies a degree of convergence that few companies have ever attempted. Clearly, the message the Red Bull Media House wants to send is that they can reach audiences wherever they are with messages that appeal specifically to them, regardless of the tools, the platforms or even the content. Brand image trumps everything.

WORKING FOR YOURSELF

In these days when many of the traditional journalism jobs no longer exist, it is common to hear about both beginning and seasoned journalists going to work for themselves instead of waiting for someone else to give them a job. This can mean any number of things, from freelancing and doing consulting work, to forming a partnership or taking on a new project. For some particularly ambitious and hard-working journalists, it can mean building a new business from scratch. Although some journalists end up doing work that is outside the sphere of what we might ordinarily think of as journalism, many gravitate to projects that are a more natural extension of the work they did either in their journalism classes or in earlier, more traditional journalism careers. For this latter group, launching a new publication is an obvious choice. While in the past this was a particularly ambitious project given the high cost of print and distribution of a physical product, in the online world new publication launches are quite common since the costs are low, although news sites, blogs, and online magazines face more competition than ever. Creating them is relatively easy. Getting them to generate revenue is another matter entirely.

In 1995, as print journalism was enjoying its last days of prosperity, the late John F. Kennedy Jr. famously introduced the political glossy *George* into an already crowded magazine marketplace. Clearly, Kennedy's famous name was an advantage for the magazine, whose early issues attracted significant attention. Although the magazine's own lifespan was cut short by the death of its co-founder in a 1999 plane crash, it was unlikely

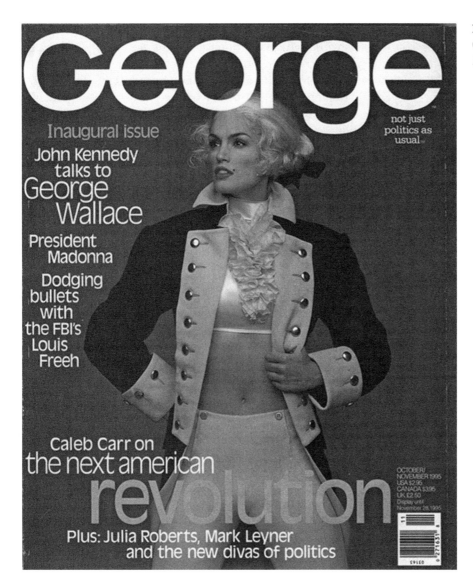

Figure 5.4
George *magazine's debut*
November 1995 issue.

that even it would survive for long in the face of rising paper and print-
ing costs. *George* ultimately folded in 2001, at a time when print journal-
ism's revenue model was beginning to falter as websites, blogs, and other
online publications started multiplying. The economic retrenchment that
occurred at the end of 2001, in the wake of the 9/11 terrorist attacks, has-
tened the decline of many print publications that were already struggling
or vulnerable.

As the Internet expanded, bandwidth increased, and more people gained access to computers with high-speed connections, the Web gradually became more influential. Audiences grew more fragmented as their viewing and listening choices expanded. Even though speed and access remained significant barriers to true entrepreneurial journalism in the 1990s, it was gradually becoming clear that the mass media model was in trouble—and that was not such a bad thing for readers, writers, and other content creators who had become less dependent on gatekeepers to deliver their messages to the world. The first journalism entrepreneurs created online newspapers and magazines that looked much like their print cousins. It is understandable that the mass media model, which provided a small, fixed selection of content to the largest possible audiences, would serve as a model for the first journalism entrepreneurs who had known little else. The vast majority of startup publications in the 1990s had circulations that were quite small compared to the reach of today's most successful blogs. A September 2014 report estimated the readership of the *Huffington Post*, one of the most prominent online news sites today, at more than 110 million unique visitors a month.[3] At the end of 2013 (the year for which the most recent media audit figures were available at publication), the print magazines with the highest circulation topped out at around 22 million, with yearly projected declines.

Given the world's changing demographics, it should come as no surprise that the most widely circulated consumer magazines are *AARP The Magazine* and the *AARP Bulletin*, which had circulation rates at the end of 2013 of 22,274,096 and 22,244,820, respectively.[4] The AARP, formerly the American Association of Retired Persons, represents Americans aged 50 and older, not coincidentally a group more likely to read print publications. At the end of 2013, once major American magazines reported much lower circulations. *Good Housekeeping* was just above four million, while *Woman's Day, Ladies Home Journal, Sports Illustrated*, and *Cosmopolitan* were just above three million. All were down in circulation from the year before.[5] It is clear to see why those who want to reach new and grow existing readerships are not looking to print. They are looking online.

Chris Jennewein is an entrepreneurial journalist with long careers in both print and online journalism. He is a rare example of someone who has successfully transitioned from the traditional to the new journalism world. As early as 1993, Jennewein ushered the Knight–Ridder newspaper chain into the digital age with the United States' first entirely online newspaper at the *San Jose Mercury News*. At the *San Diego Union-Tribune*, he led that paper's early popular website, SignOnSanDiego.com. He then led digital-only initiatives at the former San Diego News Network and Patch.com, where he was

Figure 5.5
AARP The Magazine,
*which serves an age
50-plus readership, has
enjoyed among the highest
circulation of any print
publication in recent years.*

editorial director for Southern California until early 2014, when he founded the online news site *Times of San Diego*. He is a graduate of the University of Pennsylvania (where he studied urban planning) and the London School of Economics.

Figure 5.6

Chris Jennewein.

INTERVIEW: A Conversation with Chris Jennewein, Veteran Journalist and Founder of *Times of San Diego*

Is the kind of change we've seen in media in recent years unprecedented?

If you entered the business in the late '70s or early '80s, you could sort of plot your career and say, "I want to be A, B, C, and D," and it was a pretty straight course. But since then, and largely because of technology, it hasn't been, and I think that requires people in media to be entrepreneurial. If you went back fifty or a hundred years, this is exactly the way it was. People who got into media in those days had to completely reinvent themselves as things changed. New York once had twenty-five daily newspapers, and they kept changing, going out of business, restarting . . . it's really a wonderful, exciting business that you have to be continually adapting yourself for.

Where do the biggest opportunities in journalism now lie?

In addition to this tremendous growth in online is the growth of non-media newsrooms. One of them, for example, is the county news center here. It's really a news website for San Diego. Another good example is San Diego State University. Their home page is really a news site. Another example is Martin Guitar. Some of the stories on their home page are about particular models, but a lot of what you see is something an editor would put together.

Does it matter that the boundaries that once separated journalism from public relations are falling away?

Almost any PR person will tell you placement doesn't matter anymore, that it's nice to get into the *Union-Tribune*, yeah, it's nice to get on TV, but increasingly you go directly to your audience. Public relations companies get hired to create news sections for sites. They get hired to create a Facebook page. They get hired to create the online profile of a company. And if they get a placement along the way, that's fine. That's wonderful. It's opened up many more opportunities. Now increasingly you see people moving back and forth a lot between journalism and PR. In the old days of PR there really was a separation of skills; the PR world was very different.

What should beginning journalists do to prepare for a job in the field?

I think technical virtuosity is an important thing. That almost goes without saying, When you're 18, 19, 20, you've got a laptop, you've got a smartphone, you're on Twitter, you're on Facebook, on Instagram, you know these things.

What is the best way to prepare for a career in journalism?

You have to have a lot of internships where you do a lot of work. I learned how to write news style, which still has a lot of value, in internships. When I first joined the college newspaper, my writing was atrocious because I hadn't taken any courses and I had no examples. So I learned by doing it.

What kinds of unexpected skills do journalists need to prepare for new and future careers?

A year or even a semester of statistics could be extremely helpful. I'm amazed at the people who still can't do a percentage or who look at numbers and don't know what they mean.

Where is online journalism going?

Across the Internet, communities of interest are extremely powerful. A community of interest might be West Coast surfing or it might be home vineyard growing, or it might be taxpayer advocacy. There are hundreds of thousands of websites out there that do very well focused on things like that. Something like Lifehacker. That's a community of interest, and it works because it draws from the entire world. What I'm trying to do with *Times of San Diego* is, I'm trying to provide essential news for San Diego for a largely younger audience, but by making it all of the metropolitan area, I've got a bigger audience to draw on for advertising and just for pure audience size.

How did you immediately differentiate Times of San Diego *from the many other local online news sources out there?*

What I'm doing is not that dramatically different from what anyone else could do. I think that's the nature of a lot of innovation. I'm trying to provide twenty-five essential stories a day on a typical day. I'm aiming at a younger audience that wants to know what's happening in San Diego but doesn't read a

newspaper, doesn't watch TV. We keep our stories short. We often use bullet point style to say what we want to say. We post very rapidly. I've focused a lot on search engine optimization. That's one reason for our growth, because we very early on got into Google News. I personally cover one thing a day in person. I approach it not like a traditional reporter, where you hang in the back and take notes. I walk in with a pocket full of cards, and I hand out cards, and I send everybody who I get a card from a link, and that's one technique anyone can copy.

Describe the mission of Times of San Diego.
To a certain extent it's a labor of love. I wanted to start something new. My mission is to provide essential local news for a primarily younger audience that is not now getting its news in any other way. That's one thing. In terms of a business, I want to make it self-sustaining, and to do that I need to reach about 300,000 unique readers a month, which I think can be done by the end of the first year.

How long did it take you to launch?
The short answer is: not long. I sat down and did a business plan, filed for an LLC registration, and I think eight weeks later launched the site.

How did you get Times of San Diego off the ground so quickly?
I think my connections locally have helped build traffic. I sent an email when I launched to probably 500 people. But a lot of it was pretty basic. It was setting the site up properly for Google News indexing. It's not rocket science. I used WordPress. That's the best CMS out there. It's really the world's standard. I spent three or four days looking at different WordPress themes until I found one I really liked. Then I set it up and started experimenting with it for a couple weeks, trying different combinations of things. And once I got it the way I liked it, I hired some contractors, some people I'd worked with, and that was it.

How do you monitor the success of Times of San Diego?
One of the things I spend a lot of time monitoring is which stories are getting traffic at any given time. There are a wealth of tools out there, like Google Webmaster Tools for example, that can give you very detailed information on how the site is doing.

Would you call yourself a journalism entrepreneur?
Sure I would.

What's next for Times of San Diego and the news business in general?
I think you'll see a lot of entrepreneurs and sites vying for attention. The entry costs are low, people are getting more and more sophisticated about how to do this. The tools are out there, things like Google Ad Sense and AOL networks. You can monetize the site. I've had ads on the site since it went public. So we have an environment now that's very encouraging for entrepreneurs and media. The bar is higher in the sense that there's more competition, but

the costs of entry are lower. Twenty years ago if you wanted to start something you couldn't really start anything in the video world. It was far too expensive. You could start maybe a suburban newspaper, but even that was expensive. Now it's much easier to do this across the board.

Did you get any investors?
I haven't yet. I wanted to move very fast, and I could do this very fast. Bootstrapping is an old concept. You start out with some money you have. I'm not endangering my financial future, but I want to show several months of success, then I will be looking for additional investment.

Is there any new proven model of journalism on the horizon?
I think there'll be many models competing. I think nonprofit works to a certain extent, but if you're not buying advertising, what are you buying? I worry about nonprofit because the people giving the money at some point will want something, especially the really big givers.

What is the future of journalism?
I think it's completely positive. I think there is a wide variety of new opportunities out there for graduates, primarily in the online world. And for those who don't want a media role, there are these non-media newsrooms that are springing up everywhere. The challenge there is finding out what the job is called. You're not going to be hired as a reporter or an editor. You're going to be a manager or a director or a coordinator, and it might be marketing and it might be content and it might be something different.

ANALYTICS ARE EVERYTHING

Analytics is the in-depth analysis of data patterns to determine trends or predictions in consumer behavior. Although analytics doesn't just apply to online readership, most people these days are familiar with the term as it relates to measuring the performance of websites in terms of hits, clicks, and visitors. Analytics are critical to journalists launching ventures online because they are the only means by which they can measure how well (or whether) they achieve their goals. Much like how traditional media audits provide information on newspaper readership, radio station listenership or television station viewership, analytics show how many people visit a site, how often they visit, what pages they click on within the site as well as the pages from which they landed on the site and the clicks on links that took them off the site.

If bloggers or website administrators want to show potential advertisers or investors how successful they've been at reaching their goals and attracting online audiences, analytics are the only solid and reliable data they can produce. Analytics data are also much more detailed than most of the old media measurement tools that could only speculate on such things as pass-along

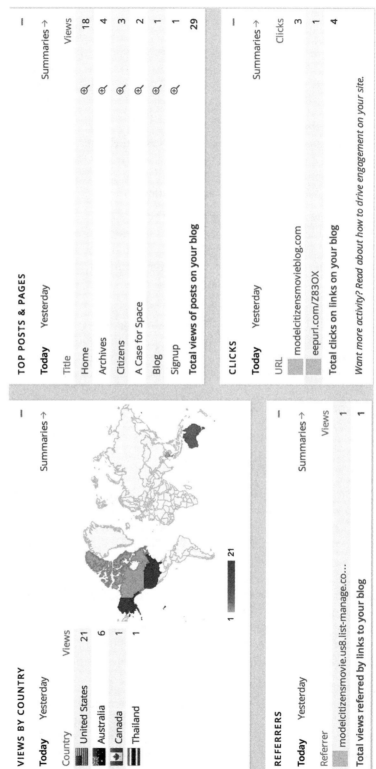

VIEWS BY COUNTRY

Today Yesterday Summaries →

Country	Views
United States	21
Australia	6
Canada	1
Thailand	1

21

REFERRERS

Today Yesterday Summaries →

Referrer	Views
modelcitizensmovie.us8.list-manage.co...	1

Total views referred by links to your blog 1

TOP POSTS & PAGES

Today Yesterday Summaries →

Title	Views
Home	18
Archives	4
Citizens	3
A Case for Space	2
Blog	1
Signup	1

Total views of posts on your blog 29

CLICKS

Today Yesterday Summaries →

URL	Clicks
modelcitizensmovieblog.com	3
eepurl.com/Z83OX	1

Total clicks on links on your blog 4

Want more activity? Read about how to drive engagement on your site.

Figure 5.7
A snapshot from wordpress.com blog stats.

readership and consumer attitudes toward various media based on self-reported information that was often misleading or wrong.

One story from an actual media audit of weekly newspapers in Philadelphia in the early years of the new millennium illustrates a common problem with the traditional process of surveying local media consumers. In Philadelphia at the time there were several local newspapers—two major city dailies, two weekly tabloids, and a few specialty papers with small distribution or specific readerships (such as student newspapers or shoppers). At the time, readership surveys were conducted via landline phone, and the mostly older people who would take the time to answer the surveyor's questions were casual media consumers. They lived in homes that for decades had received their news from the city's big daily broadsheet the *Inquirer* or its big daily tabloid the *Daily News*, and from the six o'clock news on one of the local network affiliates. In these demographically older households, the younger-skewing alternative weekly newspapers the *Philadelphia Weekly* and the *City Paper* were not as well read. It is likely that few of those who picked up their landlines in the middle of the day to answer a fifteen-minute media survey were even aware of their city's alternative weekly newspapers, which contained extensive entertainment calendars, movie listings, news analysis with a liberal bent, and pages of personal and pornography ads in the back pages. However, when asked if they read the *City Paper*, respondents said yes in greater numbers than when they were read the names of the city's other papers. One of the auditors at the time speculated that the respondents had considered "city paper" a generic term for Philadelphia's big daily, the *Inquirer*. This kind of polling mistake would be much less likely in online analytics.

WHY ANALYTICS?

Google Analytics is the most established and best-known tool for measuring visitor behavior on your site. Businesses use it to better understand the needs and interests of their customers and the performance of various pages on their site. Like businesses that measure and analyze customer behavior so they can make their products and messages more appealing to current and potential customers, those who manage blogs or news or media sites use the same tools to determine the kind of content that most interests their readers. Using the information they collect about their visitors, they can learn more about who they are and what their habits and interests are. This can help content managers and producers determine the most (and least) appropriate content for their site. If a lead story on local politics coincides with a measurable drop in visitors to the site, the content manager may consider replacing the lead story with another story that more closely aligns with the interests of site visitors, who, for example, through their clicking behavior, show a distinct preference for arts and entertainment stories.

Common Analytics Terms

Bounce rate: The percentage of users who view only one page of a site; an indication of how relevant the site is to those who arrive on it.

Click: The action a user takes to reach a page on a site.

Conversion: The rate at which visitors to a site execute a prescribed action, such as subscribing to or following a blog.

Direct traffic: Traffic to a website that does not arrive through a link to the site.

Impression: Each display of an online ad.

Keyword: Term users enter in a search engine to find relevant content.

Landing page: The page on which a visitor to a site first arrives.

New visitors: Visitors to a site who do not have stored information, or cookies, on their computer that indicate a previous visit.

Paid traffic: Visitors who arrive on a site after clicking on an ad.

Page view: A visit to an individual page on your site.

Referring site: A site from which visitors to your site arrive.

Returning visitor: Someone who has visited your site more than once; this indicates the content is relevant or meaningful to them.

Traffic: Total visits to the site.

Unique visitor: Each non-repeat visitor to a site.

Visit: Each time a site is accessed.

Quantcast.com is a tool that allows users to compare traffic on various websites to determine their relative performance over time. This helps bloggers and website managers better understand how well they are doing in comparison to their competitors. Quantcast is similar to Google Analytics in that it provides information about the number and frequency of hits, demographic information about those who visit a site, how and from where they access the site as well as their interests as reported in an "Affinity Index." This helps those who run websites better understand the habits, needs, and interests of website visitors.

Jennewein also makes use of Google Webmaster Tools, which help him maximize his site's reach and performance proactively. While Google Analytics shows him where his readers come from and where they go when they're on his site, Webmaster Tools can proactively troubleshoot the site, helping him

avoid malware and bad links. Webmaster Tools also helps him improve the way his site and its pages appear in Google searches. While Google Analytics measures the behavior of visitors to a site, Google Webmaster Tools focuses more on how search engines find a particular site. This is the kind of detailed data that may have made a difference to the fate of print and broadcast outlets had it been available to measure their audiences years ago.

SUMMARY

While many beginning journalists still pursue work through traditional mass media channels, a growing number of them now entertain entrepreneurial opportunities. For some, like veteran journalist and public relations professional Gayle Falkenthal, the transition from mass media to media on demand was seamless, as she has spent her entire career learning new tools and techniques in anticipation of potential clients' future needs. Although Falkenthal now runs her own public relations consulting company, her clients are also her employers. But unlike most of her predecessors who worked for one boss in an office for forty hours a week, she serves them on her own schedule, which she flexibly adapts to meet both their needs and hers.

With years of experience across most media, Falkenthal has first-hand knowledge of the benefits and challenges of doing journalism today. Unlike many of her peers, she was not caught off-guard by the changes the Internet brought to journalism. Even though the nature of her job has changed in some dramatic ways in recent years, she is always happy to retrain and learn. It may be easier for her than it is for most, given the degree of change she has already faced during her career.

Falkenthal is excited and energized by the transformation of media business models in the Internet era. That she is more focused on producing content for her public relations clients than pitching traditional media outlets on her clients' stories means she is able to shift her emphasis to a different set of related skills. Navigating such a dramatic shift is no problem for those who have a wide and varied skill set.

Chris Jennewein is another veteran San Diego journalist with strong technical skills as well as an extensive journalism background. Like *George* magazine founder the late John F. Kennedy Jr. and *Huffington Post* founder Arianna Huffington, Jennewein decided not to wait for others to give him opportunities to work for them, and decided to make his own. Although he spent most of his career in print, Jennewein has seen print newspaper circulation decline year after year. It wasn't difficult for him to determine his future would be online.

These days the largest circulation print magazines, *AARP The Magazine* and the *AARP Bulletin*, reach a fraction of the readers the most successful

websites do. Clearly, traditional print journalism shows no signs of a rebound, and Jennewein doesn't think that's a problem. That's because he understands the media are in constant flux and that the changes the Internet has brought to print only add to the century of changes that have transformed journalism. Indeed, journalism is not dying. It is simply done differently these days.

Central to determining the success of a website, blog or online publication are analytics. Data assembled through analytics include the number and frequency of visits to a website or page, demographic information about those who visit websites, and the way visitors to a site interact with its pages and content. Much more detailed and accurate than traditional media audits that relied largely on self-reported information gathered in telephone interviews, Web analytics provide essential feedback to those who determine and direct online content. Analytics data can aid in deciding which content is appealing to visitors and should be promoted, and which content is not appealing and should be eliminated. These decisions allow a site to better serve the interests of its key audiences while helping to meet the needs and serve the interests of more readers and viewers. Effective analytics tools now available to bloggers and journalists working online include Google Analytics, Quantcast, and Google Webmaster Tools.

JOURNALIST'S TOOLKIT

An entrepreneurial journalist, like any other kind of journalist, must always keep in mind her audience. Increasingly these days, journalists serve various employers, clients or simply themselves. Fewer journalists now want to work for others in dusty traditional newsrooms forty—or sixty, or eighty—hours a week. Many now work for clients or for themselves out of home offices or even libraries or coffee shops. Thanks to new tools and technology, entrepreneurial journalists can work anywhere—and they *are* everywhere, just like their clients and audiences.

Skills

Writing

Producing multimedia content

Basic Web development

Making presentations

Search engine optimization

Social media optimization

Basic analytics.

Tools

Laptop or desktop computer

Digital voice recorder

Internet-connected tablet or smartphone.

Sites

Commdiginews.com: The website for Communities Digital News, for which Gayle Falkenthal writes.

Google.com/analytics: Home page of Google Analytics, a popular tool for analyzing website traffic and visitor behavior.

Lifehacker.com: An online resource offering tips for simplifying life and getting things done.

Quantcast.com: Browser-based tool that allows visitors to compare traffic patterns across websites.

Application

1. Interview an entrepreneurial journalist in your community who used to work for one or more traditional media outlets. Ask them to explain the challenges and other considerations they weighed as they decided whether to go into business for themselves. Also ask them how their current work differs from the traditional work they used to do, as well as what lessons they learned in the career transition. *Optional*: Assemble your interview into a feature story with additional background reporting. Pitch the resulting story to a student publication or other publication in your community.
2. Find a "lifestyle publication" that is published by a non-media company. Analyze its content for image, quality, and integrity. Then describe the publication's impact (if any) on the company's brand.
3. Use Quantcast or a similar site to compare visitors to two or more websites. List at least three conclusions you can draw from the comparison.

Review Questions

1. Why does the company that manufactures Red Bull also create and distribute content?
2. What kinds of information can you find in analytics reports, and what kinds of adjustments can you make in response to them?
3. What is the difference between Google Analytics, Quantcast, and Google Webmaster Tools? What kind of information does each tool yield, and how can that information be applied?
4. What is the difference between WordPress.com and WordPress.org? How do analytics options differ between them?

REFERENCES

1. "Who Makes Red Bull?" *Red Bull U.S.A.*, http://energydrink-us.redbull.com/company.

2. Horovitz, Bruce. "Red Bull Plans Glossy Mag in U.S.: '*Red Bulletin*' Targets Lovers of Energy Drink," *USA Today*, May 9, 2011, http://search.proquest.com.ezproxy.nu.edu/docview/865306540.

3. "Top 15 Most Popular News Websites September 2014," *eBizMBA.com*, http://www.ebizmba.com/articles/news-websites.

4. "Top 25 U.S. Consumer Magazines for December 2013," *Alliance for Audited Media*, http://www.auditedmedia.com/news/blog/2014/february/us-snapshot.aspx.

5. Ibid.

Entrepreneurial Fundamentals

In short, entrepreneurship means going it alone. Instead of asking for someone else to give you a job, you find a way to employ yourself and possibly others. Although it has traditionally meant building your own business—anything from opening your own restaurant to buying your own franchise—the meaning of the word has liberalized somewhat in recent years as more people have found different ways to innovate that don't always look like old entrepreneurship models. Part of this was born out of necessity, as an unstable world economy and changing labor markets forced people to consider different ways of making a living than they had prepared for or than their parents had known.

Journalism in particular has been subject to entrepreneurial shifts in Western economies, as changes in the labor market coincided with declines in traditional business models. While less than a generation ago most journalism students prepared for coveted, stable, often union jobs that guaranteed a solid middle-class wage, health benefits, and a pension, now those kinds of jobs are few, and their numbers are shrinking. Initially, as these traditional career paths disappeared, students worried about the wisdom of their major as working journalists worried about their future. In the first years of the new millennium, as print journalism began declining and the Internet became ubiquitous, senior reporters and editors at large urban dailies began to take contract buyouts as the union realized slipping revenues would not be sufficient to fund generous pensions. Then, a few years later, as the American economy declined dramatically toward the end of the decade, the buyouts started drying up. Layoffs followed, and soon the entire industry appeared to be in free fall. Journalism instructors and students could no longer afford to look the other way and pretend that it was business as usual for their field. Although this was an undeniably scary time for journalism, many positives have emerged from it. Among the key positives is the rise of entrepreneurial journalism and the idea that a journalism career could still be highly promising as long as one didn't expect to work a traditional job for a traditional mass media company.

WHAT DOES ENTREPRENEURIAL JOURNALISM MEAN?

Entrepreneurial journalism can mean a number of things, and for many journalism students the meaning can change by the day. One of the nice things about entrepreneurial journalism is that you don't have to wait to graduate before you get to work. You can start work as an entrepreneurial journalist at any time. All you need is an idea, the time (and it doesn't have to be full-time) and no more equipment than the typical journalism student keeps in her dorm room.

Because freelance work has always been a popular model in journalism, entrepreneurship has come naturally to most journalists. For some people it has felt like more of an extension of what they have traditionally done. The adjustment has been difficult only for those who have relied on the old union model for much of their careers. Entrepreneurial journalism has been a motivator for some. Instead of working for someone else and waiting to take assignments, entrepreneurial journalists make their own assignments. Of course there is somewhat more pressure to get the job done, as unlike their peers working staff jobs, entrepreneurial journalists don't get paid if they don't work.

THE DEMOCRATIZING NEWS BUSINESS

In more ways than one, journalism has been swiftly moving toward individualism in recent decades. Just as journalists are no longer reliant on large organizations with access to printing presses to publish their work, news consumers are no longer reliant on big daily or small community newspapers to find out what's going on in the world. With the advent of new online media and the fragmenting of audiences, power in journalism has been consistently shifting from the company to the individual, from the one to the many. This has created a natural climate for entrepreneurship.

WHY DOES IT MATTER?

The rise of entrepreneurial journalism is important for several reasons. Most regular people—whether they live in democratic or oppressive societies—agree that people need to know what's going on around them. They need access to news. Open access to news and information makes a society stronger. The free flow of information is in (almost) everyone's interest. Only dictators and hostage-takers may disagree. As the print news business was beginning to decline after decades of prosperity, some worried about a future

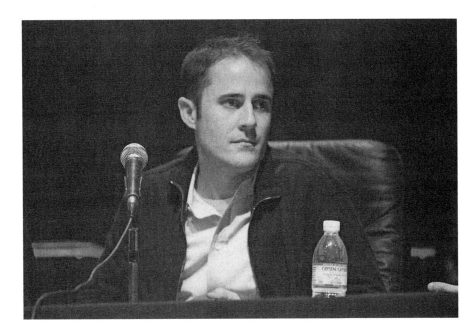

Figure 6.1
Twitter co-founder Evan Williams left the University of Nebraska Lincoln after a year and a half to be a full-time tech entrepreneur. Photo by Brian Solis / briansolis.com.

without news. Thanks to entrepreneurial journalism and the work of the committed individuals leading its charge, the world runs little risk of a future without information. While there are most certainly other challenges, a lack of news and information is not among them.

ENTREPRENEURIAL OPTIONS FOR JOURNALISTS

Journalists who want to work for themselves face multiple options these days. While some may want to build their own companies or publications, many will want to work for themselves, as consultants, writers, editors or communications professionals with a roster of clients they manage with or without the help of others. Other chapters describe options for journalists who want to work for themselves or work for others. This chapter discusses business basics that apply to any kind of entrepreneurship.

ANALYZE THE ENVIRONMENT

Before you set out to plan a journalism or media business, you need to understand the environment into which you plan to launch. At this stage in the planning process, being realistic and honest with yourself is essential to avoid investing time and money in an enterprise that is not likely to succeed.

This doesn't have to be a complicated long-range study. At the very least, do a quick SWOT analysis. You've probably heard of SWOT before. It stands for "strengths," "weaknesses," "opportunities," and "threats." It is a simple way to look at the environment into which you plan to launch the business. By looking at the negatives and risks involved in launching a new initiative, as well as the opportunities and strengths of your position or proposal, you can avoid a myopic vision and prevent miscalculations that could jeopardize the future of the enterprise. You can easily draw your own SWOT template or find one online. It will look similar to this:

Figure 6.2

A template for SWOT analysis. Image by Xhienne / Wikimedia Commons.

BUSINESS STRUCTURE

What kind of business do you want to create? Your answer to that question depends on how large you expect your company to grow; how involved you plan to be in the company's operations; and how exposed you feel to the company's potential risks as well as its gains. In other words, how close do you want to be to the company? When it is doing well and the job is easy, you may feel you want to be very closely involved in the company. But remember, close involvement with the company goes both ways. With the upsides come the downsides.

A *sole proprietorship* is the simplest business structure. In this model you, as the owner, take on all the company's risks and responsibilities. You alone collect all profits and you alone are responsible for all debts and liabilities. In most locations, you don't need to do anything special to qualify as a sole proprietor. If you are already working yourself, you are most likely already a sole proprietor. In most areas, the way you file and pay taxes is the only way a sole proprietorship is different from working for an employer who deducts taxes directly from your paycheck. As a sole proprietor, you have no employer to deduct taxes from your income, so you have to do it yourself. You need to pay self-employment tax (for social security and Medicare) and estimated taxes quarterly. But as a sole proprietor, you essentially *are* the business. If the business gets sued, you are liable for any judgments or losses. If the owner of a sole proprietorship wants to be able to operate under a business name (that does not include their own name), they have to register their "doing business as" (or DBA) name. Filing a DBA allows a business owner to cash checks and file other paperwork under a business name (instead of their own).

A *limited liability company* (or LLC, also a "limited company" in England and other countries) offers somewhat more protection to business owners, who are defined as "members" of the company. In an LLC, members are like partners. They report profits and losses on their personal tax returns. The benefits of an LLC include less liability than a sole proprietorship and fewer taxes than a corporation. Taxation differs from state to state and location to location, but in general, an LLC's profits and losses are realized by members alone. The exact tax form that is used differs depending on how the LLC's members want to identify the company on their tax forms.

The steps involved in creating an LLC differ from state to state and from nation to nation. In the United States, the process is often simple and requires little time to process. In general, you need to select and register your business name with your state. You then file the "articles of organization" for your business. This includes basic information such as the business name and address, as well as the principals' names. You need to file for any required

licenses or permits, then advertise the formation of the LLC. Unless your business plans to broadcast radio or television programming, you should not need any special operating licenses from the federal government. Other licenses may be needed on the state or municipal level. Make sure to check your local jurisdiction.

Journalists may also want to form partnerships or cooperatives for journalism ventures. A cooperative would be a tricky business structure for a media endeavor. Cooperatives have members who apply for membership and then contribute to the organization. Bylaws are created and a board is elected. This business form is far more common for organizations that trade in physical goods such as health food markets or farmers' cooperatives. Partnerships can be like sole proprietorships except two people instead of one share all profits and losses. And limited partnerships are much like LLCs that involve more than one person.

Although you probably won't be forming one for your media venture, a corporation is its own entity, legally separate from its principals. The big advantage to a corporation is protection from liability. But the big downsides include higher expenses and double taxation, meaning both the company and its shareholders pay taxes on profits. Corporations exist to maximize profits for shareholders—which is why it may be an uncomfortable structure for a journalism or media business. With high overhead costs and many layers of bureaucracy, forming a corporation doesn't make much sense for a startup journalism enterprise. Maybe once you have a few hundred employees and eager investors clamoring for an IPO, or initial public offering of shares, you will want to reconsider.

THE BUSINESS PLAN

There are countless business models and plans readily available to entrepreneurs in various industries. There is no one right model for journalism entrepreneurs, but there are many that can be eliminated immediately. Although they are now rare, journalism startups that involve distribution of a physical product (a newspaper or magazine, for instance) are understandably more complicated than exclusively online startups, and their business plans are usually more complex. For the sake of simplicity, let's assume the journalism entrepreneur will be working exclusively online and providing a service (news and information or marketing or public relations content) instead of a product (a physical newspaper or magazine).

The Small Business Administration (SBA) is an excellent resource for planning your business, whether you're planning for an ambitious startup or small consultancy. Although its tools are not specifically tailored to digital

media companies, the SBA provides basic information that applies to all small businesses. It also provides an online tool for creating a business plan (at http://www.sba.gov/tools/business-plan/1). Not everyone creates a business plan for a new enterprise, and not having one does not necessarily mean the business will struggle. Particularly if you're starting small, you might not believe that you even need a plan. Maybe you don't, but it's helpful to create a business plan for two basic reasons: (1) It helps you understand the scope, risks, and degree of commitment required to launch and grow a successful business, and (2) most investors or organizations you hope to support your business will want to see that you have planned for at least the next few years.

Although business plans differ, the basic sections the SBA recommend are: executive summary, company description, market analysis, organization and management, service or product line, marketing and sales, funding, and financial projections. One small note to hopeful entrepreneurial journalists: If you don't like numbers, hire or partner with someone who does. Even the best entrepreneurial idea will likely fail without solid financial projections and a real understanding of the costs of running the business.

You may want to write the **executive summary** last (although it should appear first), as it is a quick synopsis of the plan that you can show busy professionals who can't afford the time required to read a long document about which they know nothing. The summary should make it easy for them to decide whether it is worth their time to read the whole document. Ideally, the executive summary should be no longer than a page, and it should avoid dense blocks of type to keep it readable. Bullet points will help save time.

The **company description** comes next. You may be familiar with the term "elevator pitch." It is more fully explained in Chapter 10. In short, the elevator pitch is about getting your idea across in about thirty seconds—the span of a typical elevator ride. You should know your business idea so well that you can express it in a sentence or two. Keep it quick and to the point. Make sure it's closely targeted to your audience and focuses on their needs and interests. The SBA calls the company description "an extended elevator pitch"[1] that allows stakeholders and potential investors to quickly understand the business and how it will serve an unmet need.

Your **market analysis** is a bit more involved. It requires you to analyze the competition, focusing closely on the measures of their health, such as circulation, paid and unpaid subscribers, and advertising revenue. Be realistic about your competition. Ask yourself what you plan to bring to the market that is different from what is already available. Ask yourself if the marketplace is saturated, or if there is an unmet demand that you could fill. The more information you can gather about your closest competition, the easier it will be to make the case that you are bringing something different—and needed—to

the table. Also investigate any startup costs, including licensing, legal fees, rent, salaries, utilities, and insurance. Some of these expenses may be small or nonexistent if you plan to work from home and you don't plan to hire staff, but even small expenses can add up, and you can't afford surprises when you're starting a new business.

At this point you may realize that your struggle to gain market share may be harder than you had anticipated. This is part of the value of a business plan. If your plan shows little chance of success, better to abandon it now, before you've invested money and countless hours in a doomed endeavor.

Describing the **organization and management** of your company will likely be easy unless you're establishing a huge venture that may employ many people or have a board of directors. For many entrepreneurial journalists, the organizational and management structure consists only of themselves. If that's the case for you, simply describe your own unique qualifications and how they will well serve the business and ensure its success.

Next comes your description of the **product** itself. This should be your most extensive section because it describes your planned business. Include as much detail as possible about exactly what you plan to provide, to whom you will provide it, and your goals and measures for success. A mission statement and strategic plan may provide guidance here. The mission statement may be for only you and your potential partners or investors, but it is important because,

Figure 6.3

Some organizations, like the Federal Emergency Management Agency, make their mission public. Photo by Martin Grube / FEMA Photo Library.

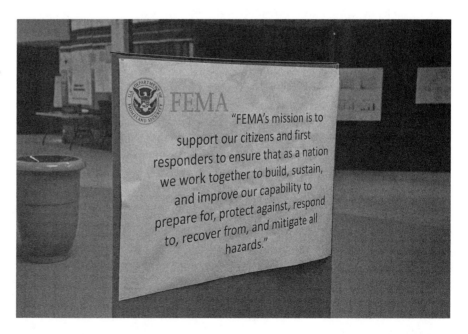

like the business plan itself, it focuses you and requires you to consider things you may not have otherwise given thought to. There is no universal format for mission statements, but at the very least you want to include: (1) what you provide, (2) to whom, and (3) how that is different from what anyone else provides.

Entrepreneur.com suggests studying other companies' mission statements for ideas.[2]

You will also want to consider a vision for your business or undertaking. Your vision is about the future of the organization—where you would like to go or what you would like it to look like in the future. The website Lifehack compiled some particularly memorable vision statements. They can be short or long, specific or general, but they should be inspiring. One of the shorter statements is from Disney: "To make people happy." One of Wal-Mart's older vision statements was quantifiable: "Become a $125 billion company by the year 2000."[3]

Your **marketing strategy** should be relatively easy given that you have likely put a lot of thought into it already. Marketing, communication, and outreach are central to the job of an entrepreneurial journalist. This is what you do. Because of the nature of the business, there is likely to be some overlap among this section, the company description, and the market analysis. The questions you'll want to ask when conceiving the marketing strategy include:

- Who is your target market? *or:* Who are your target markets?
- How will you reach your targets and with what message?
- How will you convert targets to followers, subscribers or "eyeballs" on the page?
- What are your goals for one year out? For three years out?
- How will you measure your progress toward (or achievement of) those goals?

Next comes your request for **funding** (if applicable). For this, you'll want to create a budget for launch as well as a monthly (or quarterly) operations budget. Since potential funders will want to know where their investment is going, you will have to break it down for them in as much detail as possible. Be careful. Any vague language here could give potential funders pause and keep them from opening their wallets.

Financial projections are the next part of the business plan. Unless the business already has a financial record, it will be difficult to project the future financial picture with much precision. However, you can include general industry information such as marketplace trends. Conduct consumer research on the media. The Pew Research Center publishes an annual report titled "State of the News Media."[4] The report includes some of the most current

data available on trends in journalism technology, media ownership, and news reporting. Pew's searchable "Media and News Indicators" database includes more than enough specific trend data to build a solid report.

Since journalism business models are so different from the models for most businesses that provide goods and services, and many media companies take years to realize a profit, you will need to be a bit more creative in finding useful data for comparisons and projections. For example, instead of tracking profits and losses that arise from consumers buying goods and services, the metrics of your success may be determined by the number of hits to your websites, the number of paid and unpaid subscribers, the average number of clicks and average amount of time visitors spend on your pages. To get a better idea of what kinds of data you might include in your own financial projections, review the annual reports of publicly traded media companies and nonprofits like *Voice of San Diego* or the *Tampa Bay Times*. While public companies (which report to the Securities and Exchange Commission, or SEC, in the United States), make their annual reports available to shareholders, nonprofits' tax filings are available to the public through the Internal Revenue Service (IRS) or other taxation board as well as other nonprofits dedicated to transparency, such as the enterprising news site ProPublica.org.

Get a Journalism Grant

If profits aren't your primary motive, and you're more interested in journalism for the public good, you may consider applying for a grant. Journalism innovation is among the Knight Foundation's favorite causes. Since 2006 the Foundation has run the Knight News Challenge asking journalists to submit innovative ideas for "using digital media to transform community news."[5] In 2014 the theme was "the role of libraries in the digital age."[6] The theme nicely represents the increasing emphasis of research in journalism, as well as the convergence of information professions, including journalism and library science. For more information on the Knight News Challenge, visit the Knight Blog at knightfoundation.org/blogs/knightblog/.

THE STRATEGIC PLAN

You will have already developed elements of the strategic plan while drafting the business plan. Both documents work together. While the business plan may be used to attract investor support, the strategic plan provides guidance for the first three (or fewer, especially when they are for technology companies) years. The business plan is created once, but you'll want to revisit

and renew your plan on a regular basis. Don't feel like you need to wait until the term defined by your last strategic plan is over before you consider modifying or replacing it. Market conditions change quickly in media and technology, so it never hurts to revisit your plan earlier than you had expected to.

In addition to doing an internal and external SWOT analysis, you should consider the mission and vision statements you drafted for the business plan, as well as your organization's core values. Your core values determine what you stand for and how you do business. The core values of some businesses are quite well known because they've done a good job publicizing them. The retailer Target, for instance, values volunteerism, and promotes its values by publicizing that it donates 5 percent of its profits to local charities and encourages its employees to volunteer. The vacuum cleaner company Dyson has done a great job promoting its quality workmanship and precision engineering, certainly among that company's core values. An organization's core values can be key to its differentiation. Will a company be a low-price leader? Will it define itself by offering the highest-quality products? The company's values will determine how it differentiates itself.

As a news organization, you may strive to offer the most comprehensive local news reporting or the most in-depth investigations. Or maybe your organization will set itself apart by offering the most current breaking news headlines to your community via mobile devices. All of these decisions are determined by the organization's values. The main section of a strategic planning document usually highlights a few major organizational goals, then describes how and by when one or more responsible parties at the organization will reach those goals through determined strategies (the overall means of achieving measurable objectives).

Watch the Video
For more information on small business development, the Small Business Administration (SBA) offers video tutorials and other resources at their learning center here: http://www.sba.gov/tools/sba-learning-center/search/training.

EFFICIENCIES THROUGH (INFORMAL) PARTNERSHIPS

The new media industry is all about partnerships. These partnerships don't necessarily refer to a company's business structure. Rather, they can be informal agreements to share resources or work to accomplish a common goal. Informal partnerships can be particularly useful for a small but growing

business with limited resources, and they're ideal for media organizations because they can expand the reach of a company's message without adding extra costs. Since the beginning of convergence, media companies have leveraged their resources by partnering with similar companies that have complementary strengths, and partnership is becoming a more common model. For instance, a local news website will partner with a local radio station, each one providing more exposure for the other in a different medium, thereby extending the reach of their message. In San Diego, public radio station KPBS has several media partners, including the *Voice of San Diego* investigative news website. Both entities contribute to the reporting of the local "Speak City Heights Project" documenting life in San Diego's challenged urban core. Each organization leverages the strengths of the other to do resource-demanding enterprise reporting in the inner city. It is unlikely either organization could do as well without the other. KPBS also partners with 10 News San Diego, the local ABC news affiliate, to produce local stories. Several public broadcasting stations in five U.S. states along the United States–Mexico border contribute reports to "*Fronteras*: the Changing America Desk." Limited budgets and resources prevent any one of these stations from covering the length of the U.S.–Mexico border themselves, but together they are able to produce ambitious investigative journalism that covers a territory nearly 2,000 miles long. This kind of cooperation would not have been possible in the preconvergence days when competition was cutthroat and media outlets were bitter rivals by necessity.

In these days of fragmented audiences, media companies need each other to survive. The same is true of individuals. Let's say you're a skilled reporter and writer, and you have a friend who's a great photographer. Find someone who's good at Web design, and you're on your way toward starting a media company. For a media startup, it's easier to form partnerships than create a business on your own and then hire people.

Hiring employees is one of those landmark actions that takes your business to the next level. Once you become an employer, you need to be concerned not only for the company but for the people who work for the company. But for most entrepreneurial journalists, hiring employees is far from the initial plan. As a media business grows and workloads expand, an easier initial option for a journalist who needs help is to hire a contractor. That means that unlike hiring a full-time employee for which benefits must be provided, office space must be found, and all sorts of provisions must be made, an independent contractor can be hired who will then function as the sole proprietor of their own business, paying their own taxes and providing for their own benefits. A company should be fairly well established and enjoy strong projections for growth over the next three years at least to make hiring employees worth everyone's time and investment.

TO HIRE OR NOT TO HIRE AN ATTORNEY

If you're starting small, you have no employees, and you're not facing any imminent litigation, you may want to wait before hiring an attorney. Do keep in mind that sole proprietors have no legal separation from their businesses. So if your company gets sued, you're on the hook for any fees or damages. It wouldn't be a bad idea to have a lawyer, but whether you need one on call or on staff depends on your comfort with risk and your patience for reading fine print. For most people running small businesses that are either sole proprietorships or limited liability companies, a lawyer becomes necessary only when the business is sued.

The Small Business Administration (SBA) suggests that individuals themselves can handle filings to create a business name, register for licenses or permits, register for a tax ID number and pay taxes, and establish an LLC or partnership. Unless you are forming a corporation, you should be able to file all the paperwork you need to start your business. You may also want to hire an attorney if you are filing a patent or buying or selling the business.[7] This should come as good news for most media entrepreneurs, who will likely want to keep their businesses lean and their expenses low.

If you have established a news organization or website, and you are doing investigative or other serious journalism, you may be able to get free, *pro bono*, or inexpensive legal representation from the Online Media Legal Network at Harvard's Berkman Center for Internet and Society. The Online Media Legal Network (omln.org) is a nonprofit that supports independent journalism. Specifically, it calls itself a "referral service" for "qualifying online journalism ventures."[8] Attorneys who want to support quality unaffiliated journalism in the interest of upholding the First Amendment and journalism's highest democratic ideals volunteer their time to the service.

SUMMARY

At its most basic, entrepreneurship is about going into business for yourself, either as an individual or as a startup company. Entrepreneurship is a great option for journalists today, particularly since the number of traditional jobs in journalism has declined in recent years. Entrepreneurship is also a natural fit for journalists who are already familiar with the freelance model.

Fragmenting audiences and the decline of large entrenched mass media companies have shifted power away from big business in favor of individuals with innovative ideas. This has led to a climate ripe for media entrepreneurship. An environment of flexible thinking, quickly advancing technology, and ongoing evolution and change has brought new excitement to journalism,

as possibilities for forming new partnerships and enterprises bring more opportunities to the field.

Many journalists today are building their own businesses, either as freelancers or independent contractors, or at the helm of a new startup that may ultimately grow to employ others. These businesses can work as fairly lean enterprises if the journalists who run them are willing to do the small amount of research necessary to understand what legal paperwork they need to file in their state or jurisdiction and have the ability to read small print and the patience to complete any necessary forms.

One of the first questions you will encounter as you start your business is what kind of structure to employ. Will you run the business as an extension of yourself, subject to all the profits and liabilities of a sole proprietorship? Or will you establish a limited liability company to protect some of your personal assets from potential business losses? Few entrepreneurial journalists will be interested in forming a corporation.

Regardless of the business structure you choose, writing a business plan is a good idea if you want to attract outside funding, or even if you just want a better sense of how viable your plan is based on a careful analysis of the competitive market environment, the needs and interests of your target markets, the feasibility and costs of reaching them, and the long-term sustainability of your plan.

Creating a business plan forces you to examine what you may not have looked closely at before, and may even show that what you had in mind will be too challenging to make work. Better to know this at the planning stage than after you've invested huge sums of money and time in a doomed project.

Keep in mind that you don't need to do everything yourself. While partnerships may have been unheard of in previous times, partnerships are the nature of the media business today. Companies both big and small now routinely work together to complement each other's coverage. Lacking the enormous resources of their mass media predecessors, media companies today survive only by working together.

JOURNALIST'S TOOLKIT

Although all journalists now need business skills, not until recently have many needed to employ them on their own behalf. Today's journalists not only need to understand numbers well enough to accurately assess the competition and create a business plan with measureable milestones for growth, but they also need to know how to research laws and regulations to which they are subject. With more journalists practicing entrepreneurship all the

time, increasing numbers are turning their quantitative skills on themselves in the hope of building a sustainable business. Any journalist who has ever reported a business story already likely has the basic skills needed to establish their journalism enterprise.

Skills

Writing

Research

Basic business acumen

Basic math and statistics.

Tools

Computer, laptop or mobile device with a fast Internet connection

Optional: financial calculator.

Sites

Journalism.org: Home page for the Pew Research Center Journalism Project.

Knightfoundation.org: A foundation that supports journalism ventures through grant funding.

Knightfoundation.org/blogs/knightblog: The Knight Foundation's blog.

Omln.org: The Online Media Legal Network at Harvard's Berkman Center.

Sba.gov/tools/sba-learning-center/search/training: Find Small Business Administration (SBA) online educational videos here.

Sba.gov/tools/business-plan/1: An SBA resource for completing a business plan.

Application

1. Write a mission statement for an entrepreneurial journalism venture you either could or will launch. Make sure to address what your enterprise will provide to whom and in what special way that sets your company apart from other companies competing to offer the same services to the same target audiences.
2. Create a business plan for an entrepreneurial journalism startup, including all the basic steps listed in the "Business Plan" section above. Make sure to include an executive summary, a company description, market analysis, organization and management, marketing, funding request (if any), and financial projections.
3. Research recent media trends and use them to identify the five most influential trends for the next five years. Compile your findings into a report with an executive summary.

4. Interview someone who has created his own blog or online publication. Ask him about his background and formal training in journalism. Ask about the research he did and preparations he made before launch, including any business or legal filings or the purchase of insurance. Create a story about your subject's experience using any media or platform. *Optional:* Pitch your story to a community or student publication.

Review Questions

1. What is entrepreneurship and how does it apply to journalism?
2. Why is entrepreneurship a good option for journalists today?
3. What are the strengths and weaknesses of the sole proprietorship and limited liability company models for entrepreneurial journalism ventures?
4. Why are partnerships useful for entrepreneurial journalists?
5. Why is it important for entrepreneurial journalists to set goals and measure their progress toward them? How do you know if a goal is measurable? Please provide examples.

REFERENCES

1. "Company Description." The U.S. Small Business Administration, *SBA.gov*, http://www.sba.gov/content/company-description.

2. "How to Write Your Mission Statement." *Entrepreneur.com*, October 30, 2003, http://www.entrepreneur.com/article/65230.

3. O'Donovan, Kirstin. "20 Sample Vision Statement for the New Startup," *Lifehacker.com*, http://www.lifehack.org/articles/work/20-sample-vision-statement-for-the-new-startup.html.

4. "News Industry Data and Trends," *Pew Research Center's Journalism Project*, http://www.journalism.org/media-indicator-tags/.

5. "History," *Knightfoundation.org*, http://www.knightfoundation.org/about/history/.

6. "Knight News Challenge: Libraries Opens for Entries," Knight Foundation, http://www.knightfoundation.org/blogs/knightblog/2014/9/10/bracken-knight-news-challenge-libraries-offers-25-million-innovative-ideas/.

7. "When to Hire a Lawyer for Business Matters (and When to Do It Yourself)!" The U.S. Small Business Administration, *SBA.gov*, http://www.sba.gov/blogs/when-hire-lawyer-business-matters-and-when-do-it-yourself.

8. "About Us," *Online Media Legal Network*, http://www.omln.org/aboutus.

Don't Forget the Story

People of all ages and backgrounds are drawn to stories because they not only convey ideas, but they connect those ideas and put them in a meaningful context. They are much more than just an assemblage of disconnected information. While reporters bring audiences facts, storytellers let audiences know how those facts are relevant to their own lives and why they should care. With rare exception for short breaking news updates and spot news, today's entrepreneurial journalists are charged with providing a more meaningful service to their audiences than simply delivering facts. Facts alone are only part of the story. It takes a skilled and thoughtful journalist to tell the story *behind* those facts, those data points or those trends.

Basic human stories cross cultures and time. They've been passed down from the earliest humans to today, carrying living traces of those who have informed them and shaped them along the way since the very beginning. Stories are universal. Like each day and each lifetime, they have beginnings, middles, and ends. They are the basis of mythology, the way people have tried to understand the world and their place in it since the dawn of humanity. They respond to humanity's universal unanswered questions through the ages, although the questions have evolved somewhat from "What makes the sun rise each morning in the east and fall each evening in the west?" to "What is the meaning of life?" or "Why am I here?"

The human desire to understand the world is remarkably similar in both the realm of fiction storytelling and nonfiction news reporting. Although it may sound odd or opposed to the journalistic ideals of objectivity and accuracy, understanding the central role storytelling plays in our daily lives can help all kinds of journalists forge deeper and more meaningful connections with their audiences. Most of us are familiar with how the human hunger for stories led to the earliest dramas staged by the ancients, many of them depicting the mythic world. To this day, our hunger for stories keeps us watching movies, TV shows, and plays. People are naturally interested in others' stories. This makes the journalist's job easy—as long as he's able to think like a storyteller.

Figure 7.1

Ernest Hemingway applied the storytelling skills he had acquired as a journalist to his spare, tightly written novels. Photo by Lloyd Arnold.

Figure 7.2

The 230-foot Bayeux Tapestry told the story of the Norman Conquest in the first century of the last millennium. It was likely commissioned to help the French make sense of the violent events that led to the Battle of Hastings.

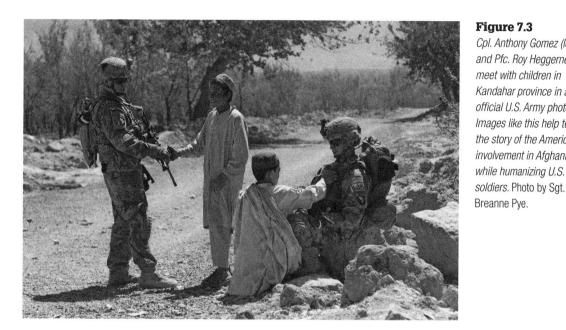

Figure 7.3
Cpl. Anthony Gomez (left) and Pfc. Roy Heggernes meet with children in Kandahar province in an official U.S. Army photo. Images like this help tell the story of the American involvement in Afghanistan while humanizing U.S. soldiers. Photo by Sgt. Breanne Pye.

THE HUMAN ANGLE

Stories involve people. Readers respond to stories they can relate to. That's why editors sometimes ask writers to "put a human face" on an issue. Let's say a reporter is deep into researching a story about how new health care laws will affect people in her community. The reporter goes to her editor with the basic facts of the story: Low-income families will have to spend a larger percentage of their income on health insurance, they may have to change primary care doctors, and some general practitioners may leave the community.

The editor may try to put herself in the mindset of the story's target audience. She might say to the reporter, "This all sounds like it could be bad for me, but I'm already working two jobs. I'm not motivated enough to spend my limited free time reading this story."

How does the reporter make the story—that is already relevant to the target audience—more *readable*? Actually telling a story will help. No matter how relevant a topic may be to a particular audience, reading a dry analysis is like homework. Most people won't do it unless it's required. But everyone likes a good story. So the reporter's challenge is determining how to convey what may ordinarily be dry facts in a way that entertains and engages. This is almost impossible to do without including people.

Instead of simply reporting on changes to health care policy, the journalist finds a family in her community that will be deeply affected by the changes. For a long-form story, the journalist may visit the family several times to document a complicated morning routine:

> Nancy, a single mother who works two full-time jobs to support her two kids, gets up at 4 a.m. each day to bathe her youngest child, who is developmentally disabled, and get her ready for the day program she attends for sixteen hours each weekday when she is at work. She then must feed and dress both of her daughters, then ride the bus with them to different stops on the way to her first job of the day. It's a punishing schedule that's about to get worse when changes in her health care coverage mean that she will no longer be able to afford to send her youngest daughter to the day program while she is at work.

Instead of simply asking the reader to imagine how tough life will get for some people already on the edge, a skilled reporter will bring the story of this new legislation's impact directly to her audiences and make it real. Instead of simply explaining that cutbacks will mean less money for daycare and skilled nursing programs, the reporter can show the real human impact on those directly affected by the changes. While richly detailed writing could help bring this story to life, a reader would also want to see photos of the family. It is difficult for readers to ignore a photo in which subjects with worried or worn-looking faces make eye contact from the page or the screen. An image brings an emotional impact text alone cannot produce. This is the same reason why child welfare organizations that ask for donations advertise their services using pictures of children with dirty faces or clothes—and why animal rescue organizations run commercials on late-night TV showing injured or suffering animals. While a statement or plea may be easily ignored, it is nearly impossible to ignore a photo or a video of an animal with exposed ribs or visible sores.

The online version of Nancy's story would be much more compelling with a video or two, depending on the length of the main story or the text. The editor may want a short video showing Nancy's grueling morning routine. Shots could include a close-up of Nancy's alarm clock as it registers 4 a.m., followed by a close shot of Nancy's tired face as she rubs the sleep from her eyes. These images would show Nancy's fatigue in a way no amount of text can. (Remember your old English teacher's admonition to "show, don't tell"? Video makes that easier than ever.) The editor may then want to see several quick clips of Nancy rushing to get her children ready for the day. She may want to see additional shots that suggest Nancy's frustration and the challenges she faces before she even leaves her apartment in the morning. Maybe her daughters are fighting, and one starts crying. Maybe she drops the oatmeal while

rushing across the room. Maybe the dog starts barking, raising stress levels for everyone. It takes just a few seconds of this kind of footage to paint a clear and compelling picture.

Another video later in the story could show Nancy as a loving mother, hugging her children as they drift off to sleep. Or it could show Nancy, in a short interview clip, crying and wondering aloud whether she'll be able to manage when the new health care changes are enacted. While there are several other important aspects of the story that will be included in its text, such as sidebars or information graphics explaining the relevant changes to the law, an information-heavy story like this would be unlikely to attract much readership without the human element.

ASK THE RIGHT QUESTIONS

Effective interviews are the cornerstone of compelling feature stories, particularly profiles. Regardless of whether they will be shared with audiences directly via video or audio or contextualized by a journalist taking notes, interviews get to the heart of a story's key questions. The information sources provide is only as compelling as the interviewer is skilled because it's more than just the questions themselves that journalists must concern themselves with. It's also how and when to ask, and knowing how to conceive good follow-up questions on the fly.

In addition to excellent oral and written communication skills, journalists must be interested and engaged in the interview if it is to yield any compelling quotes. Attitude is everything, and interview subjects can pick up subtle cues from the journalist that may make them more timid or less likely to open up and provide the kind of sensitive or personal detail that makes for great stories. If a journalist expects to get good quotes from an interview subject, he must be as genuinely interested in the subject as he expects his readers or viewers to be.

Because we all spend much of our lives speaking with the people all around us, most of us tend to think we are reasonably skilled interviewers. After all, some people may ask themselves, how hard could it be to talk with someone? As it turns out, conducting effective interviews isn't quite so straightforward or intuitive. First of all, it is important to keep in mind, conducting an interview is more than just talking with someone. Consider that most conversations are two-way interactions. Although some prominent journalists are known for making themselves central to any interview they conduct, for the rest of us, the focus must be on the subject.

Anyone who has received even the most basic journalism training knows that journalists report the story without becoming part of the story. The same rule

applies to interviews. Although it can be difficult for a journalist to resist the urge to insert himself into the conversation, a true pro knows that the focus must remain on the subject. This means that the journalist needs to listen and let the subject complete his thoughts before asking the next question. Even if the journalist disagrees with what the subject is saying or has conflicting or contradictory information to share, that information should be based in fact and not the journalist's personal observation. That doesn't mean that the journalist shouldn't question or challenge a point or assertion when the subject says something that differs dramatically from the viewpoints of a significant share of the audience. But it does mean that a journalist should base his questions on what his audience would like to know rather than what he would personally like to challenge or question.

Trained journalists and probably others can easily recognize when a journalist inappropriately inserts himself into a story by adding personal anecdotes or other information that is relevant only to him. This not only wastes time for the subject and the audience, but it rings of amateurism and lack of professionalism that can damage the journalist's reputation. Sometimes a journalist will add something to prove knowledge in a particular area. Other times a journalist will not say something to avoid looking ignorant. This is not a good strategy. Often people worry about revealing themselves as ignorant on a particular subject. It is essential that the reporter adequately prepares for an interview by learning key ideas and biographical details about the subject. However, it is just as essential that the reporter puts himself in the position of an audience member and asks the subject to define terms, acronyms, and other words and phrases not in common usage. Even if the reporter knows what these words and terms mean, his audience may not. The reporter should not be concerned about looking stupid. The best, most respected interviewers everywhere use this technique without any loss of respect or prestige. It is the sign of a true professional who is more concerned about his audience's welfare than about looking smart. (A journalist who goes out of his way to show that he knows something actually only winds up looking incompetent.) Like all other effective interviewing techniques, being a better listener becomes second nature after a while. Journalists can expect that improving their listening skills on the job will also make them better listeners at home.

Al Tompkins, senior faculty for broadcast and online at the Poynter Institute for Media Studies in St. Petersburg, FL, is a veteran journalist and one of the top journalism trainers in the United States. Tompkins wrote the book *Aim for the Heart: Write, Shoot, Report and Produce for TV and Media*, which serves as a bible for many multimedia journalism professors and their students. In *Aim for the Heart*, Tompkins wrote that the most important part of reporting is listening. Indeed, he continued, "Listening is the essence of journalism."[1]

It takes some work for most of us to become better listeners because most people could stand to work on their listening skills in daily life. Among the bad listening habits most people have, Tompkins wrote, are lack of interest, judgment or bias that could lead to a lack of attention or respect. Journalists often interview people with ideas and mindsets that are different—often radically different—from their own. Like any true professional, even on hearing something he finds highly offensive, the interviewer must not let the words or ideas derail the interview. Above all else, he must not involve himself in the discussion or get drawn into a debate on the topic. Occasionally an interview subject will challenge a reporter to weigh in or cast judgment on an idea. Regardless of his personal beliefs, he must at least maintain the appearance of neutrality and let the subject know that the code of journalistic professionalism prevents him from becoming personally involved in the discussion.

ASK THE RIGHT QUESTIONS IN THE RIGHT WAY

Not all interviews are conducted under ideal circumstances. Reporters know they will not always get the time they think they need to meet a story's demands. But entrepreneurial journalists in particular are flexible and able to adjust their plans as needed. If they can schedule a sit-down interview with a subject, seldom do they get all the time they want. Alternatively, they can conduct interviews by phone, Skype or other means. And sometimes, because of scheduling or a subject's unwillingness to talk, the journalist may have to catch him between meetings or events. Regardless of the time or circumstances, a skilled journalist is prepared with broad, thoughtful, open-ended questions that may take the subject some time to respond to, as well as short, quick, to-the-point questions that may put the subject on the spot or make him look guilty if he is avoiding the media. In this kind of unplanned situation, an entrepreneurial journalist needs to have various tools available to record the subject's comments for sound bites or short video clips, or even for longer interviews if there is a last-second opportunity to conduct one.

The appropriate choice of media depends on several things, some of which can be anticipated and planned for in advance. If the subject is actively trying to avoid the media, video is the best tool to reveal his behavior and personality. Because it gives a more complete picture of the subject's appearance, voice, and behavior, it provides the most information with which the audience can reach their own conclusions. For situations like this, a reporter might want to have a portable video camera and microphone of reasonable quality (on a smartphone or other mobile device, if necessary) and higher-quality equipment (including a tripod) if the opportunity to hold a sit-down interview arises.

ELEMENTS OF EFFECTIVE STORYTELLING

Tease the story

Stories can be told in all media and through all combinations of media. Anything that is more than just a fact or collection of facts can be a story. Even a tweet can be a story if the writer is skilled at compression. Let's say that while reporting a story, a writer shot a portrait of the subject in which he has a curious or revealing expression on his face. The reporter could tweet the photo along with a link to the story online and the comment: "Who is Mr. Wonderful?" Of course it's not a complete story. It's just a tease for the full story—which is exactly what's expected on a microblogging platform. But instead of simply tweeting just the link or the photo, adding an attention-getting line helped start the story for the reader, who may be compelled to find out why this widely smiling man is Mr. Wonderful, and why she should care.

Start strong

From your early literature classes, you may remember having discussed the type of conflict in a story. Common conflicts included "man vs. man," "man vs. nature," and "man vs. himself." Although the centrality of conflict to storytelling may not have been clear to you as a young person, all you need to do to understand the statement that all stories involve some kind of conflict is read a story that is utterly without conflict. If you have read such a story, you probably don't remember it, because stories without conflict tend not to be very memorable. Stories without conflict lack a main point. No journalist wants to write pointless stories.

What's important to remember about conflict in stories is that it usually dictates the overall structure of the story. Although the pacing in a news story is generally much different from the pacing in a work of fiction, some elements are remarkably the same. Just like a good fiction story or movie, a good news story begins with a hook—or a lead—that graphically or dramatically presents the problem or question. Just like the opening scene of a movie, the beginning of a news story needs to hook the audience and keep them reading and wanting more. It is highly advisable to start with a powerful scene that illustrates the main conflict or question while creating suspense. The scene itself may prompt questions that will motivate the reader or viewer to stay tuned for the answers.

It is dusk. A constant drizzle has left the streets wet. A police car, its siren on, speeds by. A teen boy lies crumpled in the street, his tan pants marred by tire tracks. Why did the police car rush *away* from the scene? Whether it's a movie or a news story, the audience wants to know. This will keep them watching or reading.

Of course not all stories must start dramatically in order to entice audiences. Smaller stories can be just as compelling—although they tend to work better in journalism than in mainstream movies, where subtlety tends to be a hard sell. As a journalist creating a feature, you can find powerful ways to tell human stories through small, rich details. You may describe or show, for example:

- A family sitting down to dinner, one place set but empty.
 o Question raised: Who is missing and why?
- A middle-aged man packing small items from his work cubicle into a box.
 o Questions raised: Where is this man going? Was he fired?
- A woman with a large backpack hugging a small boy and crying.
 o Questions raised: Where is she going? Is she leaving her son?

Be guided by questions

Sure, you won't know your exact thesis when you first set out to research your story, but you should at least have some idea of what you're expecting to find. In the early phase of your research, a general idea or broad question is enough. But you should have at least some sense of where you'd like to go with the story before you start conducting interviews. After all, your subjects want to know what the story is about before they sit down for an interview. Tell them your general direction but don't be too specific until you've conducted enough research and interviews to have a working thesis to guide you. But the real value of a working thesis is in guiding your research and saving you the time of investigating false leads or pursuing other avenues of research that will not be relevant to your story.

Let content dictate structure

We've already established the importance of conflict. The nature and timing of that conflict will go a long way toward determining the appropriate structure for the story. If the conflict itself is dramatic enough to open your story, you will need to orient the audience as soon as possible after the dramatic opening scene. A cinematic structure is one common way to structure a story with a dramatic climax. It looks like this:

- Dramatic opening scene.
- "Nut graf" or informational paragraph explaining the basic facts needed to understand the opening scene while preparing the audience for the journey to come.
- Chronological description of events leading to the opening scene (the actual beginning of the story).

Not all engaging narratives need a dramatic opening scene. Less dramatic stories or stories without a major climax such as a shooting, a robbery or the birth of a child will likely follow a different structure. Because the reporter wants to ensure the story is relatable to his audience, he may want to open with a universal situation or a familiar question. For example, a story may begin with a familiar question: "Does my vote really count?" or "Should I give money to panhandlers?"

The question itself doesn't require much explanation, but the audience will want to see examples of other people like them who have been plagued by similar thoughts. They will enjoy trying to get their own questions answered by those in the story to whom they can relate. This kind of story will likely build more slowly. Although there is a conflict, it is more subtle and internal. It may not be particularly cinematic.

Regardless of the nature of the conflict, there is a classic structure familiar to most people from all kinds of storytelling, including television and film. It is often quite formulaic, but the formula exists for a reason: It works. Think about the following formula the next time you watch an hour-long television drama:

- Scene setting and establishing characters.
- Rising tensions as the story ramps up toward its central conflict.
- The crisis point.
- Resolution of the crisis.
- Conclusions and lessons learned.

Although television audiences and writers have become more sophisticated in recent decades, back in the 1970s and 1980s, the classic storytelling structure was in clear evidence. *Fantasy Island*, a relic of classic 1970s TV, was perhaps most direct in its embrace of traditional narrative technique. At the beginning of the show (Act 1), guests would arrive on the island and explain the nature of the fantasy they would like to live out on their visit. In the middle section (Act 2), which lasted about half the show, the guest would have their fantasy, only to realize—at the crisis point—that they didn't really want what they thought they wanted or that they already had everything they needed in daily life. Then in the final ten or fifteen minutes of the show (Act 3), the guests would reveal that they had learned and grown from the experience of their failed fantasy and would be better people for it. This is the classic three-act play structure, consisting of the establishment of story and character rising to a point of conflict, then a turn or transformation, followed by resolution, which is often—but not always—satisfying. As audiences have grown more sophisticated and aware of the classic three-act structure, they have become open to new variations, among them the inconclusive ending (which has itself become an action film cliché, alerting viewers to the likelihood of a sequel).

Applying narrative structure to journalism is now a decades-old concept, yet for some journalists—particularly those more interested in reporting than writing—the inverted pyramid still rules. For decades, the inverted pyramid has been sacred to journalism, requiring reporters to provide the most important facts at the beginning of the story with details in decreasing importance toward the end. One of the main reasons for the popularity of this structure was to accommodate old layout techniques in which stories that were too long for the allotted space were simply cut off at the end. Although many reporters still use the inverted pyramid for their news stories, printer's tools (and online publishing) have evolved to allow for more flexibility in page layout, and an increased interest in narratives that began with the rise of New Journalism in the 1960s gave other, more creative forms of storytelling a legitimate place in reporting.

Despite that, when Roy Peter Clark first identified a new journalism story structure in the early 1980s—the hourglass—newsrooms reeled. New structures were already old news to the feature magazines for which New Journalist Hunter S. Thompson had been writing narrative stories for more than a decade, but they were virtually unheard of in daily journalism. Clark was uniquely qualified to identify the hourglass story structure since he had been a college literature professor before making the leap to journalism (a reversal of what often happens today). Clark described the hourglass as consisting of three sections: the top, the turn, and the narrative.[2] The idea was that this form allowed journalists to offer all the information they were used to including (and readers were used to seeing in the inverted pyramid structure) right up front, while allowing them to use their narrative skills to tell a more complete story at the end. Clark's discovery, while not new, helped legitimize new ways of practicing journalism that are more relevant than ever today.

Make the details memorable

Often when a journalist has spent a great deal of time with a subject or researching a story, the sheer number of interesting facts and ideas can start to overwhelm. These facts may be complicated or layered, or require a great deal of explanation by the journalist. Providing lengthy descriptions of these observations may make what should be an engaging story dull, confusing or even unreadable. A skilled journalist will find ways of letting the story tell itself. Remember that an audience is interested in the story and its characters, but usually not the storyteller. When reporting a story, a journalist should always be on the lookout for facts, quotes, and other details that directly *show* the audience what no amount of descriptive language ever could. This is the fastest, most compelling way to tell a story.

Let's say you just spent a day with a political candidate. You return home or to the office at the end of the day with a pile of notes—scraps of paper, brief

audio recordings on your phone, and photos and comments you tweeted to tease the story. It's a good idea to immediately isolate some of the more revealing things you saw or that the subject said. You can be reasonably sure that whatever stood out for you will also stand out for your audience. Considering how you might describe highlights of the story using the limited character counts of social media may help you decide which items are most revealing. Think about actions and words that need no explanation. Think cinematically.

For example, you interview an accused mobster with a terrible reputation for ordering hits on his rival gangsters. He lives with his mother, who brings both of you tea and cookies, including anisette—his favorite, according to Mom. Include that fact. The mobster has a pet rabbit that sits on his lap throughout the interview. Include that fact too.

Instead of explaining that he has discriminating tastes, simply show him (in print or on video) enjoying his "favorite" of Mom's cookies. Instead of explaining that he loves animals, show him cuddling his pet rabbit. Also try to get him to talk about his pet. *What's its name? What's so special about it?* The mobster's response—although it may be calculated—may surprise you. After all, what mobster looking to improve his public image wouldn't want to shift attention to his pet rabbit? Even small details like these create a much clearer, more telling picture than any amount of description could, no matter how well written.

Less is more

Compression is discussed in detail in Chapter 4, but even when you're producing feature or other long-form stories (this includes all story forms—not just print), keep the adage "less is more" top of mind. Just because a story can run longer doesn't mean it can be fat or overloaded with extraneous detail. No one wants to waste time with irrelevant information. Feature writing isn't creative writing. It still needs to get to the point.

Resist the temptation to overly quote your subjects. Limiting yourself to only the most interesting short quotes will help your subjects seem more engaging and keep the audience moving quickly through the story, eager to learn what happens next. Resist the temptation to include interesting or fun details that do nothing to advance the story or explain its characters or their actions. If you ever find yourself wondering if a paragraph, photo or video clip is needed to tell the story, take it out. Just asking this question usually means it can—and should—go. If you later realize that text, photo or video was critical to the story, you can always add it back in again. Also try to give yourself time between drafts. It can be difficult to see where a story can be

edited when you've been staring at it for hours. Give yourself as much time as possible—ideally a day, but an hour or even twenty minutes is better than nothing—away from the story. Or, better yet, let someone else take a look at the story to suggest needed cuts you may not have been able to identify yourself.

DON'T FORGET YOUR ROLE

Despite the preceding discussion of objectivity, neutrality, and approaches to interviewing reluctant subjects, keep in mind that you, like your subjects, readers, viewers or listeners, are human. While it can be difficult to remember that when you're hard at work tracking down unwilling sources or desperately digging for answers, an obsession with uncovering facts and exposing wrongs is never an excuse to act unethically.

Always be honest about your angle or general intentions before an interview. Don't misrepresent yourself or take advantage of those (including children) who are not media savvy to get access to a key figure in your story, and never lose track of the reason why you are doing something. That should inform your decision-making about how best to proceed with a story. Reporters often possess a tremendous amount of power relative to their subjects, so they must be mindful of their capability to influence the lives of others in both positive and negative ways. Remember, even bad guys have rights. And don't forget that it's not up to you, the journalist, to decide who's a bad guy. Everyone deserves their day in court.

If you ever find yourself deep into the reporting of a story and wondering how far you should go, it's a good idea to step back and consider the goals of your reporting. Is your goal to show your audience that Mayor Jones is corrupt, or is your goal to ruin Mayor Jones' reputation? If your goal is the latter, it may be time to revisit your reasons for entering journalism. Despite the increase in opinionated journalism that has coincided with the rise of blogs and online reporting, the journalist is not judge, jury, and executioner. Rather, journalism is about informing audiences, then letting those audiences draw their own conclusions. The more closely journalists honor that fact, the better journalism's reputation will be going forward.

SUMMARY

Journalists have long used narrative tools and techniques to tell news stories in compelling ways. They should be familiar with narrative storytelling techniques so they can apply them when appropriate.

Stories are more than just collections of facts. They put ideas in context and help people make sense of the world. Journalists can use storytelling tools to make their reports both interesting and relevant to their audiences. One of the most important ways of doing this is to put a human face on an issue.

Key to good stories are good questions and answers. Journalists with strong interviewing skills get the best quotes, and great quotes make for compelling narratives. To get the best from interviews, a reporter must be flexible and prepared to shift gears if necessary. She needs to have a list of essential questions, then be prepared to depart from the list when necessary.

Stories should start strong, with drama or universal questions and themes. Storytellers think cinematically. Whenever possible, they let stories tell themselves by showing revealing actions or including pithy quotes instead of editorializing or engaging in lengthy descriptions.

Journalists will be well served by starting the reporting process with guiding questions or a working thesis. While they won't have a precise thesis until they finish reporting, having a sense of where they expect to end up will make it easier to focus the story as they go. Interview subjects will also be more willing to talk if they have some idea about the story's focus.

A story's content should determine its structure. Traditionally, news stories have followed the inverted pyramid form in which the most important information appears at the beginning, followed by all other information in decreasing order of importance.

Finally, the most successful storytellers never forget that they, like their subjects, are human. This helps guide their decision-making as they report. While the reporter should never be a focus of the story, she must also remember her reporting goals and not let personal agendas interfere with journalistic objectivity. The more honest and straightforward a journalist is about her reporting, the easier time future journalists will have gaining access to the information and sources they need to tell compelling stories.

JOURNALIST'S TOOLKIT

Storytelling doesn't require any special tools beyond what journalists now use to report all their stories. Applying narrative tools and techniques to journalism mostly just requires journalists to think differently about the work they do and the goals of their reporting.

Skills

Listening

Interviewing

Writing

Editing for meaning and compression

Basic photography and photo editing

Basic video shooting and editing.

Tools

Digital audio recorder

Smartphone or tablet computer *or* a digital video or still camera

Laptop computer

Basic photo, video, and audio editing software.

Application

1. Read a news feature in a magazine or online. Identify the author's narrative techniques. Analyze the lead, the structure, the characters, and the presentation of facts and quotes. Explain how these narrative techniques affected the story's readability and how the story would differ without them.
2. Write or rewrite a news story you reported using narrative techniques. *Optional*: Submit the story to a community or student publication.
3. Conduct an interview for a story you are reporting in a subject's home or office. Use a digital voice recorder, smartphone or video camera to record the interview. During the interview, take notes on revealing details that could help "show" the subject's personality without your having to describe it. Pay attention to less obvious details such as the way the subject treats an assistant or the way he handles an unexpected phone call. Also look around for evidence of the subject's true self. Write a character study of the subject based on your objective findings during the interview.

Review Questions

1. What is narrative and how does it relate to journalism?
2. Why would a journalist want to apply narrative techniques to her work?
3. What does it mean to think cinematically when you write?
4. What does it mean to put a human face on a subject, and why would a journalist want to do that?

5. Why is listening important to journalism? What about observation?

6. Are there any circumstances in which narrative techniques would be inappropriate for a journalist?

REFERENCES

1. Tompkins, Al. *Aim for the Heart: Write, Shoot, Report and Produce for TV and Multimedia* (Washington, DC: CQ Press, 2012).

2. Scanlan, Chip. "The Hourglass: Serving the News, Serving the Reader," June 18, 2003, *Poynter.org*, http://www.poynter.org/how-tos/newsgathering-storytelling/chip-on-your-shoulder/12624/the-hourglass-serving-the-news-serving-the-reader/.

Find Your Audience

The funny thing about entrepreneurial journalism is that no matter how talented you are or how strong your content is, none of that means much if you can't find and reach your audiences. These days your readers, viewers, and listeners are everywhere. They are mobile; they are connected. And they won't come looking for you. You have to find them where they are. That can be challenging, but it also allows you to understand and engage with them in ways journalists couldn't do until fairly recently.

In other chapters we discuss mission statements for entrepreneurial journalism businesses and branding messages for yourself. These are essential for knowing who you are professionally and what special value you can bring to others who need your services. Let's not forget that you also need to know who you are targeting and what their habits are. Do you have different messages for different groups, or will you deliver the same value to every reader, viewer, listener, customer or client? For most people, fully understanding the product or service you provide is the first step toward understanding your target market. Think about what value your product or service may already be providing— either to your existing audience or to the audience of your competition. The competitive analysis you do for your business plan should provide you a basic profile of the market for your kind of product as well as the unmet needs in the marketplace that you are trying to fill.

PROFILING YOUR AUDIENCE

Who is the entrepreneurial journalist's audience? If you've been producing content for any length of time, you should have a pretty good sense of your audience. Even if you aren't yet working in the field full-time, you probably have social media accounts and profiles, each with their own distinct audiences. Let's say you have Facebook and LinkedIn pages, and Twitter, Instagram, and Pinterest accounts. You probably have other pages and accounts, but let's start with these.

125

Think for a minute about each of these accounts in terms of your followers in each, your content in each, and how you use each. While there will likely be some overlap, they all function a little differently. Each has different strengths and weaknesses, and each was designed with a different audience and purpose in mind. Knowing who each social media platform targets and reaches may help improve your understanding of how you can use social media to promote your work.

In her entrepreneurial journalism classes, Professor Jane Singer asks her students to consider how they might use social media to promote their stories or media ventures. Teaching students to go beyond their reporting and writing to consider monetization, marketing, and reach has helped her reflect on her own newsroom days when reporters were trained to ignore the financial realities of their work. An American, Singer took a temporary teaching appointment in London, among the world's most vibrant media cities. Having taught entrepreneurial journalism in two countries makes her uniquely qualified to discuss the emerging discipline.

Figure 8.1

Jane Singer.

INTERVIEW: A Conversation with Jane Singer, Professor of Entrepreneurial Journalism, City University London and Associate Professor, University of Iowa School of Journalism

Is teaching journalism in England much different from teaching journalism in the United States?

The media here are fascinating. I came here from the University of Iowa, which is in Iowa City, Iowa. A lovely place, but a town of 60,000. We have our little local Gannett newspaper, then there's the affiliate TV stations in Cedar Rapids. But that's about it.

London and New York are really the media capitals of the world. All the U.K. media are based here except the local and regional papers. There's really no local television, so everything's out of London. The BBC is also out of Manchester now, but basically it's a different media structure, very London-centric. There's a really vibrant startup community here that I'm marginally more plugged into now than when I first arrived.

What do you teach?

Entrepreneurial journalism. Essentially it's a research position, but I'm teaching one class. It's a master's class. The substantial majority of students here are master's students. The master's students' main program of study is in a particular media sector. Their main program of study would be broadcast journalism or newspaper journalism or magazine journalism or whatever it

is. But then they take this class in entrepreneurial journalism that cuts across their main program of study. So students from different backgrounds who are planning different sorts of careers get experience in and knowledge about journalism innovation and some of the things they can do within an existing media structure.

Is this a new curriculum for the university?
This is the third year the class has been offered, which makes it kind of a long time because entrepreneurial journalism is so new. Most people still aren't offering it. There are very few programs here that offer it. It's been an innovative and forward-thinking approach, but it also is still new and evolving. For instance, next year we're actually going to call it journalism innovation. The way the course is structured now, it's mostly about starting a business on your own. So they work primarily in groups. They take an idea and tease out the different aspects of the idea. It's a business model approach. We really want to make it useful to them not just if they're starting something on their own, but also teach them how they can be change agents in whatever organization they find themselves in.

It sounds like there are better prospects for journalism graduates in England than in the United States.
The instructors here have really good experience and really good contacts in the industry. The students here almost all do internships. The students in Iowa do internships too, but they're doing internships at the *Cedar Rapids Gazette*—not that it's not a great newspaper, but the students here are doing internships at the *Guardian*. They're in a media environment where they can do very well. Not to say that they all do. Apparently it used to be that their first job would be on the local level or the regional level and they would work their way up. Now they seem to be getting entry-level positions at some really nice places. We have a lot of international students here. We have a lot of students from all around Europe, from the Middle East, the Mediterranean, quite a few from Asia as well. They're going back to their home countries, where they're also able to get positions. A lot of them do wind up freelancing, but again they're freelancing in a place where there's a lot more demand for freelancers than in smaller places in America.

Do students come into the program with a lot of experience or a developed idea of what they'd like to do with the degree?
If you study journalism as an undergraduate in the U.K., it's a three-year program. It's entirely about journalism. To graduate from a university in the U.S., you have to have had science and math and language and literature and a gazillion other classes. Here, if you graduate with a degree in journalism, all you did at the university level was journalism. That might include journalism history, journalism law and some other things, but it's a very focused

program. At the master's level, all they do is journalism. This is a one-year program, just like the Columbia University program. They come out of here able to hit the ground running in journalism.

What kinds of skills do students need for today's journalism marketplace?

They need some business skills. Something we do in my class, we actually do a business plan. They all come up with ideas. They're pretty good ideas, but they think about what it's going cost to actually bring that idea to life. It's hard for them. All of them are low-balling their costs. They're not thinking about what it actually takes to do something. What kind of staff do you need, what kinds of skills do those staff people need? How much will it cost you to get those people? Do you need a lawyer? Do you need an accountant? Do you need a software programmer? How 'bout marketing? How are you going to find new customers? How are you going to get your customers to come to you? How are you going to get advertisers? What is your revenue stream, and how are you going to attract money—all those kinds of things journalists have never had to think of before.

Are there good examples of alternative journalism funding models that you can point students to?

The organizations that have found themselves doing well have really diversified their revenue streams and have thought about things that journalists never really thought about. The *Texas Tribune* gets some huge percentage of their revenue from events that they sponsor and host. Doing seminars. Journalists can become experts in something and consultants. So you're putting out your product but you may also be a consultant for other people who might want to do something similar or use those skills. Sponsorships, meetups. There's just all different sorts of things that journalists who go into entrepreneurial enterprises think about that are completely new to them. Traditional media organizations have advertisers, and they have people paying in one way or another for their product. We try to expose students to other ways they can generate revenue.

How is journalism education in the U.K. different from journalism education in the United States?

In general, journalism programs in England are journalism programs. They don't have PR. They don't have advertising. That is very separate. Most journalism programs in the States have large PR components, and/or advertising, but particularly PR. In fact that's what sustains a great many of them. Most of the students who wind up going through journalism programs in the States, in my experience at least, wind up going into PR. We argue—rightly—that there are many of the same skills, and you need to know how to do the same things, and you need to know how each other thinks. Less so here. The classes they take are converged in the sense that they get skills in different media forms. They graduate with a degree in broadcast or in newspapers, but

within that they get a lot of different stuff. In broadcast, they're required to take an online journalism class, they're required to take a journalism and society class, they're required to take law, entrepreneurial journalism, a public admin class. They get production, they get technique, they get reporting, they get multimedia.

What are some of the key skills you teach in your class?
It's absolutely vital that students are able to work with different people who have different strengths and different skills and that they be able to negotiate that—who's good at what and how you can take advantage of that. Someone in the group has to step up and do something that none of them think they know how to do. So they learn how to do that and they learn how to be competent at it. They also need to think realistically about the audience. They have to think about what need they can fill that isn't being filled by someone else.

Do you have an example?
Last week they did pitches to a little dragon's den. I brought in five experts on each day, and the students pitched. They each had five minutes to pitch and five minutes for feedback, so it was kind of real-life. Each day the judges gave them feedback and asked them questions. It went really well. We got together over lunch, and the judges picked a winner each day. On one day the judges picked the one group that had identified a target market. They had a nice idea to do a travel website, a travel product, targeted at people age 50 to 65—not themselves. The target audience was people who had some time and money. They had traveled before and were looking for a particular kind of somewhat upscale and interesting travel experience.

What did the judges think?
They thought: They've identified a market, they've identified a need for that market, because this doesn't really exist in the U.K. They figured out how they were going to make money on this. They had thought it through. It was a really valuable experience for them to think about someone who was not them—what they might want, what they might use, how they might satisfy that need that wasn't being filled that someone had. Whether you're doing that for the *Times* or you're doing it on your own for a startup and getting some funding in a way doesn't matter. You still have to think through those same things. If you're doing it for the *Times*, the *Times* wants to know how they're going to make money on it, who's the audience, how it's going to reach them, all those same kinds of things. It was really valuable for them to think through those things because otherwise they really don't.

What's different about teaching journalism today?
In journalism programs here and in the States, they're very focused on the content. That's what journalists have always been focused on. It's been all about the story. Entrepreneurial journalism forces them to think about the

audience. That is absolutely vital in a digital age. You can't just go through your journalistic career thinking about what's an interesting story to me and my peers in the newsroom, which is frankly what we all did. Essentially we wrote for ourselves and our editors. We had a monopoly market, and people were interested I guess because that was all they had. That's not the world anymore. You really have to think about who you're doing this for, why they want it, what they're either going to be willing to pay for or what someone will pay you to reach them, or whatever your funding model. You have to think through those things that journalists never had to think through before.

How do you teach entrepreneurial skills?

In one class session, we had someone come in and teach them how to pitch. They learned that selling an idea—whether it's selling it to your boss in the newsroom or selling it to a potential investor or selling it to your target audience—that's vital. You have to know how to do that. Journalists never had to know how to do that. You had to pitch your editor, but your editor was just like you. They looked at the world probably in a very similar way to you. Now you have to pitch and present it and convince someone who's not like you that it's something they want. You have to be outgoing, yes, but you also have to be outward thinking. The traditional journalist is outward thinking in that they think about the service they're providing the public or society, but that's such a nebulous concept. Now you really have to think about who wants this product and how you are going to get it to them and how you are going to convince them that they want it not just this minute, but tomorrow and down the road.

How do entrepreneurial journalists need to think differently?

Entrepreneurial journalism challenges journalists' traditional ways of thinking about themselves and what they do: "We don't get involved in money. We don't have much interaction with the audience." Social media have changed that somewhat. Do they really interact and engage with the audience? More than they used to, but still in pretty limited ways. But if you're going to be an entrepreneur, you have to think about your audience and you have to go out and talk with them. You have to talk with your advertisers. Your advertisers are your customers as well. You have to do all kinds of things that journalists have never had to do and they have quite explicitly thought that they do not do that. You have to learn to think of yourself as the person who goes out and deals with how you're going to make the money while you also maintain your integrity. You have to maintain your integrity because you have to convince everyone involved—advertisers, customers (whoever they may be), content suppliers—that you are a credible and trustworthy journalist as well.

WHERE ARE YOUR AUDIENCES?

As entrepreneurial journalists know, audiences are everywhere online. Social media provide a relatively quick and easy way to reach them and get nearly immediate feedback on user habits and attitudes. Each social media platform has its own special functions and user profiles.

Facebook

Despite periodic rumors of its impending demise, Facebook is still the biggest social network on the globe. It connects more than one billion users around the world.[1] Facebook users skew slightly female, a group that made up 58 percent of its subscribers as of late 2013. The largest share of those who consume news on Facebook are between 30 and 49 years old and have completed high school or less.[2]

Facebook is ubiquitous, not just as a personal space for individuals but as a commercial site for businesses. Facebook is so ubiquitous that customers and potential customers can be reasonably certain that they can find not just their

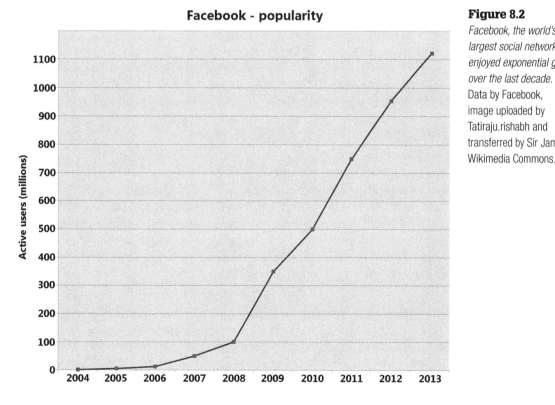

Figure 8.2

Facebook, the world's largest social network, has enjoyed exponential growth over the last decade. Data by Facebook, image uploaded by Tatiraju.rishabh and transferred by Sir James / Wikimedia Commons.

friends but their favorite companies on Facebook. Because so many people are on Facebook, the network's sheer size increases the likelihood of maximum exposure for their brand or message. However, Facebook's size can also make it more difficult to draw attention to messages without paying to "boost" a post or promote a page.

Facebook is a mature social media company. While Facebook's size and penetration makes it the most successful social media tool now used, its very ubiquitousness has also led to a decline in new users in recent years. Now that older people, companies, and brands of all kinds have Facebook accounts and pages, young people are less interested in using it. Like many older social media, Facebook is not growing at the rate it once was. Facebook may still be a good place for mainstream messages tailored for wide audiences.

Twitter

Now moving into its second decade, Twitter is strong (particularly in the United States) and still growing. It lacks the cachet of newer social media tools that young people like, and some communities (particularly visually oriented communities such as artists) have abandoned Twitter altogether for Instagram. Despite this, Twitter remains an effective broadcast tool for short messages that refer people to blogs and other media. Twitter use is evenly divided between the genders, and users are, on average, younger than Facebook users. While Twitter users tend to be younger, they are generally better educated. Forty percent of those who access news content on Twitter have a bachelor's degree or more.[3]

YouTube

YouTube is the most popular place on the Internet to find streaming video content. Almost ubiquitous for years now, it is a social media platform as well as a tool for sharing and streaming video. Google bought YouTube in 2006, and it is now integrated with other Google products including Google+ and the Chrome browser. A mobile application (app) makes it easy to access YouTube videos on the go. News consumers on YouTube skew slightly male at 57 percent. They are also younger and less educated. Most are 18 to 29 and have a high school education or less.[4]

LinkedIn

Since its beginning in 2002, LinkedIn has set itself apart as a professional social networking platform. Individuals and companies have a presence and identity on LinkedIn, which now boasts more than three million users. Half of the world's hiring now involves LinkedIn.[5] Also a mature platform, LinkedIn's professional orientation sets it apart. Maturity is not the issue for

LinkedIn that it is for other social media. Its professional orientation provides its niche. LinkedIn does not suffer from perceptions that it is less fresh and innovative than newer social media platforms. Its strength is in its professional credibility. Its comparatively early founding allowed LinkedIn to develop such a strong foothold in the professional realm that would be quite difficult for any other social media platform to closely replicate. Nearly twice as many men as women use LinkedIn to access news. It should come as no surprise that the average news consumer on LinkedIn is also older and more educated and earns more money. He is 30 to 49 years old and most likely has a bachelor's degree or more.[6]

Google+

Google is now a ubiquitous name in the daily lives of those in the developed world. Between Google mail (Gmail), Google maps, and the ubiquitous Google search engine, Google has made significant inroads into our daily lives. Google+ has been slow to build strong membership, but its system of allowing users to group their connections in circles that define the nature of the association ensures deeper connections among users. In other words, connections on Google+ are likely to be more deliberate and meaningful than connections on Facebook or other social networking platforms. Google+ has more than 540 million active users, with 25-to-35-year-olds the most active.[7] Nearly equal numbers of men and women access Google+ for news, but those who do tend not to be as well educated as those who use Twitter. The average news consumer on Google+ has a high school diploma or less.

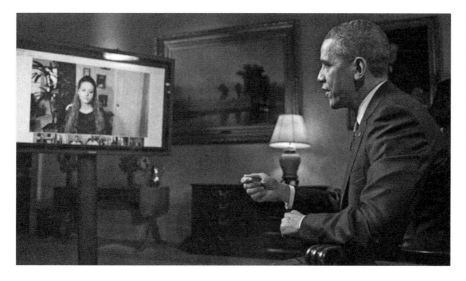

Figure 8.3
President Barack Obama used Google+ to participate in the first ever completely digital interview from the White House after his State of the Union address in January 2012. White House photo.

Instagram

A mobile app for forging visual connections, Instagram has more than twenty million users.[8] Specifically designed to allow users to share photos and videos immediately from their smartphones (but not from the Web), Instagram is almost exclusively mobile. Text is used only to accompany and explain images, although its unlimited character count gives it a competitive advantage over Twitter with its famous 140-character limit per tweet. Instagram, like Twitter, uses hashtags (#) to organize keyword searches within the platform.

Pinterest

Pinterest is small compared to its social media competitors, with more than twenty million users and growing. Given Pinterest's strongly female orientation (about 83 percent of its users are female), it is more focused than the other networks. Pinterest users "pin," or mark and save to their Pinterest profile pages, pictures that describe their personal or professional interests. The most popular Pinterest subject matter includes traditionally female-skewing topics such as fashion, health, crafts, cooking, and interior design.[9] Its highly targeted subject matter makes Pinterest a very good fit for a limited number of products and brand messages.

Reddit

Reddit calls itself "the front page of the Internet." The platform has a large dedicated subscriber base that posts original content and links to published news stories while responding to each other's posts. Social media tools allow members of the community to either increase or decrease each post's prominence in the community as items with a lot of "upvotes" move toward the top of the site's first page. Although there are no official gatekeepers determining the position of news stories on the site based on their individual merit, the community itself determines the value of each story. Clearly, the Reddit community is highly engaged. It should come as no surprise that 62 percent of them get their news from the platform.[10]

SPREADING THE NEWS ONLINE

When it comes to distributing news content, not all social media sites are equal. To those used to getting news through traditional channels—newspapers and local news broadcasts on television and radio—this may seem a strange metric to examine. After all, a social media site is for socializing, isn't it? Not anymore. In fact, for years many people have relied on social media as their primary source of news and information. Although it may raise some

concern, journalism faculty are no longer surprised when their students—most of them journalism majors—claim to get all their news from Facebook or YouTube. According to the Pew Research Center, half of Facebook and Twitter users get their news from those platforms. Additionally, 78 percent of Facebook users are exposed to news content when they log onto the site for other reasons, and 22 percent of Facebook users report that the site is a good place to get news.[11]

What does this mean to entrepreneurial journalists? The most basic lesson is an important one: Not all social media use the same technology to spread the same messages in the same way to the same people. Rather, each social media site (and we discuss only the largest ones here) has its own special uses, its own target demographics, its own way of reaching various demographics, and varying success levels for everything they do, as measured by different expectations and metrics. The way we use the term "social media" as if it is all one thing, is misleading. Using social media is not as simple as tweeting or posting to Facebook. Knowing how to most efficiently and effectively use the various social media platforms in coordination with each other is one of the key skills entrepreneurial journalists need today and will need in the future.

Let's say you have just finished the first installment of a news series for an online magazine or your blog. How do you get the word out to your current followers and possible new followers in a way that might bring them to your site to read, comment, like, share, retweet or reblog? While you could (and many do) promote the publication widely across multiple social media sites at once, the same message may not always work the same way for the different platforms and the audiences on each.

Let's consider a few general guidelines for determining our audiences and who we need our campaigns to reach. Remember that not all campaigns work equally well on social media. Although social media sites (particularly Facebook) are now almost ubiquitous worldwide, keep in mind that not all networks are popular in all parts of the world. Although Facebook is far and away the most popular platform anywhere, the second most popular social media platform worldwide is QZone, with 644 million active users as of June 2014.[12] Virtually unheard of in the West, QZone is a highly popular platform for blogging and sharing content in China. Among the world's largest online communities, only a handful are known in the United States. That doesn't mean that to be relevant online you need to blog in China or in Russia. But it does mean that if you are using only one or two favorite social networks (that are not Facebook), you are missing out on a very large share of those online worldwide. It is not enough to simply tweet.

In journalism's pre-Internet days, there were several international newspapers (the *Wall Street Journal*, the *Financial Times*), and several national newspapers

(the *New York Times, USA Today*), but most newspapers served a local or regional subscriber base. Even today, there are many regional newspapers that are maintaining strong circulation and sustaining themselves financially because they reach a small, specific readership. What is relevant to the audience of a community newspaper will not be relevant to many people outside the community.

It may not be a goal of the paper to distribute its stories to other states or countries. It may only wish to serve its home county. Internet metrics have led most of us to believe, by default, that bigger is always better. Although most journalists like to see their work travel far, and feel a little jolt of excitement when analytics data show that a story they wrote was read by someone on the other side of the globe, simply getting your message out to as many people as possible is far less important than getting your message to the right people, your target audience.

TARGETING THE MESSAGE TO THE AUDIENCE

Who you want to reach determines the best way to reach them. Once you know your target audience, you will want to think about their online habits and how you can best get your message to them in a way that they find valuable and not obtrusive. It is not an exact science, and it is constantly evolving. People's needs, interests, and moods change by the day and the hour. However, there are some general guidelines that hold true for most online campaigns.

Timing

If your target audience is in the West, you will have to consider weekends in your plan. Traditional print and broadcast news have long taken weekends into account. It is the same for public relations practitioners, who have always advised their clients to break bad news on Friday afternoon, when any stories journalists wrote about it got buried in little-read Saturday newspaper editions. Weekends have always been a slow time for news, and it's not hard to understand why. People in Western countries just aren't as interested in following the news on their days off. Aside from breaking news and weekend stories, major reports should wait for a weekday release if at all possible. Although some reporters blog and tweet over the weekend, many don't, and they don't miss out on many opportunities because of it.

Similar issues arise when determining the time of day to distribute a story. For many office workers in the West, the day begins at 9 a.m. with necessary office tasks or morning rituals such as making or picking up coffee or talking with colleagues. Especially on Monday mornings, when there may be a pile

of work to sift through from email sent and voicemail left over the weekend, there may not be time to open an unsolicited email until 10:30 or 11 a.m. Bloggers need to be particularly mindful of the time of day they post new content and let their followers know when to look for it. Key to growing readership for general interest blogs is consistency and posting daily updates to keep readers coming back. Those with more personality-driven blogs would be wise to post early each weekday before their readers get to their desks. If followers can be certain there will be a new post waiting for them when they first sit down at their desk, they will keep coming back for new content each morning as part of a daily ritual.

For news and more general campaigns that are not announced daily, it might be best to avoid Mondays and Fridays, as new work may have been piling up since the end of office hours Friday, and may not leave much time for anything but catching up on Monday. Some social media strategists say that Tuesday is the best day to launch a new campaign, as the madness of Monday is over and the weekend is still far off. In the West, Friday afternoons are also bad times to send messages, as the excitement of the coming weekend shifts the focus from working. The only solid exception to this rule involves messages related to entertainment or weekend activities.

Medium

What kind of media will you use to reach your target audiences? Much of this also depends on the time of day and who you are trying to reach. Although most office workers still use desktop or laptop computers, an increasing number of people everywhere use mobile devices (including tablets such as iPads) as their main computer. Understanding the habits and preferences of your target audiences will go a long way toward winning them over. These days people form extremely quick perceptions of other people and companies based on the way they use technology. If you use the wrong tools to communicate with your core audiences, you send an unconscious message to them that you either aren't that bright or don't care enough to learn about them.

What media types are best for which audiences?

Before you sit down to craft a message to a target audience, try your best to determine what these people are like. While there are exceptions everywhere and trends are a moving target, in general, as younger groups adopt newer technology, older groups continue to use older technology for some time until they too abandon it for newer tools. Because it is built into the communication systems of many offices, email is easy to track, and it leaves an electronic record that can improve clarity and reduce mistakes when sending campaigns. Since it can be used to send large attachments, and character counts are unlimited, email also remains a favorite communication tool in

offices and among older people who may be used to writing letters and communicating in other asynchronous ways.

Office workers in their thirties and forties may prefer to communicate via Facebook, a favorite tool for their age group. However, like younger workers, they may also frequently communicate via text message. Generally speaking, younger people favor real-time synchronous communication tools such as mobile apps that geolocate their friends while sharing their own location with others in their networks. Unlike older people who may find these tools invasive, younger people who grew up online are more accustomed to sharing personal information—including their location or the location of the photos they share through mobile applications such as Instagram—via their mobile devices. Screen size also dictates the appropriate length and size of the message or media shared. As a rule, the more synchronous and mobile the tool, the shorter, quicker, and more focused the message must be.

Although the following classifications are neither perfect nor complete, they can guide your thinking about what media types are the best fit for various audiences. The main differences among these very broad categories mostly reflect two major ongoing trends in information consumption: (1) the shift toward synchronous technology, and (2) the move to mobile technology.

Communication Tools: Moving from Asynchronous and Fixed to Synchronous and Mobile

Table 8.1 Asynchronous and Fixed

Technology	Key Users
• Email	• Retirees
• Text-based blogs	• Full-time office workers who are mid-career or nearing retirement
• Facebook	

Table 8.2 Asynchronous and Mobile

Technology	Key Users
• Email	• 25-to-45-year-olds
• Facebook	• Full-time office workers
• Other social networks (e.g., Instagram, Pinterest)	
• Twitter	
• Text messages	

Table 8.3 Synchronous and Fixed

Technology	Key Users
• Twitter (browser-based)	• Businesses (Twitter)
• Skype (browser-based)	• Retirees, deployed military (Skype)
• Chat (Gchat, Facebook chat, Google hangout)	• 25-to-45-year-olds, full-time office workers (chat)

Table 8.4 Synchronous and Mobile

Technology	Key Users
• Chat (Gchat, Facebook chat, Google hangout)	• Those 24 or younger
• FaceTime	• Students
• Snapchat	
• GPS-based mobile apps	

CITIZEN JOURNALISM ON SOCIAL MEDIA

It doesn't take much more than a glance at social media these days to see that the users themselves are actively engaged in creating and distributing original content. This has created some marketplace confusion while forcing entrepreneurial journalists to work harder to differentiate their work from that of the many untrained users of social media who aspire to do the work of journalists. For veteran users of social media who are not journalists, the idea of sharing content is nothing new. It is a normal part of their daily lives and usually not intended to challenge the work of professional and entrepreneurial journalists. In a 2014 study the Pew Research Center found that 50 percent of those on social networks said they had "[s]hared or reposted news, stories, images or videos." Just shy of that, 46 percent said they had "[d]iscussed a news story or event." Another 14 percent had "[p]osted photos they took of a news event." And 12 percent had posted videos they had shot of a news event.[13] Clearly, a lot of citizens are now doing journalism. It is a trend with which entrepreneurial journalists must be acutely aware as they attempt to differentiate themselves as professionals in the news marketplace.

SUMMARY

An entrepreneurial journalist, like any other kind of journalist today, must always keep in mind her audience. Increasingly these days, journalists serve various employers or clients, which are among the audiences for their work.

Journalists do not have to work in newsrooms forty—or sixty or eighty—hours a week or work for others. Many now work for clients out of home offices or even libraries or coffee shops. Thanks to new tools and technology, entrepreneurial journalists can work anywhere—and they *are* everywhere, just like their clients and audiences.

No matter how strong your content is, it will mean nothing if your audiences don't see it. Today's consumers of news and information are increasingly mobile. They are connected, and they are everywhere. It is the journalist's job to find these audiences and reach them where they are.

With the sheer number of choices news consumers now enjoy, there is little reason for them to come to you for news and information. Rather, the entrepreneurial journalist must provide valuable, relevant content that can be of real use to the consumer, and she must make it widely known to current and potential readers and followers where this information is and why it is worth the news consumer's time to seek it out.

It is as essential to understand the content you are providing your audiences as it is to understand the actual and potential consumers of your content. While it is true that your content means nothing if no one sees it, it is also true that your content means nothing if it is not relevant to your assumed target audience. In other words, your content is only as good as its consumers deem it. In the new news business, the consumer is king.

Not all online communities are the same, and neither are your audiences. That's why it's essential to understand the basic demographics and news consumption habits of your target audiences before deciding which combination of social media you will use to reach, connect to, then interact with them.

There are several highly developed social media sites through which entrepreneurial journalists and others now distribute their work. Not all platforms are the same, and none are equally valuable when it comes to distributing relevant content to those who want or need it. While Facebook is ubiquitous, many of the world's largest online communities are virtually unknown in the West. China and Russia are home to some of the world's largest social networks.

Understanding the typical user profile and behavior of those using particular social media tools should help entrepreneurial journalists target their messages in more meaningful ways. It can also help save time and resources by helping journalists create more efficient and effective campaigns.

Significant numbers of those on social media use these sites to access news. Users' interests and levels of engagement differ from platform to platform, but users of each explain that exploring news content is at least one of their activities while on the site.

When it comes time to share messages with online communities, there are no set rules or expectations. However, there are basic guidelines regarding timing, media type, and even length that should be followed by journalists who hope to maximize the effectiveness of their campaigns.

Increasingly, thanks to the ease of access to digital recording media, individuals are recording and reporting on news events, as well as providing commentary and discussion. This is a concern for trained journalists who must work harder to prove the value of their contributions to actual and potential audiences.

JOURNALIST'S TOOLKIT

Among the significant new challenges for entrepreneurial journalists are identifying and reaching their target audiences, many of which belong to one or more online communities. Each of these social networks has its own profile and characteristics, as well as its own way of engaging and interacting with members. Getting the right message to the most appropriate groups using these media is an essential skill set for all journalists.

Skills

Demographic research

Social media mastery.

Tools

Desktop or laptop computer

Internet-connected mobile device

Browser-based applications.

Sites

Facebook.com: The ubiquitous social network.

Instagram.com: Website of the popular photo sharing app.

LinkedIn.com: The best-known professional networking site in the United States.

Pinterest.com: Website of the female-skewing app for sharing design and ideas.

Plus.google.com: Website of Google+.

Reddit.com: Home page of the content sharing social network.

Twitter.com: Website of the popular microblogging app.

YouTube.com: Home page of the video sharing site.

Application

1. Create a survey for users of one social network to which you belong, asking users to whom you are connected about where they get their news, including social media sites. Use the appropriate combination of social media to report and publicize the results.
2. Create an information graphic comparing the news consumption habits and interests of your connections on social media. Use the appropriate combination of social media to distribute your information graphic.
3. Compare a social networking site that belongs to an established journalist to a site on the same platform that belongs to an untrained citizen journalist. Note the similarities and differences. Describe any differences in credibility between the two sites.
4. Create a professional social media site for distributing news and information. Share the link with your professor and your classmates for feedback and critique.

Review Questions

1. Why does it matter whether a social media account disseminating news belongs to a trained journalist or an untrained citizen journalist?
2. How could you develop a demographic profile of an audience, and why would you do it?
3. How do you define your audience and then reach them?
4. Describe some of the trends regarding the use of social media among different demographic groups.
5. How should an entrepreneurial journalist determine the appropriate mix of social media to use—and in what combination—to disseminate and promote their stories?

REFERENCES

1. "Social Media Comparison Infographic," *Leverage New Age Media*, https://leveragenewagemedia.com/blog/social-media-infographic/?randomParam=1409210430874.
2. Matsa, Katerina Eva, and Mitchell, Amy. "8 Key Takeaways about Social Media and News," *Pew Research Center's Journalism Project*, March 26, 2014, http://www.journalism.org/2014/03/26/8-key-takeaways-about-social-media-and-news/.
3. Ibid.
4. Ibid.
5. "Social Media Comparison Infographic," *Leverage New Age Media*, https://leveragenewagemedia.com/blog/social-media-infographic/?randomParam=1409210430874.
6. Matsa, Katerina Eva, and Mitchell, Amy. "8 Key Takeaways about Social Media and News," *Pew Research Center's Journalism Project*, March 26, 2014, http://www.journalism.org/2014/03/26/8-key-takeaways-about-social-media-and-news/.
7. "Social Media Comparison Infographic," *Leverage New Age Media*, https://

leveragenewagemedia.com/blog/social-media-infographic/?randomPar am=1409210430874.

8. Ibid.

9. Ibid.

10. Matsa, Katerina Eva, and Mitchell, Amy. "8 Key Takeaways about Social Media and News," *Pew Research Center's Journalism Project*, March 26, 2014, http://www. journalism.org/2014/03/26/8-key-takeaways-about-social-media-and-news/.

11. Ibid.

12. "Social Networks: Global Sites Ranked by Users 2014," *Statista.com*, http://www. statista.com/statistics/272014/global-social-networks-ranked-by-number-of-users/.

13. Matsa, Katerina Eva, and Mitchell, Amy. "8 Key Takeaways about Social Media and News," *Pew Research Center's Journalism Project*, March 26, 2014, http://www. journalism.org/2014/03/26/8-key-takeaways-about-social-media-and-news/.

Content and Distribution

In the midst of so much discussion of research and metrics, let's not lose sight of the real reason why journalists enter the field in the first place: to create and distribute news, information, and stories. It is also important to remember that simply having an online presence is no longer enough. Entrepreneurial journalists not only need something to say, but they also need to determine the right way to say it depending on who and where their audience may be.

The big questions this chapter addresses are: (1) What is your content? (2) Who is it for? and (3) How will you present it? As a journalist today, there are almost limitless kinds of content you can provide your readers, viewers or listeners. You may already have an idea of what you may want to do—and you may already be doing it. Here we explore a few solid strategies to consider.

CREATE AN ENGAGING WEBSITE AS YOUR ONLINE HEADQUARTERS

One of the first things you need to develop an online brand is a website. In fact, anyone who does business online needs a professional website. Fortunately for entrepreneurial journalists, it is easier and less expensive than ever to build a professional website. Although you can hire a professional Web developer to create a site for you or your business, anyone with basic online skills can easily build their own website these days. While it's not the only alternative for creating high-quality free websites, WordPress is the world's most popular software for blogging and online creation. It's easy to use WordPress.com to build a basic website using an attractive template. There are hundreds of themes—or templates—available for your website, and many of them are free. But before you choose a theme, you'll want to choose a name, or URL, to identify your site. Keep in mind that WordPress.com sites (they call them "blogs") are hosted on

a WordPress server and you will not have access to the "back end" coding that determines how the site behaves. However, the options provided by most themes offer enough design flexibility for most. When you register for a free WordPress.com account and create your first blog, the URL will look like this: yourname.wordpress.com. Since that URL is clunky and not very memorable, you may want to customize your WordPress.com blog with your own URL. This is fairly simple and inexpensive to do. The process is called "domain mapping," and WordPress.com offers it as an upgrade for a small annual fee. Keep in mind that you can use only a domain that is available. That may require several searches for an available URL, especially if you want a .com domain.

You can buy your domain directly from WordPress.com, or from a domain (URL) registration and hosting company such as GoDaddy (godaddy.com), Register (register.com), or Network Solutions (networksolutions.com). On any of these sites, you can search until you find an acceptable domain that is available. Although companies will not usually admit to registering domain names that people search for, that has happened in the past, so if you see that a domain that you are interested in is available, you will want to purchase it quickly. If you purchase your domain from WordPress.com, it will replace the default WordPress domain for your blog. If you purchase your domain from another company, you merely need to direct visitors to your blog to WordPress servers. This, which happens behind the scenes, is called updating your name servers, and you can do it by logging into your account with your domain registrar, and typing in WordPress' server names (currently NS1. WORDPRESS.COM, NS2.WORDPRESS.COM, and NS3.WORDPRESS.COM). WordPress.com support (en.support.wordpress.com) provides step-by-step directions for domain mapping and pretty much anything else you may want to do with a blog.

Anytime before or after you map a domain to your WordPress.com site, you need to select a theme (or a template) to create its overall design. At theme.wordpress.com, you can search all available themes. You can filter your search by main theme colors, layouts, subjects or styles. Premium themes require a one-time fee that is usually less than $100. You can preview and change themes as often as you like, but keep in mind that changing premium themes can get expensive, and a coherent brand will be difficult to establish if you change your website's theme frequently. So take your time and pick a theme that will work for you for at least a year or two. Some things to keep in mind as you select your theme include how much space you need for text, whether you need space for videos, and how large you want your photos and other images to run. If you are a photographer and have compelling, high-quality images to feature on your home page, choose a theme with space for a large featured image.

But if you don't have access to compelling images that will look great large, do not select a theme that relies on large, dramatic images. Preview the theme before you buy it, but keep in mind the preview may not display properly if the text and images on your current site don't match the new theme's specs. (WordPress.com currently allows users to request a refund for a premium theme within thirty days of purchase.) You will want to set your site (or blog) to "private" in the Settings > Reading menu until you are finished building it out. WordPress.com has an excellent community-based support site and easily searchable information on building websites and blogs. New users can start at the support home page (en.support.wordpress.com), where online tutorials and videos provide step-by-step guidance on creating and updating sites.

WORDPRESS ANALYTICS

Unlike in the days of traditional print journalism when publications had to hire auditors to determine their readership and reach, now these analytical tools are available to everyone who manages or maintains a blog or website. How much information you can get depends on how you run your site and how much access you have to the code that creates the infrastructure for your site. For example, if you have a WordPress.com site, you will have access to some basic analytics through WordPress, but because WordPress hosts the site instead of you, you will not be able to take advantage of more robust tools like Google Analytics.

WordPress has long been the gold standard for blogging and Web design platforms. Most of the world's websites run WordPress software. It is an intuitive, robust tool for creating all kinds of online sites and pages. WordPress software is free and open source, and it is available in two forms: WordPress.com and WordPress.org.

WordPress.com is the basic, free WordPress-hosted platform that anyone can use after opening a WordPress.com account and selecting a theme that will determine the site's appearance. WordPress.org, on the other hand, is free software that you can use to create websites and blogs independent of the WordPress servers. WordPress.org requires you to find paid hosting and server space, and allows full access to the code that runs the site. Those with Word-Press.com sites can buy customization packages that allow for some changes in site appearance or functionality but do not allow full access to the site's code. To set up Google Analytics to measure traffic to and within your site, site administrators need to type in code that is available only in WordPress.org. For more on the difference between WordPress.com and WordPress.org, go to en.support.wordpress.com/com-vs-org/.

BLOGGING

The explosion of microblogging platforms in recent years has somewhat diminished the enthusiasm and excitement that once surrounded general interest or personality-driven blogging. With fewer people interested in reading long-form stories on desktop or laptop computers and ever greater numbers of people interested in getting quick updates on their mobile devices, it has become increasingly difficult to draw people to general interest or informational news blogs. While in the early days of blogging, individuals with some technology skills and an engaging personality drew much attention, the general public has by this point been exposed to so many personalities online that it is nearly impossible to break out as a new online talent without a special niche that differentiates what you do.

In Chapter 1, Scott Lewis, CEO of *Voice of San Diego* investigative news site, underscored the importance of entrepreneurial journalists today—regardless of where they post their work—having a niche or a specialty that sets them apart and defines them as an expert in a particular subject matter or area of expertise. These days bloggers without a specific niche or brand may be able to grow a modest following, but will most likely find themselves lost among countless other personality-driven or opinion bloggers without a singular identity.

Figure 9.1

Jessica Lee Rose as Bree, a.k.a. lonelygirl15, in a screen capture from her July 22, 2006, video "My Lazy Eye (and P. Monkey gets Funky!)." Image by Lonelygirl15 Studios.

The Lesson of Lonelygirl15

Think back, if you can, to 2006. Although it wasn't all that long ago chronologically, it was still a very early time for user-produced content online. When lonelygirl15 videos began showing up on YouTube in 2006, not many individuals had the tools and skills to create watchable online content.

Lonelygirl15 was the user name of the show's main character, Bree, supposedly a 16-year-old Los Angeles girl (played by 19-year-old Jessica Rose). The first installments of her video blog were about the details of her daily life. Audiences were intrigued by the intimacy of the venue: Bree spoke to them about her personal struggles, face-to-face, from a webcam in her bedroom. Not only was an attractive young woman supposedly sharing the secrets of her daily life with anyone willing to navigate to

YouTube, but she was a real person with common interests (many of them nerdy) and problems who would respond to their messages on MySpace.

Lonelygirl15 fans were happy to go along with the illusion until late 2006, when the entertainment media gathered enough evidence that the video blog was in fact an elaborate teaser campaign for a Web series that evolved into a multi-layered narrative about an occult group's pursuit of a group of Los Angeles teens. The series continued for two years after the hoax was revealed, although it was never able to generate as much buzz as the early lonelygirl15 videos. At the time, media experts and reporters believed the lonelygirl15 experiment would lead to similar campaigns that would generate publicity and buzz for other projects that appeared to be grassroots but that in actuality were backed by big Hollywood names. Lonelygirl15's email originated from an IP address at the Creative Artists Agency, which represented the team involved in the project.

At the time it seemed possible that this would open the door to more interactive Web-based projects that would draw followers who had initially been tricked into thinking that they were interacting with real people instead of actors. While there have been countless Web-based hoaxes in the last decade or so, it seems the public has for the most part learned their lonelygirl15 lesson. As the skills and tools required to produce Web-based content have become much more accessible, the process of producing video blogs and similar multimedia content has been largely demystified in recent years, and most consumers of online media are now too sophisticated to be drawn into dubious campaigns. There's a good reason why entrepreneurial journalists no longer turn to video diaries to connect with their audiences.

PHOTO SHARING

Since the rise of Instagram several years ago made it easy for amateurs to share attractive photos that were optimized for social media, professionals have faced strong competition from amateurs as well as other pros. The high-quality photos most smartphones and other mobile devices can now produce have largely leveled the playing field for all shooters. Professionals now face a unique challenge in trying to distinguish themselves from the pack. How can entrepreneurial journalists produce higher-quality images than amateurs who now have the same tools they do? Here are a few tips:

1. Frame your photos well. Take your time to make sure that everything you want in the frame is there, that heads aren't cut off, that trees and lamps aren't growing out of people's heads. Consider the foreground and the background. Remember that viewers with fresh eyes will

Figure 9.2

This image illustrates the "rule of thirds," in which the main focus is about one-third of the distance from the closest edge. Photo of Mary Barstow's model train layout by Sara Kelly.

see everything in the frame—even what's in the background. And collectively, viewers don't miss much. Among the evidence that helped prove lonelygirl15 was a hoax was the presence of suspicious items in Bree's bedroom behind her.

2. Remember the rule of thirds. This guideline for framing photos attempts to avoid the boredom of centered images by dividing the frame into a nine-square tic-tac-toe board. To create more drama, energy, and elegance, the photographer, writer or editor should ensure that the main image is roughly aligned along one of these lines, with about one-third of the frame occupying the space between the image and the closest edge, and (particularly if the subject is a human or animal) facing toward the negative space that occupies roughly two-thirds of the frame between the main image and the farthest edge.

3. Use adequate lighting. While the background can be shaded, it is essential that the main image in the frame is well lit and visible. You don't need a professional lighting kit, but it is a good idea to invest in two or three inexpensive portable shop lights on stands from your local hardware store. If you don't want to invest in additional lighting, you can also use available light. Indoors, bright lamps without their shades may be sufficient. Professionals use three-point lighting to ensure that the subject of a photo is well lit from all angles with no

harsh shadows on the face. In three-point lighting, one main light, called the key light because it is the brightest light, points toward the subject at an angle from one side. Another light, the fill light, illuminates the side of the face that the key light left in shadows. It is usually less bright and positioned slightly lower than the key light. A third light, sometimes called a hair light or a back light, illuminates the subject from the back, sometimes creating a halo effect. For outdoor shoots, natural light is almost always preferable to staged lighting. Daytime shots outdoors are usually bright enough (often they are too bright and require subjects to move to shadier areas or away from direct sunlight), and most contemporary digital cameras will automatically adjust brightness levels. Under most conditions, cameras on smartphones and other mobile devices will produce images of adequate quality for the Web. However, if lighting, colors or contrast are extreme, a DSLR camera may be necessary to produce high-quality images. Keep in mind that when the sun is bright, the more interesting shot may result from shooting into the sun. In the days before digital photography, photographers were often cautioned against shooting into the sun to avoid shooting an image in which the subject would appear as a darkened silhouette. But digital photography is more

#3 Back Light

Standard
Three-Point
Lighting

Figure 9.3

A demonstration of three-point lighting.

Object

#1 Key Light

#2 Fill Light

forgiving, and often with careful positioning, the sun or other light source can create a halo or a dramatic sunburst around the subject. Many smartphones now also allow users to avoid capturing silhouetted images by illuminating a backlit figure with the tap of a finger.

PODCASTING

Although audio blogging has existed for decades, "podcasting" became a popular term in the first years of the new millennium, shortly after the iPod was first developed, popularizing portable media. In the early years of podcasting, some predicted the medium wouldn't last. In those days, before cars were routinely built to accommodate iPods and smartphones, podcasts were mostly informational and blog-like. They were conceived as audio blogs. As text-based blogs began losing ground to microblogs and other shorter forms, attention spans also began to shorten for audio content. At around the same time, as media prognosticators began to ring the death knell for podcasting, noting that no one was interested in hearing someone else talk for an extended period of time, the media began to change. Fewer podcasts followed the blogging model in which an individual may discuss one or two topics for several minutes to an hour or more.

In keeping with the convergence of all other media, podcasting morphed into more of an audio alternative to broadcast radio. By the middle of the first decade of the new millennium, people were already familiar with satellite radio and other ways of receiving radio-like content. Once Apple made it easier to subscribe to podcasts, and automobile manufacturers began equipping vehicles with ports and outlets for iPods and other mobile devices, interest in podcasting was renewed. This time, instead of thinking of podcasts as audio blogs, podcasters and podcast subscribers simply started thinking of them as another way to distribute and consume media. Instead of expecting people to listen to one person hold forth on whatever topic interested them, podcasters began directing their recordings as if they were radio shows. Many shows began to feature more than one personality, and the medium became more conversational and engaging than the one-way content of the old days. Entrepreneurial journalists and other professionals took advantage of the low cost and portability of the format to create entertainment and educational programming as well as talk shows that resembled those on broadcast radio. For listeners, podcasts proved a favorable alternative to radio because they were available on demand and without so many advertisements. And the overhead costs were minimal.

There are now many highly professional podcasts that are recorded in dedicated studios (or home garages) and utilize high-end production equipment,

including studio microphones. But podcasts of an acceptable quality can now be produced using Web-based software such as Skype and limited equipment such as USB headsets or microphones. Many podcasts today are recorded using available equipment, then edited using Apple's GarageBand or the free open-source audio editor Audacity.

POST EFFICIENTLY

There is an old blogging rule that says you must post fresh content daily to keep readers visiting your site. If fresh content isn't available, they'll stop coming back. Something similar could be said about social media, except posting only daily may not be enough. During the work week, entrepreneurial journalists take every opportunity possible to reach their audiences and add value to their brands by delivering relevant content to those who need and want it. Since not all of your audiences may be users of each platform and not all platforms work the same way, you may not want to customize your messages for distribution to different networks. Even so, it may save time and work to view and update your social media accounts and to distribute content to each from one location. Hootsuite (hootsuite.com) is a social media dashboard that allows you to access your Twitter, Facebook, LinkedIn, Google+, Foursquare, WordPress, and Mixi account through a single site. (Mixi is a popular social network in Japan.)

CROSS-PROMOTE THROUGH SOCIAL MEDIA

Just because you build a professional blog does not mean your audiences will be able to find it easily. Although liberally tagging (with searchable words and phrases) and providing metadata for your posts will certainly help, driving traffic to your site or blog is largely a job for social media. In addition to your website, you will want to have related accounts on Twitter and Facebook, and possibly Instagram, Pinterest, YouTube, Vimeo, and other social media platforms. While these sites may stand alone, they can expand the reach of your brand by introducing it to new audiences and reinforcing it among existing audiences. Although different themes offer different options, most WordPress.com sites allow users to connect their social media accounts right on the home page. Allowing website visitors multiple ways to interact with your content helps improve traffic across all your accounts. Since social media are designed to maximize connections among users, they are ideal for growing audiences and engaging them with your content. For instance, every time you post a new blog entry, you should use sharing tools to maximize the reach of your content. WordPress.com has built-in sharing resources,

including ways of embedding Twitter, Instagram, and Facebook posts on your site as well as ways of publicizing your posts as you create them. Using the "Publicize" tool, you can connect your WordPress.com site with your Facebook, Twitter, Tumblr, Google+, LinkedIn or Pinterest accounts to simultaneously publish your blog posts on multiple sites. Publicize is a quick, efficient tool for many, though users should test out how it works on various sites before deciding to use them consistently. Users may not like the default messages that will appear with the post on other sites. Default messages can be edited, but since some knowledge of HTML code is required to change them, some may prefer to simply post their own messages to Twitter or Facebook that publicize their posts in exactly the way they would like to see them appear.

Microblogging: Twitter, Instagram, Pinterest, Tumblr, Status Updates

Microblogging is one of the most basic ways to contribute to the online conversation today. So many people are microblogging now, and very few of them are professional journalists. Clearly, one doesn't need to be a pro to open a Twitter account. Microblogging is for everyone. Like many online and mobile tools today, it is democratic, and that's why it's so popular. For many people, sharing status updates with friends and followers is enough. For journalists and others who want to attract a following beyond just friends and family, there is the matter of value to consider. Unless you have built a strong personal brand and an online identity that those outside your usual circles will be attracted to and will want to follow, you can be sure that no one wants to know the details of your day—what you are eating, where you are going, that you're doing laundry. For professionals, microblogging is a marketing tool and a way to drive traffic to your sites. While microblogging isn't quite enough for most entrepreneurial journalists to build a career, it is a good way for them to publicize their work and maximize the number of people who see it. It is also good for reinforcing branding and, if used correctly, creating additional value for audiences.

Instagram and Pinterest are easiest to discuss because they are visual tools. Photographers, artists, and anyone working in a visual medium should consider opening an Instagram account. The mobile app allows for easy manipulation and sharing of snapshots from a cell phone, though it is not convenient for sharing images captured with anything other than an Internet-enabled mobile device. Pinterest is ideal for those who follow design and other visual and practical fields, including fashion and interior design, but do not necessarily create the images themselves (although some who make or design things may want to post original images).

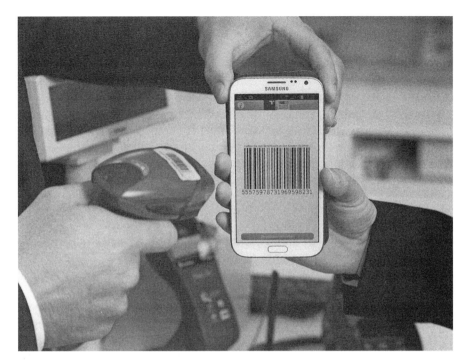

Figure 9.4
Mobile media make the world go 'round faster every day. Photo by Richard Tanzer Fotographie / Wikimedia Commons.

Twitter is a little different. While you can use Twitter to tweet images, it is primarily a text tool. With its famous limit of 140 characters (minus room for your photo link), Twitter is a known entity that is still popular but is declining in interest among some users of social media as newer tools (namely Instagram) offer greater character counts and better image editing tools.

Tumblr is somewhat of a hybrid microblog that allows short posts and relies heavily on multimedia. It is also highly interactive, encouraging bloggers to link to and follow each other's blogs. Although some companies and organizations use Tumblr, it is best known as a personal blogging platform. Status updates on Facebook are another way to provide short-form content to followers instantaneously.

MAKE IT MOBILE

If you're using social media, much of your audience is getting your content on their mobile devices. Instagram, Twitter, Pinterest, and even Facebook (along with pretty much every other social media platform) are now heavily mobile. Although Instagram can be accessed through a regular Web browser, users can post only via a mobile application, or app. But maybe you want to

go a step further and create your own app to carry your brand and do something different from what social media apps do.

The first thing you need to consider before deciding how to develop your app is what you want it to do, and whether that is something that can't be done using existing mobile apps. Once you decide you do want to develop your own app, your next decision will be what kind of app to develop. The question has become easier in recent years as native apps, developed for specific mobile devices, have lost ground to Web-based apps, which, as their name suggests, are more platform agnostic. Developing Web apps, like developing websites, has become much easier in recent years thanks to Web-based tools. Although there are now many template-based free app developers available online, Como (como.com) is one of the easiest ones. Like most online Web development tools, Como offers free and paid accounts. Free accounts allow users a limited number of downloads and mobile site visits a month and do not include the submission of your app to Apple's App Store, Google Play or Amazon's app store.

Browsing Como's app gallery is a good way to get ideas for your app. There you'll find templates, much like website themes, that you can adapt to fit your own needs. Although most templates (and most mobile apps for that matter) are a better fit for business than journalism or even professional communication, a basic design could provide users with a quick way to read general messages and connect to your social media feeds, contact information, and Web-based content. Another template would work well for conferences or other events by allowing users to register, access schedules and basic information, buy tickets, access social media feeds, and learn more about you or your company. While you may not see the need for mobile apps today, you probably will eventually, as the world—and your audiences—increasingly access content via mobile devices.

AVOID ONLINE EXPOSURE

Although many people blogging or running online publications today do not have formal training in journalism and many learn through internships or on the job, anyone creating online content needs training in libel law as it applies to the Web. While instruction in libel law is a necessary and important part of any journalism curriculum, it is unlikely that anyone who studied another field would even think of libel law when blogging or launching an online publication. This is potentially disastrous. Anyone who understands the legal implications of publishing realizes the vast scope of the problem, as a distressing share of blogs—both personal and "professional"—include illegal material or material that violates copyright. You don't have to be a major

player with millions of monthly hits to get sued for libel or for a copyright violation. As any decent First Amendment attorney will tell you, anyone can sue at any time for any reason. They don't necessarily need to have a winnable case. And as one libel lawyer once told the author, it's always the little guys you have to watch out for. In other words, most libel cases catch you by surprise.

Most veteran journalists can recall working on an important, high-stakes story—about a prominent local politician, for example. They spend so much time and effort trying to avoid a lawsuit from the politician, they are caught off guard by the lawsuit that ultimately arrives from a neighbor of the politician who was mentioned in passing by another person briefly quoted in the story. Stories like this are common in libel law, and they are particularly hard to anticipate when journalists are working alone or with a small staff. Although there are endless examples of libelous online content that has not been the subject of a lawsuit, there is no predicting what potentially libelous content could ultimately be the subject of a suit. For this reason it is a very good idea for anyone who plans to blog professionally or to blog about more than just personal details relevant only to themselves to buy liability insurance.

For the *Times of San Diego*, Jennewein bought liability insurance from an Orange County, CA, company called BloggerShield. Although bloggers and online journalists can buy liability insurance from any number of companies, BloggerShield is one of few to specialize in blogging specifically. On its website (bloggershield.com), the company promotes its product to protect bloggers and journalists working online from legal claims for defamation (libel) and copyright infringement. Media liability insurers have existed for some time and offer various types of coverage that may or may not be appropriate for the kind of work you are doing. The Authors Guild (authorsguild.org) offers its members group media liability insurance through AXIS PRO (axiscapital.com/en-us/insurance/us/professional-lines/axis-pro), which covers clients in the film and entertainment industries as well as journalists. The company specifies that it covers blogging as well as posts to social media.

It is important to remember that libel law is technically the same online as it is in print. There are, however, several practical differences, including the fact that online information can travel more quickly than print, it is global and accessible on various devices and platforms, and even after it is deleted, modified or otherwise changed, any content posted online can never be eliminated for good. Thanks to online archives such as the Wayback Machine (archive.org/web/), traces can almost always be found by those willing to dig. Although there are statutes of limitation that require plaintiffs to file their

lawsuits within a specific period of time after publication, some states consider online publication "continuous," meaning the statute of limitations never expires and aggrieved parties could sue years—or even decades—after publication.[1]

A Libel and Copyright Law Primer

Libel law is constitutional. In the United States, its protections and authority are based on the First Amendment. Libel law is somewhat different in England, where the legal system puts the burden on the defendant, the journalist, to prove that he or she did not violate the law.

The basic components of a defamation (libel) claim are that:

- Information was published or disseminated.
- The information was false.
- The information was about the plaintiff.
- The information was harmful.

If the plaintiff is a public figure, he or she also must prove actual malice, which means that false information was published with reckless disregard for the truth. This is a higher bar than simple negligence or an error in fact-checking.

Opinion

Statements of opinion are protected by the First Amendment. However, that doesn't mean that journalists can publish opinion without fear of legal action. Sometimes what journalists or bloggers may consider an opinion does not qualify under the law. In libel cases involving opinion, courts may decide that what the defendant considers an opinion is actually a fact. If something can be proven either true or false, it is not an opinion. There is a difference, for instance, between calling a local teacher a "shrew" and calling her incompetent. Clearly, there is no way to determine whether a teacher named in a blog post is, in fact, a shrew (although we can assume she is not the animal that shares that name). However, calling a teacher incompetent suggests she is not qualified to perform her job—or worse. Such a claim could have serious implications for her career—and the teacher could sue the person who wrote that she was incompetent.

Another common problem related to opinion arises with reviews. This is an area in which bloggers must tread a fine line. The value of a review is directly related to the integrity of the review. In other words, if a reviewer gives only positive reviews or positively reviews businesses that have provided her with free meals or merchandise, the reviewer has violated her

contract with her readers or followers: to provide unbiased information about the quality of a meal, of a show or of another kind of entertainment or service. When an establishment being reviewed pays a reviewer (payment need not be in cash), the accuracy of the review cannot be trusted, and the reviewer fails to perform a legitimate service to her readers. Rather, she has provided paid advertising to her readers under the guise of objective evaluation.

An example from the other extreme: a blogger's negative review of a local restaurant could negatively impact the establishment's business. Since the reviewer's objectivity is paramount to the establishment and maintenance of his reputation and that of his blog or publication, the reviewer must be honest. If service was slow or the tomato bisque arrived cold, he should mention that. But if the reviewer had a bad experience at the restaurant, he must resist the temptation to exaggerate the negatives he encountered. If, for example, the restaurant looked dingy and outdated, he should explain that. And he can without fear because he is simply presenting his opinion. But he should resist the temptation to suggest the kitchen is infested with rats (unless he has hard evidence that it is). Without evidence, the latter is not an opinion and is not protected by the First Amendment. Since infestation is a fact that can be proven true or false, a false suggestion could—and likely would—invite a lawsuit. And if the critic has no evidence the restaurant is infested, he would likely lose the suit. Although this may seem like a small risk, it really isn't. A successful lawsuit with significant damages could easily prove fatal to a startup blog or news site.

Copyright Violation

The most common sources of legal claims against bloggers and journalists working online are libel claims that arise from statements of opinion and copyright violations. On the Web, it is quite common for personal blogs and social media sites to feature media (often photos or music, but increasingly also video) that was not created by the owner of the site. Online, it is easy to copy images from blogs, sites or other online sources and repost them to personal or even professional sites. There is now more awareness of the dangers of reposting copyright protected content than there was a few years ago, yet it is still commonly done. Further complicating matters is the

Figure 9.5

Copyright infringement has vexed artists and writers for more than a century. These days the rules are less certain and the risks are harder to avoid. Image by MikeBlog / Wikimedia Commons.

fact that it can sometimes be difficult to determine the original source of an image online. In the past, bloggers have been sued by photo services such as Getty Images for reprinting their photos without permission. In some cases, defendants claimed that they thought they were free to repost the images because they found them through a search of royalty-free content.

Another common source of copyright troubles for bloggers and journalists working online is music. Although music is not a common feature of blogs and news sites, music does often accompany slideshows and videos. A quick search of YouTube will bring up endless amateur videos that feature copyrighted music by major artists that is used illegally. YouTube does remove content that it has determined violates copyright; however, the burden of discovering it rests largely on the copyright holder, who must file a complaint with YouTube or its owner, Google. That most people have never heard of someone being sued for publishing content to which they have no rights keeps this a common practice. However, that does not mean you should feel free to violate the law yourself. Just because someone else has violated the law without consequence doesn't mean you'll be so fortunate.

Figure 9.6
Many of the images in this book were found through CreativeCommons.org. Photo by Creative Commons, Mountain View, CA / Wikimedia Commons.

Finding Royalty-Free Material

Despite the term, royalty-free material isn't necessarily free. However, it is often available for little or no charge, providing proper attribution. It's important to use royalty-free work in both print and online publications to avoid legal action for using work that belongs to someone else without permission. Below are a few good places to search for free or inexpensive content. Just remember to follow any rules regarding the sharing of these materials.

Creative Commons (creativecommons.org): An excellent search engine for royalty-free media, CreativeCommons.org draws from Google images and Flickr, Wikimedia Commons, YouTube, SoundCloud, and more. Entrepreneurial journalists can also use Creative Commons to distribute their own work for others to use (with credit).

Wikimedia Commons (commons.wikimedia.org): A smaller but growing repository of mostly images but increasingly video and other types of media from various sources including the White House. There is a substantial collection of media from the U.S. government and other official sources that are in the public domain.

Video Blocks (videoblocks.com): This site offers lots of excellent high-definition stock video and production music to accompany multimedia presentations such as slideshows and videos. There is a free seven-day trial, and a six-month subscription with unlimited downloads is reasonably priced.

SUMMARY

Entrepreneurial journalists face a number of choices when it comes to deciding the best way to present and distribute their content. They may want to develop text-based or video blogs. They may want to post photos or create podcasts. Journalists would be smart to create professional websites to promote their skills and help develop their branding message.

They may want to use WordPress.com as a platform for developing their website. WordPress.com is easy and quick to learn. Entrepreneurial journalists also want to develop social media accounts to connect with and draw readers and followers to their main websites. Adding tags (searchable keywords and phrases) and metadata to their posts will help drive traffic to their site.

In the early days of self-publishing online, some people developed significant followings through highly personal blogs that resembled online diaries. An

early Internet sensation was lonelygirl15's video blog, which ran on YouTube for months before intrepid followers and members of the media grew suspicious and began investigating lonelygirl15's mysterious origins. After the online diary was revealed to be an elaborate marketing campaign to generate interest in a forthcoming Web series, loneygirl15 became increasingly far-fetched, and viewers eventually lost interest.

The novelty of online diaries has long since worn off. Today's savvier online consumers demand more than a pretty face or a direct appeal to read or follow a personal website. Consumers want content, and those with expertise in a specific subject matter can develop their brands and followings based on the educational value of the information they post or distribute.

Among the chief concerns of those beginning their own solo journalism endeavor should be staying on the right side of the law. Especially those launching blogs and online publications without formal journalism training (and there are many these days) must make a special effort to learn the law. Important legal issues related specifically to the content journalists produce include libel (defamation) and copyright law. Online journalists and bloggers are particularly at risk for lawsuits arising from their unauthorized or unattributed publication of proprietary content (sounds and images created by or belonging to someone else). They also face significant risk for publishing potentially damaging material that they may consider opinion.

Because opinion is protected by the First Amendment in the United States, some writers may wrongly assume that they can write negatively about anything as long as their statement is framed as an opinion. ("It is my opinion that John Smith murdered his neighbor," for instance.) However, anything that can be proved correct or incorrect is, indeed, a fact, and thus, it is not protected speech. Anyone planning to blog professionally or create an online publication may want to consider buying liability insurance to prevent potentially devastating legal action.

JOURNALIST'S TOOLKIT

Content is king—especially for journalists, who face stiff competition these days from citizen journalists and bloggers with strong opinions and plenty of attitude but often not much more. It is no longer enough for anyone to simply blog without a narrow focus or point of view, or without some specific knowledge or insight that is useful to the audience. Media consumers demand value for their investment of time. It is up to the journalist to deliver that value.

Skills

Writing

Editing

Basic photography

Photo editing

Basic website creation

Optional:

Audio or video recording

Audio or video editing.

Tools

Desktop or laptop computer

Internet-connected mobile device

Smartphone with a high-quality digital camera or a separate digital camera

Optional:

Webcam

High-quality microphone for podcasting

Basic audio editing software

Basic video editing software.

Sites

Archive.org/web: The Internet Archive's Wayback Machine for searching old Web pages.

Authorsguild.org: A labor group representing writers.

Axiscapital.com/en-us: Home page of Axis Insurance, which sells multimedia liability coverage.

Bloggershield.com: Home page of Blogger Shield insurance for bloggers.

Como.com: Web-based mobile app builder.

Creativecommons.org: Nonprofit resource for royalty-free media.

En.support.wordpress.com: Comprehensive support site for WordPress.com.

En.support.wordpress.com/com-vs-org/: Website explaining the difference between WordPress.com and WordPress.org.

Facebook.com: The ubiquitous social media platform.

Foursquare.com: A GPS-based mobile app that helps users search nearby locations.

Godaddy.com: Popular domain registrar known for a sexy brand image long associated with female racecar driver Danica Patrick.

Hootsuite.com: A site for distributing messages across various social networks simultaneously.

Instagram.com: Mobile photo sharing network.

Linkedin.com: The ubiquitous professional network.

Mixi.com: Social media platform based in Japan.

NetworkSolutions.com: A domain registrar.

Pinterest.com: Visual scrapbooking social network.

Plus.google.com: Google's social network, Google+.

Reddit.com: Content sharing social network.

Register.com: A domain registrar.

Theme.wordpress.com: WordPress.com's main page for choosing themes.

Tumblr.com: Social microblogging platform.

Twitter.com: Popular microblogging platform.

Videoblocks.com: Website of the subscription-based stock video and audio site Video Blocks.

Vimeo.com: Professional video sharing network.

Youtube.com: Google's popular video sharing network.

Wordpress.com: The WordPress-hosted blogging site.

Wordpress.org: The self-hosted version of WordPress' open-source software for building websites.

Application

1. Critique a personality-based blog. Describe its major characteristics and the blogger's brand or niche.
2. Create an outline for a personal blog with a specific brand and a target audience that brand would serve. Explain the unmet need your blog would fill for the target audience or community.

3. Research and write a case study of an online journalist or blogger who was successfully or unsuccessfully sued for libel or copyright infringement.
4. Compare one of the largest-circulation print magazines today with one of the most successful blogs or news sites. Use specific evidence from each—including any analytic data you can find—to show the differences between the target audiences and key demographics of each publication.
5. Develop a pitch for a podcast with a specific focus and target audience based on that focus. Describe the target audience and explain what unmet need the podcast would fill for the target audience or community.
6. Determine what kinds of liability you could face as a blogger or online journalist. Compare media liability insurance at three or more companies, then write a brief for a classmate or peer in which you do or do not recommend each product for online journalists. Include specific reasons for each recommendation.

Review Questions

1. What does the phrase "content is king" mean to a journalist working online?
2. How can a journalist determine her audience and the best tools to use to reach that audience?
3. Why do personality-driven bloggers face a greater challenge today than they did ten years ago?
4. As an entrepreneurial journalist, how can you differentiate your blog or news site from all the others out there? How can you make what you create special?
5. What is a niche, and why do bloggers need one?
6. How can you decide the best tools for distributing content online? How do you determine which online platforms to use to distribute your content?
7. How do you use social media to promote your story both when you are working alone and when you are working for a media employer?

REFERENCE

1. "Online Defamation Law." Electronic Frontier Foundation, https://www.eff.org/issues/bloggers/legal/liability/defamation.

Brand and Market Yourself

Journalism, like all media, suffered an identity crisis following widespread adoption of the Internet. Now that anyone with access to a computer and an Internet connection owns a virtual printing press, there is understandable confusion over who is a journalist. Is a blogger a journalist? Is someone with a huge Twitter or Facebook following a journalist? Is someone who posts news stories on behalf of a company or organization a journalist? These questions are often tough to answer, partly because there are no clear answers or set rules.

Journalists aren't licensed as are practitioners in many fields. How is anyone to know whether a journalist not affiliated with a professional news organization is legitimate? The truth is, it's difficult, and it's not an exact science. But just like in the old days, a journalist is only as good as her reputation. And unlike in the old days, reputations are now pretty easy to check online. They're also—particularly if they're negative—very difficult to change, as anything posted to the Internet lives on in some form forever.

The best way to protect against a negative reputation is by upholding the highest standards for both your work and your professional and personal ethics. But how do you develop a reputation in the first place? For some, simply explaining who they're working for is enough. Fewer journalists these days work for employers as ever greater numbers go to work for themselves. But regardless of whether you're working for a known media entity or for yourself, journalism has always been more about individuals than companies.

While a business card from the *New York Times* or the *Washington Post* will most certainly open (or close) doors, the best journalists have always been their own brand. Think about Katie Couric, Anderson Cooper or Tina Brown. You likely know these names and are familiar with their reputations. But you may not remember who these journalists work for. All three have worked for different employers during their high-profile careers. Among the reasons for their success through the decades is their focus on building and curating a solid reputation through good work and a commitment to letting the world know about it.

Figure 10.1

Perez Hilton (Mario Armando Lavandeira Jr.) made an early name for himself as a celebrity blogger. It is more difficult to gain fame as a blogger today. Photo by Keith Hinkle / Wikimedia Commons.

Although these media stars represent a very small fraction of the journalists working today, they are compelling reminders of the fact that in journalism, personality and voice trumps employer. Now think about Matt Drudge, Arianna Huffington or Perez Hilton. These famous bloggers have names that are synonymous with their work. If they were to go to work for someone else, few of their fans would even notice. They are media brands unto themselves. And because they have strong online brands, their names are recognized worldwide. While Walter Cronkite was known in American homes for decades when he was an anchor for the CBS Evening News, today's successful journalists have a global online reach, and unlike Cronkite, they can build a reputation through social media in a matter of months or even weeks. Blogging pioneers Drudge and Hilton (his real name is Mario Armando Lavandeira Jr.) have been developing their online brands for years. Having emailed his first report in 1994, Drudge has been blogging for more than two decades—longer than some journalists starting out today have been alive. Clearly, online journalism has been around for long enough to no longer require much explaining. Neither it nor its practitioners are new to the game. Although it is now more common for journalists to get their first jobs at websites or blogs

than at newspapers, magazines or broadcast outlets, not all online journalists today are young. Tina Brown, who is in her sixties, deftly made the switch from print media icon to new media icon.

Brown got her start as a young editor at the high-end British lifestyle magazine *Tatler* before moving on to helm the high-end American lifestyle magazine *Vanity Fair*. As prospects for print journalism began to decline, Brown turned her talents online. In 2008, she founded the online magazine the *Daily Beast*. Then, in 2010, she took on the ailing *Newsweek*, which became an online publication. *Newsweek* has since been sold off. Through it all, Tina Brown managed to maintain such a strongly positive reputation for herself, it no longer seems to matter what she does or who she works for. Journalists from all generations admire her four decades of success across various platforms.

While beginning journalists today don't need to transition from print to online, like their more experienced peers, they do need to learn how to create, produce, and edit content across platforms. The good news is that as online and mobile technology evolves, the barriers continue to fall for everyone. Journalism is more accessible and democratic than it has ever been, and that's good news for everyone interested in news. Although not every aspiring journalist can look forward to a career as legendary as Tina Brown's, most can be sure they'll at least get their name—and their brand—out there.

Those old stories about digital natives and digital immigrants are no longer as powerful as they once were. We've lived in a digital world for long enough that those who did not grow up with the Internet no longer have a credible reason not to use it in the same numbers young people do. It is now common for older people to be online, to send email, to visit and even build websites. These days the majority of Americans 65 or older go online. According to Pew Research's Internet and American Life Project, 93 percent of Americans 30 to 49 use the Internet, 88 percent of Americans 50 to 64 use the Internet,[1] and as of 2014, 59 percent of Americans 65 or older used the Internet. By 2012 more than half of Americans 65 or older used the Internet.[2] In a world where everyone is online, young journalists no longer have a technological advantage over their older peers. The Web provides more opportunity to all kinds of people by the day.

YOUR LIFE ONLINE

So much of our lives these days is recorded online, whether we want it to be or not. Of course if we are hoping to develop a marketable band online in order to get work or to build or maintain a career, it is important that our online identities (and our brands) are consistent with the professional

messages we hope to send. This can pose a challenge given the permanence of Internet posts. Many young people—and even old people—today have posted to social media sites for years. Over that time, they may have uploaded thousands of photos, videos, and updates, some of a highly personal nature. While it is essential to separate your personal social media accounts from those you use professionally, it is also important to know that there is no real way to keep an online identity completely secret or inaccessible to those who may want to see it. Although we may change our privacy settings to ensure that only friends see what we post to Facebook, Facebook and other social media companies frequently change their privacy policies, and if someone can see what you post, you can assume that anyone can if they really want to.

According to a 2013 CareerBuilder survey, 39 percent of companies use social media to research job candidates. Of the hiring managers surveyed, 43 percent said they had found something a candidate had posted to social media that prevented them from hiring the candidate. Half of the posts in question were provocative or inappropriate photos or information; 48 percent of the posts in question referred to drinking or illegal drug use; and 33 percent of the posts involved the candidate making accusations about a former employer. Other red-flag posts involved discriminatory comments about sex, race or religion; lies about professional qualifications; and simply poor communication skills. At the same time, a thoughtfully created social media profile can also help improve a candidate's chance of getting hired. Among the positives hiring managers surveyed identified in a candidate's social media profiles were professionalism, creativity, a wide range of interests, a friendly personality, strong communication skills, and references for the candidate.[3]

Happily for job seekers, finding out how you appear online is as easy as searching for yourself online. Although several companies these days charge a fee to check and even improve the way you appear online, for most of us, a quick Google search is all it takes to determine how we appear online. If unprofessional images or posts by or about you appear in your search, you can either take them down or ask whoever posted them to remove them. But sometimes it can be more complicated than that. For those with lots of erroneous, misleading or just plain damaging information online, and for those with commercial sites that need constant monitoring, subscribing to a service like Reputation.com could save time in the long run. While companies can more easily resolve your online problems, they do not have any special access to your online information. They are simply more effective and efficient at resolving your online problems because they have more practice, time, and resources. You may not have hours to spend researching how you can get an online image of you removed from Facebook for good.

BUILD AND PROTECT YOUR REPUTATION

These days the key to success as an independent journalist is to build—and grow—a positive reputation. The only way to develop a reputation as a journalist is to get your work—and your byline—out there. Write for blogs, online news sites, and other publications. Use social media to build audiences of followers. Write and produce content regularly—both for others and for yourself. Make sure you have an online presence—and not just on social media. Build a professional website to showcase your work. And try to avoid creating brand confusion—and diminishing your reputation—by mixing your personal and professional lives online.

For instance, unless you are a columnist or critic whose personality is an important part of your reporting, do not use your personal Facebook or Twitter account to conduct research, make professional connections or promote stories. If you are a news reporter, you know that objectivity—along with fairness, balance, and accuracy—helps form the basis of your reputation. Because personal social media accounts are unlikely to exhibit this kind of professionalism, strongly consider limiting your communications to only the most neutral topics (and purging old posts that don't exhibit the level of professionalism for which you would like to be known) or using privacy settings to limit access to only family and maybe your closest friends. Remember that all it takes is a single poorly worded comment to mar even the most well-established journalism career.

Because the barriers that once separated journalism from public relations have largely eroded in the era of Internet news, beginning journalists should not rule out opportunities to work and provide content for companies and organizations. These days it is not uncommon for journalism students to take internships that require them to write public relations or marketing content. If formal internships aren't available, consider volunteering to write or provide other content for an organization you admire. The work you create will be a nice addition to your portfolio, plus your efforts could lead to a job.

POLISH YOUR ELEVATOR PITCH

Elevator pitches have become a business cliché in recent years. While few entrepreneurs ever get the opportunity to pitch themselves or their product in an actual elevator, there are at least a couple essential lessons to be learned from the idea. First, it is essential to keep in mind that most people who are important enough to pitch are probably also too busy to stop and listen to a long, meandering pitch. No matter how good your idea may be, if you can't express it in the span of a typical elevator ride (usually thirty to sixty seconds),

Figure 10.2

Branding expert Karen Kang's highly focused elevator pitch worksheet. From brandingpays.com.

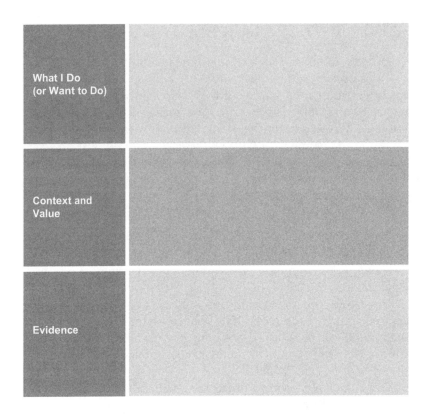

you might as well not make it. Either your idea is not focused enough for potential backers to hear or you lack the communication skills to clearly explain it. The good news is that both problems can be remedied through additional consideration, planning, and practice presenting your ideas.

There are countless websites that offer tips for honing elevator pitches. Among the most common tips are recommendations to make the pitch quick and to the point (but not hurried), personalized to the audience's needs and interests, and compelling but not complete. In other words, you want to pique the listeners' interest enough that they want to hear more. Be confident but natural, and don't come on so strong that the listener is turned off or will not be likely to follow up.

While most elevator pitches are about specific ideas such as requests for startup investment, an entrepreneurial journalist's pitch may be more general. Instead of having a polished request for funding ready to recite at the first opportunity, the journalist may instead have a short pitch for themselves and the services they offer. This should not be delivered as a sales pitch. Rather, it should be a somewhat scripted but thoughtful response to the question: "What do you do?" or "What is your profession?" Particularly when you're an entrepreneur,

being asked what you do for a living is an opportunity for networking and free publicity. You can't afford to miss an opportunity to get your brand message out there. The more clearly and quickly you can explain what you do while establishing or reinforcing your brand, the more memorable you will prove, and the greater the likelihood a simple chance encounter will lead to work.

BUILD YOUR ONLINE PORTFOLIO

While general interest blogs now face more competition than ever and it can be challenging to attract readers to text-heavy content online, entrepreneurial journalists should have their own websites to serve as both their online calling card and a digital resume or CV. The form this website takes may differ depending on whether you have a full-time employer or plan to remain self-employed. Anyone who wants to work in the digital marketplace must make it easy for potential clients and employers to find them online. There are many options now available for building portfolio and resume sites. LinkedIn is the most popular professional network. It offers excellent exposure to your resume details, as well as opportunities to show off connections from which you may want to solicit professional endorsements.

The portfolio site VisualCV allows users to plug in resume text and drag and drop blocks of content within a template. Users can upload images and documents, and embed video. VisualCV also provides users with analytics so that they can track views and downloads of their CV, and determine how visitors are finding their site. VisualCV makes it easy to share your CV via social networks.

In Chapter 9, we discuss the basics of creating a WordPress site. Although WordPress is known as a blogging platform, it is also a great tool for creating websites. If you are comfortable with basic website creation (and you should be, although you don't need to know HTML or advanced coding), you may consider simply creating a website to host your resume and professional portfolio. Regardless of what tool you use to build your online resume, there are a few basic items you want to make sure to include. In addition to resume basics such as contact information, education, and job history, you also want to include a professional headshot. You should include links to social media and sample professional projects that showcase your work. It is also a good idea to include a short personal video in which you introduce yourself to potential employers or clients.

Here are a few basics to keep in mind as you create your online resume:

- Remember your brand. Keep in mind that consistency is key. Make sure your online resume or CV, or your professional website, reflects your main branding statement. Include a brief bio statement

that reinforces your brand. Try to distinguish yourself through memorable details that don't diminish your professionalism. It can be a fine line.

- Focus on value. Although your primary motivation probably is to find work, remember that your audience is primarily interested in meeting their own needs. That means you need to focus on what value you can provide to your audience.

- Include links. Link to your professional websites, social media accounts, and professional organizations with which you are affiliated. As always, make sure any outside sites or platforms represent you in a professional way that is consistent with your branding message.

- Solicit testimonials. Ask former and current bosses and supervisors to write short recommendations or testimonials about your work. Also ask if you can feature their words on your website.

- Consider a professional blog. If you don't already have a blog that is well focused on a specific topic on which you provide content that has value to a targeted audience, consider starting one. Are you an expert on branding? On social media? On making presentations? Bring value to your audiences by blogging instructional content on your area of expertise. Post polls, games, and other interactive content to boost engagement and promote interactivity. Encourage visitors to your site to sign up for your e-newsletter, let them decide how often they want to receive the newsletter, then send it out regularly with a catchy headline that aligns with your brand and one or two brief items that provide value for your readers. Host a poll on your website asking questions your readers would want to know, then distribute the results in your newsletter.

- Distribute a newsletter. No longer a black-and-white folded piece of desktop-published legal paper updating the latest happenings in your department, book club or sewing circle, today's electronic newsletters can be created and distributed through free services such as Mail Chimp (mailchimp.com) and low-cost services such as Constant Contact (constantcontact.com). Mail Chimp's free account allows users to create electronic mailing lists and create attractive newsletters using their templates, then distribute them to targeted subscriber lists. You can segment your subscribers to send different messages to different groups. You can also check Mail Chimp's reports on the results of each campaign, which let you know who opened your newsletter, how many people clicked on links in the newsletter, and what countries they were from. These are all available with a free account. With a paid account, you can send automated emails customized for users who have subscribed to a newsletter, clicked or opened the newsletter or bought something through the newsletter.

- Share any presentations or original research you have conducted on the topic as well as links to other relevant research. Remember that Internet users love "Top Ten" (or "Top Five" or "Top Six" or "Top Eight") lists. These terms are likely to get picked up by search engines and drive more traffic to your site. Never forget that readers have millions of choices when browsing the Web. You need to provide some value to make them want to visit your site, and to keep providing value if you want them to come back.

Sample Brand Attributes

Core Values	Strengths	Personality	Image
• Trust	• Project management	• Visionary	• Sophisticated
• Courage	• People management	• Positive	• Elegant
• Respect	• Financial or operations management	• Strategic	• Edgy
• Integrity	• Technical expertise	• Creative	• Buttoned-down
• Passion	• Strategic planning	• Present	• Classic
• Innovation	• Managing conflict	• Focused	• Business casual
• Transparency	• Creative problem solving	• Flexible	• Fashion forward
• Adaptability	• Delivering presentations	• Inspirational	• Urban
• Reliability	• Decision making	• Sense of humor	• Artistic
• Accountability	• Mentoring	• Compassionate	• Establishment
• Honesty	• Communication	• Patient	• Couture
• Giving back	• Strategic vision	• Results-oriented	• Technology savvy
• Leadership	• Collaboration & teamwork	• Analytical	• Worldly
• Vision	• Building and leading teams	• Confident	• Cultured
• Quality	• Leading innovation	• Competent	• Hip
• Diversity	• Global strategies	• Expert	• Colorful
• Thought leadership	• Streamlining processes	• Unflappable	• Conservative
• Service	• Domain expertise	• Driven	• Academic
• Helping others	• Driving for results	• Passionate	• Professional
• Education	• Change management	• Collaborative	• Geek chic
• Competence		• Personable	• Entrepreneurial
• Respect		• Energetic	• Leader
• Responsibility		• Friendly	• (see Personality list)
• Open mind			
• Friendship			
• Determination			

Figure 10.3
Another handout Karen Kang provides to help others articulate their personal brand. From brandingpays.com.

PERSONAL BRANDING FOR PROFESSIONALS

Just like sports drinks and magazines, entrepreneurial journalists need clear, consistent, powerful brands. Though the idea of branding a person may take some getting used to, it actually makes a lot of sense in the era of entrepreneurship. In fact, personal professional branding has always made sense. People simply didn't think as much about it in the past, when careers and even jobs were more permanent, and employees didn't feel the need to keep current resumes. These days, regardless of the field but particularly in journalism, people change jobs frequently. They even change careers. It is not uncommon to launch startups or do freelance or contract work. The mobility of today's global job market underscores the need to not only keep your job skills current but to also maintain your contacts, create a strong professional identity, and learn how to effectively distinguish and promote that identity or brand.

Just like a product without a reputation or a clear brand identity, a person without a brand will likely get passed over for jobs in favor of people who know what special value they can offer potential employers. Since most people now use the Internet to apply for jobs, hiring managers can face a daunting task sifting through the applications of dozens, or maybe hundreds, or possibly even thousands of qualified applicants. Without a clear brand to distinguish her, even a highly qualified candidate could easily be overlooked.

I experienced this first-hand years ago when I served on a committee to select members of a student staff to work in the newsroom of a prominent journalism organization's annual conference. It was a highly competitive selection process with hundreds of applications for just twenty newsroom spots. Selecting newsroom staff was particularly tough because there were so many qualified applicants. Most of the journalism students who applied demonstrated high competency in all the essential media skills. They could write. They could edit. They could shoot and edit photos and video. Many wrote blogs. Some had campus radio or TV shows. Several had served as interns at prestigious news organizations. Rare was the application that showed a clear lack of ability. Among the majority who were highly qualified, few were clearly distinct. One had interned at a news outlet in the Middle East. Another was an older student who'd had a long career in a different field. Still another had a minor in public relations, which was unusual for journalism students at the time.

After the newsroom staff was selected, one of those who did not make the final cut emailed to ask why. After all, she had earned high grades at an Ivy League university. She had skills and experience in all the key areas of multimedia journalism. She even had her own blog. In other words, she was an excellent candidate. And so were dozens of her peers. But despite her

excellent credentials, there was nothing particular about this student that stood out. She had no brand, no distinguishing skills or specialties that helped her stand apart from her peers. In a global journalism marketplace, it is no longer good enough to merely have all the necessary skills. You need to bring something else to the table; you need a unique brand.

"Bake the cake, then ice it,"[4] wrote branding expert Karen Kang, author of *Branding Pays* and a former journalist. By this, Kang meant that professionals need to deliver all their profession's essential skills (the cake), but they also need a little something extra (the icing), things like personality, likeability, and communication skills that bring a potential employer or client more than just a competent employee or consultant. Kang, who helps individuals and companies improve their brands, outlines her entire strategy in *Branding Pays*, which you can learn more about on her website, brandingpays.com.

WHAT IS YOUR BRAND?

Although it doesn't necessarily need to appear anywhere in print, your personal brand is something you should be able to put into words—preferably a single sentence. This may be an easier process for those in other professions than it is for journalists, whose personalities are closely associated with their work. Although journalism has traditionally been about fading into the background while reporting facts, the Internet has helped lift the curtain a bit on journalists. In a world where audiences are accustomed to interacting with journalists, and many journalists have their own personal and professional websites and social media accounts, pretending they have no personal lives or opinions that could possibly skew their interpretation of events is not only naive, but it is also misleading. If the public didn't believe it before, they certainly believe it now: Journalists are people, and their followers need to know who they are before they know how to interpret their stories.

How might a journalist brand herself today? Instead of using branding templates to create jargon-heavy sentences for the tops of resumes, journalists should consider what makes them unique in their field and what special something they can provide that few of their peers can. For instance, a reporter who works in south Texas might brand herself as a bilingual political reporter with connections on both sides of the U.S.–Mexico border. A reporter who once worked as a statistician or auditor might brand himself as a skilled data journalist. Likewise, a reporter who lived or worked in various countries might brand herself a specialist in global journalism. Journalists without such clear distinctions may distinguish themselves in smaller ways, by mastering specific skill sets such as audio or video editing, Web design or search engine optimization.

INTERVIEW: A Conversation with Karen Kang, Author of *Branding Pays: The Five-Step System to Reinvent Your Personal Brand* and Founder and CEO of Branding Pays LLC, a Corporate and Personal Branding Company

Figure 10.4

Karen Kang.

What is your journalism background?

I got my master's in journalism from Boston University, and I worked as a newspaper journalist at the *Oregonian* in Portland, OR, as well as the *South Middlesex News* covering all the communities surrounding Boston.

How can journalists and other communication professionals work together in ways they might not have been able to previously?

Journalism and public relations used to be two separate areas. There's a lot of blending now. It's fine in that many of the PR specialists today have to be adept at social media, and the media are very content and engagement driven. The skills you learn in journalism are very applicable and needed in terms of social media. I have worked with a number of individuals employed by public relations firms, but actually their whole role is in social media and developing the online brand for companies they work for. But in order to have a following on social media—especially in a business setting—you have to have good content, and that content has to be focused so you're known for something or so that brand is known for something. To become a domain expert and then be able to use marketing skills to focus that content so that it's attractive and understandable to your target audience—that is really key. Truly, if you want to have a sustainable brand you need to deliver something of value. In this day and age, it's either education content around that—education about your domain area—or entertainment.

How has the Internet changed the journalist's role?

If you look at today's bloggers who are well known, they generally have a point of view. When I was a newspaper journalist, we would always strive for objectivity and not insert our opinion into the story, but today part of

bloggers' appeal is that they're human beings with personalities and a point of view. If you're going to have a blog and it's under your name, you're pretty much required to find your own voice, understand what your personality is, understand what your market is and what they're seeking from you. Write and blog and engage accordingly.

What about those who blog or write for companies or organizations?
It's a special skill to be able to write for an organization and keep the organization's core values and brand in mind as you blog, perhaps under your name but for that organization. You have to ascribe to the core values of the brand you're representing, but still have your own individual personality. Very few people want to read vanilla blogs, corporate blogs, and the corporate voice. They want to hear an individual voice but they understand that that individual voice is still representing the company.

What skills should journalism graduates have as they enter the job market?
They should have strong social media skills. They should know how to navigate the various platforms and know which platforms are the best for what kind of content and what kind of engagement, and if they are going to go into business for themselves, they definitely need to know how to brand themselves. I very much encourage them to own their own real estate online and brand it with their name and be consistent in that name. Sometimes people use nicknames on one platform and their full name on another platform and their middle initial with their full name on another platform, and you don't know if they're all the same person. My advice to people is: Don't make your audience work. Don't make a person work who may want to advocate for you and is so mixed up because you have too many online properties with different names or different brands. Your name is your brand, so figure out what name you want to be using consistently and stick to it so people know how to find you. The other thing is your photo. Get a good professional photo. I'm not saying you have to be in a suit or anything. I'm just saying that it should be high quality, good resolution, good lighting . . . Put some thought into what you're wearing if it's more than just a head shot. If you're going to be on Twitter, say, and there's only a small avatar or picture that goes with your tweets, you need to have a close-cropped picture. I see people who don't have any marketing sense at all. They have full-length pictures and their head looks the size of a pinhead.

What advice do you have for people with personal social media accounts that aren't very professional?
They need to clean up their act. If their current social media accounts are so far gone that there's no cleanup act they can do, they might want to shut them down and start new ones. Choose some variation on their name, then

make that their consistent brand. But if you don't have too much bad stuff out there, maybe you can produce a certain amount of content that would be your current stuff that exemplifies the focus and maybe the professionalism you would want to have. You need to monitor these social platforms and streams, and if there are photos you'd rather not be tagged in, ask your friends to not tag you. You can also on Facebook just block that person from showing up on your wall or your Facebook timeline. There's a number of things you can do. It's very important for journalists just starting out—or anyone for that matter—to do a Google search on a regular basis. It's a good idea to submit your name to Google Alerts so that anytime your name is mentioned, Google will send you an email and show you what's being said about you. That's a very low-cost way to figure out what's out there. It is a good idea to do a search and see what shows up on the first-page results because 94 percent of people don't go past the first page. There's a number of things that can happen. One, you can not show up on the first-page results, which is not good because not being found on the Internet today means you don't exist. Two, there can be a number of references to things that you just don't want to be known for. Maybe it was the old way you positioned yourself. Let's say you positioned yourself in a certain industry or subject area, and you don't want to be known for that anymore. When you're repositioning yourself, you need to be able to push those mentions off to the second, third, fourth page, and start populating what will show up in your Google search with current stuff that you want to be known for. Having a strong LinkedIn profile is really good for SEO, which is search engine optimization. You can start doing a blog and blogging regularly, and have that show up. Tweeting is good, because Twitter will show up. Pick a bunch of different platforms to be on, and soon you'll have content out there that will push other stuff to later pages.

Should people have just one brand or can they have different brands for different audiences?

Theoretically, if we were all in silos and never crossed over, having more than one brand would be fine. But that just doesn't work in today's world. Everybody crosses over. Everything is melding now. Not only in different industries, but also in terms of your professional life versus your social life. If you're on a platform that the whole world can see and access, that's going to be really difficult. I have a Branding Pays page for my business and I do have a Karen Kang page that is more for friends and family. However I never post anything on the Karen Kang Facebook page that would reflect poorly on my professional brand. I do have some clients who are also friends of the Karen Kang Facebook page. I feel like I'm an authentic person, and how I show up personally and professionally—I'm the same person. I may be a little more buttoned down in a business setting than I am in a social setting with my

friends, but I would never do something on my personal site that would make someone say, "Oh my goodness. Karen Kang, the *Branding Pays* author, how could she be doing that?"

Should a brand represent people's skill sets? How specific should it be?

Let's say you want to do business reporting. The umbrella of business is just huge. Do you want to talk about finance, leadership, marketing, global recruiting policies? There are all different ways to slice and dice subject matter. It doesn't have to just be subject matter. Let's say you started blogging, and you started doing a lot of little surveys. So you were sending out these online surveys to people, and each blog entry would be looking at those surveys and doing analysis and talking to experts and writing a whole story about it. You would start to be known as the journalist or blogger who does social research or analytics. Maybe you had infographics or data visualization. You would become known as a blogger who had those skills and the ability to take some really interesting topics and weave a story around them. It's that kind of stuff. It doesn't have to be one particular topic, but it can also embody the skill set around it and how you approach collecting information and reporting on it, and how you engage with the ecosystem, how you talk to thought leaders. You could help people along in demonstrating a specific skill set. Let's say you have a Twitter profile, and one of the things you have in your profile is that you're a data-loving something something blogger. Give people a few words, a few qualifiers so that people say, "oh yeah" and put you in a certain category.

How can people with very similar resumes differentiate themselves?

I'm working with a lot of sales professionals right now at this very large company, and when I see their resumes, they look very similar. They all have won achievement awards, they all are good at communication skills, sales, relationship building, and stuff like that. To help differentiate them, I went way into their backgrounds. For instance there's one guy who was a Division I college athlete. He was a catcher. The catcher is really the leader of a baseball team. He was the only one who had full field vision and could then direct what people should be doing, work on the strategy with the pitcher, really understand what they needed to do in a game, and be able to turn on a dime and adapt the game plan depending on how things were happening. We used that background for his LinkedIn profile, to set him apart so that beyond all the other good stuff he had at his company, he brought this background where he was a natural-born leader, very inspirational and motivational. He mentored people because he understood team dynamics. We were able to roll all that stuff into a catcher metaphor. A lot of times people have some very interesting things that they've done but they discount it because it happened so long ago. No. You can

use it. Dust off things. Go back and put together your personal back story and find where the gems are.

What are the most important skills journalists need to be sustainable?
The greatest skill people can have if they want to have longevity in their career is the ability to look out on the horizon and see trends and which way things are going—whether they're technology, business trends, social trends, whatever—and when things are happening. Basically the only constant today is change. Change represents fear for some people and excitement and opportunity for others. If you can embrace the opportunity part of change, you'll be so much better off.

You embraced change in your own career years ago.
I saw a long time ago that traditional journalism jobs were going to be disappearing over time and that new media and new ways of doing things would be coming online. Even with my own consulting, I saw how important social media were going to be a long time ago. I got my domain name in 1994. I'm one of a million or so Kangs in the world, and I have the Kang.com domain. Being able to jump on new things and being able to run with them is very important. I can't tell you how many times I've rebranded myself for new opportunities. You have to do that or you become a dinosaur.

What would you say to journalists who might not be comfortable with
the idea and ethics of personal branding?
Personal branding done right is totally ethical and authentic. If you do things that are not ethical and are not authentic, you will not have a sustainable brand. People have this idea that self-promotion is a vice and it's bad. I would like to dissuade people from thinking that because it's the wrong way to think about it. Personal branding is not so much promotion. It is really about education and engagement.

What is the value of branding for journalists?
Unless you're the Kardashians, you really do need to be adding value to the world. If you want to add value to the world, what is that area of value you are representing? That should be what your brand is all about, at least in a career context or a professional context. If you get away from this notion of "me," "me," "me," and shift to the attitude of "we," you'll do a much better job of branding yourself and having people understand what your value is in the world. The whole reason that people should be known is so they can have influence and have a voice and the audience that they desire in order to spread the word. But you won't have that opportunity if you're not known. Everyone needs to do the job of branding themselves, and the world will be a better place.

Professionalism Checklist

Do . . .	Don't . . .
Research and fact-check your stories.	Publish without getting feedback from another journalist or trusted friend.
Follow up with sources and keep your word, no matter what.	Maintain a one-way relationship with your sources. (Building a network of sources over the long term requires the maintenance of two-way relationships.)
Underpromise and overdeliver.	Overpromise or misrepresent to a source what you can or will report.
Report all sides of a story fairly and without bias.	Forget that facts can be easily checked online, so any clear bias will likely be noticed by sophisticated news audiences.
Know your audiences and create content for them without distorting facts.	Show obvious favoritism to one side of a story (unless you're writing an opinion piece or column).
Be platform agnostic. Be familiar with all the ways you can report a story, and choose the best tools for the job.	Limit yourself to a single platform or use only one tool to report a full-length story.
Promote your stories and media without directly promoting yourself.	Forget that your work speaks for you. (There is no better advertisement of your talents and abilities than a strong piece of journalism.)
Invest in the long-term by waiting to report on stories that need more time to research and develop.	Rush publication of unverified stories or facts.
Show respect for everyone you encounter while reporting or editing. In the world of online journalism, the person fetching your coffee today could be your boss tomorrow.	Treat anyone with anything short of the utmost respect when reporting and editing stories.

SUMMARY

Although it may not come naturally to traditional journalists, all journalists today need to understand the importance of personal branding. Despite some historically negative associations with the first-person point of view throughout journalism, personal branding is not only acceptable in the current online news marketplace, it is essential. Without a strong brand and the means to promote it, a journalist's message may get lost within a crowded

online marketplace of ideas, analysis, and opinion. Journalists also need to be aware of how they appear online by regularly conducting searches of their name and working to remove or bury any old or unfavorable content.

Journalists who have traditionally avoided the spotlight should keep in mind that branding is not about self-promotion or egotism. It is not, as branding expert Karen Kang reminds us, about "me," "me," "me." Rather, it is about "we" and serving the target audience or community with rich, relevant content that is valuable for its focus and relevance. We hear numerous times throughout this text that to establish and maintain their value to the community they serve, journalists need to deliver highly specialized content that people want or need. Unlike celebrities, journalists in the digital era need more than just a strong or interesting personality or voice to attract readers or followers. They have to fulfill an audience need. Successful branding will help them convey their specific expertise or niche to their target audience.

Journalists who can quickly and easily describe what they do and how what they do is different from what other entrepreneurial journalists and communication professionals can offer are at a distinct advantage over those who lack clear branding. Although chances may be slim that you will soon find yourself alone in an elevator with a potential funder who has the time and focus to field your pitch, having a pitch at the ready will come in tremendously handy when you are asked for more information about what you do for a living or what your long- and short-term goals may be. Consider your elevator pitch your in-person calling card.

JOURNALIST'S TOOLKIT

Entrepreneurial journalists can brand themselves online by creating simple, clear, distinctive identities on social media and the Web. They can develop their reputations for expertise in a particular subject area by offering relevant educational content. They can also build or reinforce a brand defined by a certain skill set by actively demonstrating those skills (for conducting research as one example) through their online "real estate."

Skills

Writing for the Web

Basic analytics and research

Developing specialties or domains

Basic website development

Social media management.

Tools

Desktop or laptop computer

Internet-connected mobile device.

Sites

Brandingpays.com: Karen Kang's professional branding website.

Constantcontact.com: A fee-based service for social marketing and managing campaigns.

Linkedin.com: The popular online professional network.

Mailchimp.com: A free and fee-based service for social media marketing and managing campaigns.

Reputation.com: A fee-based service for protecting online reputations.

Visualcv.com: Home page for the Web-based CV or portfolio site creator.

Application

1. Develop your personal branding statement. Start by listing your skills and qualifications as a journalist or communication professional. Browse job listings for positions you may eventually want to hold, and list five to ten of the qualifications most frequently cited in the listings. Compare your list of skills to the list of common skills. Determine what skill, experience or quality set could distinguish you as an applicant, and use that as the basis of your branding statement.
2. Check your reputation online. Enter your name into Google or other search engines, and see what information, images or other content appears. Determine the source of the first ten (if applicable) relevant items, analyze whether and why they would hurt or help your ability to find work, then make a plan to remove or bury potentially damaging items.
3. Use WordPress or a Web-based tool to create a personal CV or portfolio site that establishes your brand. Share the link to your site with your instructor and classmates. *Optional:* Workshop or critique classmates' online CVs or portfolios.
4. Script and practice a thirty- to sixty-second elevator pitch promoting your work to a potential employer or client. Record yourself on video making your pitch. Upload your video to YouTube and share it with your professor and classmates.

Review Questions

1. What does "branding" mean, and why is it relevant to journalists?
2. Why didn't journalists need to brand themselves decades ago?
3. What kinds of things should you consider when creating your brand?
4. Why does your branding need to be consistent?

5. What are the minimum requirements of an entrepreneurial journalist's professional website?

6. How do you remove online information about you on sites you don't control? What kind of information can't be removed? Are there specific laws in your state or country that determine what kind of content can and can't be removed from search engines and other online repositories?

7. What are the special branding considerations for those with common names and those with uncommon names?

8. What kind of information does and does not belong in an elevator pitch?

9. How do you know if your brand is successful?

REFERENCES

1. "Internet User Demographics," Pew Research Center's Internet and American Life Project, http://www.pewinternet.org/data-trend/internet-use/latest-stats/.

2. "Older Adults and Technology," Pew Research Center's Internet and American Life Project, http://www.pewinternet.org/2014/04/29/older-adults-and-technology/.

3. "More Employers Finding Reasons Not to Hire Candidates on Social Media, Finds CareerBuilder Survey," *CareerBuilder.com*, June 27, 2003, http://www.careerbuilder.com/share/aboutus/pressreleasesdetail.aspx?sd=6%2F26%2F2013&id=pr766&ed=12%2F31%2F2013.

4. Kang, Karen. *Branding Pays: The Five-Step System to Reinvent Your Personal Brand* (Palo Alto, CA: Branding Pays Media, 2013).

CHAPTER 11

Create and Manage Online Communities

The term "social media manager" appears with ever greater frequency on job search sites, but there is a lack of clarity and consistency in the job description and even the actual name of the position. The Creative Group recruiting firm lists fourteen separate positions, all with different names, under the "social media" umbrella. These include: blogger, community manager/online community manager, director of social media, interactive project manager, interactive strategist/social media analyst, podcaster, SEM (search engine marketing) specialist/manager, SEO (search engine optimization) specialist/manager, social media account manager/channel manager, social media coordinator, social media planner, social media project manager, social media specialist, and Web analytics specialist.[1] Most of these positions are new as of the last several years, and while they share several similarities and they can all trace their origins to the same trends in the media job marketplace, they are not all the same. Each represents a company's specific interpretation of what might generally be called the job of social media manager.

It is the expectation now that all companies and organizations have at least a Facebook page. Many also have Twitter and other social media accounts. Yet simply having these accounts is not enough. The way companies and organizations use social media sends a clear message to consumers and other stakeholders. Just like with individuals, if a company has social media accounts that are not maintained, that tells customers the company is not current or is not engaged with its audiences and clientele.

It is no longer a matter of competitive advantage. Individuals, companies, and organizations must show engagement with social media throughout the week. They must respond in a timely fashion to comments and questions people post to their sites. They must also respond to comments and questions on external social networks that may be critical to their business. These may include Yelp.com, TripAdvisor.com, Epinions.com, OpenTable.com, AngiesList.com, and others. Depending on the nature of the business, one or more of these forums may be critical to a relevant online community.

187

Companies that understand social media know how to productively respond to public messages, including criticism and complaints. Just as entrepreneurial journalists need to show engagement in social media, so do companies and organizations. Whether an in-house or contract employee, a social media manager needs to monitor clients' accounts daily—even on weekends—and

Figure 11.1

A Community Memory Project terminal from 1975 represents an early effort to engage communities through media. This one is at the Computing History Museum in Mountain View, CA. Photo by Kathryn Greenhill / Wikimedia Commons.

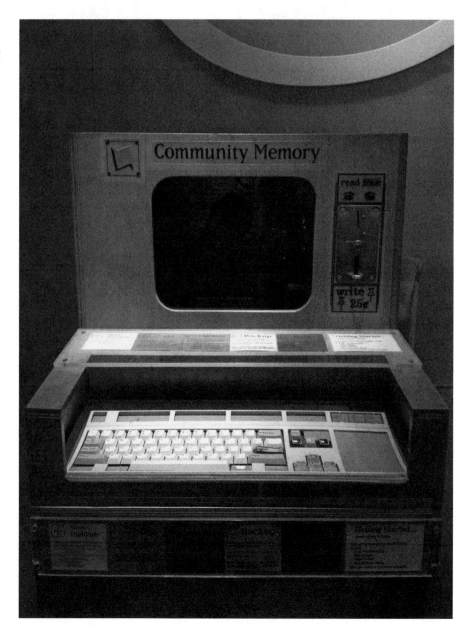

immediately respond to negative or critical comments posted anywhere online. A skilled social media manager is an excellent writer with strong editing skills who can express herself succinctly. While a social media manager would be wise to publicly thank those who post positive comments online, more important is the way she responds to negative comments and criticism.

As any trained public relations professional knows, positivity is essential to the job. Especially when comments are strongly negative or even angry and personal, it is the job of a social media manager to bring a more positive tone. If done correctly, this can actually win over new followers. Let's say a hotel guest posted a negative review on TripAdvisor.com, an influential travel information site. A well-trained social media manager will immediately respond to the complaint with an apology for the guest's negative experience, followed by a comment expressing the hotel's commitment to customer service, and a pledge to correct the source of the complaint. Depending on the nature of the complaint, the social media manager may also offer the guest something (possibly including a refund, partial refund or credit toward a future stay) to bring positive resolution to the problem and show goodwill. Responding to complaints provides businesses with an excellent opportunity to advertise their commitment to customer service. Failing to respond to negative comments, on the other hand, only reinforces the complaint and serves as negative publicity that could damage the company's business. This is just one example illustrating the critical nature of the social media manager's role in business today. It is hardly the only compelling example.

While most companies and organizations these days need to have some social media presence, the kind of presence and how they want to engage the public depends on their mission and goals. While for some companies and organizations, simply having a social media presence that they maintain is enough, others want active engagement with their audiences. The latter group may hire contract employees or firms to manage their social media presence. Some may hire writers or bloggers to actively represent the voice of the company. Experienced entrepreneurial journalists and journalism graduates are top picks for these positions.

Professional and corporate bloggers are writers first and foremost. Depending on whether they are internal (full-time) or external (contract) employees, they may also be part of the public relations or marketing team, and may produce content for the organization's website, or write press releases or speeches. Another social media position with close ties to journalism is podcaster. Corporate podcasters may do work that is quite familiar to those with a broadcast background. They may host shows or events for listeners in search of an organization's highly targeted content. Bloggers, podcasters, and other content producers may also work within companies, writing and creating media for internal websites, company newsletters or other internal communications.

Another type of social media job that requires highly developed communication skills is a community manager or coordinator. Although this kind of job goes by different names, it often requires professionals to interact with an organization's communities in a way that reinforces the organization's brand while providing a voice and a human touch, which is something customers crave at a time when companies have automated much of their customer service operations. Community managers and coordinators do the kind of work discussed earlier. They may post and respond to posts to the organization's social media accounts. They may also be tasked with launching interactive online initiatives designed to engage their communities and attract more members to join. They may start discussions relevant to the community, plan synchronous online events for their communities, or offer customer support. They may also post educational or instructional content that may add value to their customer relationships.

Entrepreneurial journalists with research and Web analytics skills are still rare and in demand. Whether you want to work for yourself or for others, demonstrating proficiency in communication research, Web analytics—including trends, metrics, and search engine optimization—should make you a highly sought-after candidate in the coming years. Although the position may not immediately catch the attention of entrepreneurial journalists and journalism students, market research analysts, who possess many of the same skills entrepreneurial journalists need today, are projected to be among the most in-demand workers in the coming years.

According to the United States Bureau of Labor Statistics (BLS), the job outlook is good for those who understand data and can conduct market research to better understand the profiles of specific audiences, including their interests, and online and consumer behavior. Regardless of the industry or job title, knowing how to identify and find target markets (or audiences), understanding their needs and interests, and measuring their responses to communication messages in order to better target them in the future will make an entrepreneurial journalist or someone with the training or experience of an entrepreneurial journalist highly employable. Although most market research analysts previously worked in marketing, research or sales, since the rise of social media, the quantitative and analytical skills that journalists now need have expanded their job prospects. These skills have also better prepared journalists to work for themselves and to improve the reach and impact of their own content. The BLS projects that job opportunities for market research analysts will increase by 32 percent by 2022, a much faster rate than for most professions.[2]

COMMUNITY IS KING

Amani Duncan's job provides much insight into the convergence of journalism careers. Although she shares skills with the journalists she employs to create editorial products for a community of readers and viewers, she

also runs a marketing department. She works with communication professionals both inside and outside her company to maintain and grow a dedicated online community through social and online media. She even employs a social media community manager. (You'll find that job description later in this chapter.) She is a manager, a content creator, and an editor. If she worked for another organization or for herself, she may have a different title. Her job description crosses several lines in ways that may not have been possible just a few years ago. Although the idea of working for a marketing department may not immediately appeal to someone who studies journalism, there are likely aspects of her job that seem familiar and, frankly, fun.

INTERVIEW: A Conversation with Amani Duncan, Vice President of Brand Marketing for C. F. Martin & Co.

Describe what you do.

I oversee the marketing department at Martin Guitars. That encompasses everything from digital marketing to social media marketing. I oversee the website and our social media. It also encompasses design services, which is our graphic designers. I'm also in charge of our artist relations department, which deals directly with our various ambassadors. I also oversee our eCommerce store, called the 1833 Shop. And we also have a storefront here at our Nazareth [PA]-based factory, so I oversee all of our Martin gear, which is our clothing and novelty and accessories line. We use an independent public relations company based out of New York City. I oversee them. And I work with various consul-

Figure 11.2
Amani Duncan.

tants that help us with our digital marketing strategy. We also partner with an advertising and creative agency. I call myself a support service department because marketing has their hands in every facet of the company.

Do you have a background in journalism?

I freelanced as a journalist. I've always had a love affair with the written word. It has served me well throughout my career. Now it's kind of like the middleman is gone. I have direct relationships with all the journalists who work with all the publications we partner with. That wasn't the norm many years ago.

How can you be sure, coming from marketing, that your content will be relevant to a community that doesn't want to be sold to?

I try to remove my personal feeling from almost everything we approach, and I try to train everyone to do that. You have to take yourself out of your job mentality. You almost have to force yourself to look at things from the end user's perspective. Information is key. We have created a direct dialogue with a lot of our consumers through social media. I run a lot of surveys, and I did that the first couple years when I started with the company because I didn't want to assume anything. I wanted to hear from our core, from our base, what they were thinking, what they were feeling, what they like because I knew I was going to be making a lot of changes that they would feel were radical. When I first started here our core consumer was older. We had a very specific demographic. I knew I was going to be ruffling some feathers because I was expanding our reach to recruit a new consumer that was possibly young and female, but I was also going to change a lot of things that over the years they got used to. We did a lot of polling. We did a lot of research, and we got amazing data back. So we took that information and we used it to our advantage. We applied it to everything we did—the website, original content. And we tried to stay authentic to who we are. I wasn't coming here to change a company with 182 years of history. I appreciate brands that are authentic and that are true to who they are and proud of who they are. We have a very strong ethos, so I stayed very much in line with that. I made everything a little shinier, a little newer, but I made sure we stayed true to the authenticity of the brand. We tested the waters a lot on social media. We would post things to see if we got a reaction, if we were on the right track. We played a lot in the beginning, and we still continue to test the waters and be provocative because we always have to take a temperature check to make sure that what we're doing is appealing to a very wide and diverse consumer base. It's not just our core that we're trying to appeal to. We're also trying to recruit a new consumer. It's really difficult to find that balance, but I think we're doing a good job at that.

Where do you reach your audience, your community, today?

When I first started, our core demographic on Facebook was 55-plus. Now we've evened that out. So our biggest core now is the 18-to-24-year-old. I know now that the marketing message and the communication that we're deploying across our social media platforms is bringing the right reaction. We're not isolating one demographic, and we're also not catering to one demographic. The content and the messaging seems to be appealing to a very wide and diverse demographic, which is really hard to do.

You publish a magazine, the **Martin Journal.**

We did one in print in January 2014. And we do a summer edition that's only available via download, and it's a small, more condensed version. The

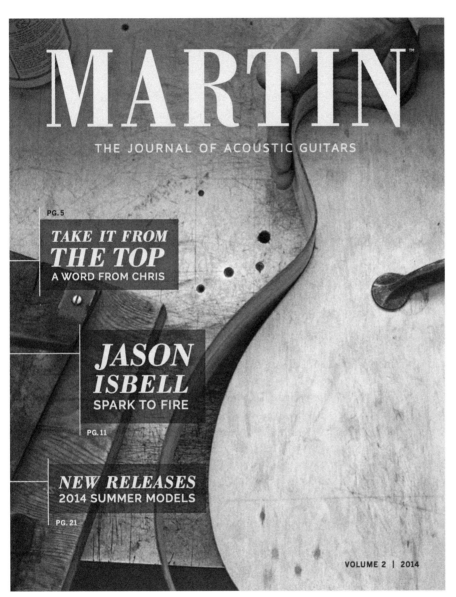

Figure 11.3
The Martin Journal.

big marquee pieces are released every January. When you look at the diversity of articles, that really illustrates the overarching marketing strategy. In the debut edition that came out in print in January, we had an article on John Mayer. We had an article on Ed Sheeran, singer–songwriter. But we also had articles on our history. We try to make sure we have something for everyone.

For someone who is 65 years old, the Ed Sheeran article may not have been appealing. But the publication is still of value because we have other articles that may appeal.

Describe your role in the editorial production process.

My role in this is the editor in chief. We used to have something called the *Sounding Board*, which was a leaflet-style paper newsletter. This was prior to my coming on board in 2011. It was kind of a passion project that was started internally, and it kind of lost its way over the years. People weren't really reading it. To me it wasn't quite on brand. It served a purpose fifteen years ago. I took it on and I said, "We need to revamp this." So I basically came up with the whole concept of what you see today with the *Martin Journal*. I think about the stories and the topics in advance, then I have a suite of professional journalists who are in my Rolodex, and I marry the story with the appropriate journalist. I know their writing style will complement the topic. And then the process gets started. We start with interviews, then there are various drafts. I will go through every draft and mark it up and do rewrites. It's the typical publication process. But I come up with the topics. It can be anything from a new artist we're working with to a milestone event—maybe an anniversary. This year we have an exhibit at the Metropolitan Museum of Art that's running all year. We did an article on that. I want it to be a lifestyle publication because I firmly believe music is a lifestyle. I want it to encompass the Martin guitarist lifestyle. The pieces run the gamut, but I always want them to be newsworthy—what's happening now or what will be prominent in the year that it's released. And it needs to be core to our business. So there will always be a feature on guitars. There will always be a feature on our guitar string line. There will always be a feature on artists because we all know the power of musicians. Everyone wants to be and play like their favorite guitar player. And there's the human interest piece. I work with our creative agency, Spark. They're based in Bethlehem, PA, and they help with the layout of the magazine. We come up with the cover ideas. Basically, I create the roadmap. I outline everything that we want. I storyboard it. And then I deploy it to all the appropriate people. As the editor in chief, I have the final say. I do all the editing—what stays, what doesn't stay. Just a typical magazine process.

How do you assess your reach?

In marketing it's so difficult to show positive ROI [return on investment]. It takes a while. When you're starting a new campaign it can take upwards of two years for the end user to really feel the impact of your efforts, so you have to pace yourself and remind yourself that it's not a sprint but a marathon. It's always a challenge in marketing to show positive ROI. You're asking for big budgets and you're asking for a lot of money to do a lot of cool things, and then your finance team or your CEO is asking, "Can you quantify this? How can you show me that this is going to be a positive return on our investment?" The blessing for marketing is social media because they gave us the

opportunity to actually quantify things. When I hear, "Amani, I don't like this new catalog you did, I don't think it's resonating with the consumer," what I can do to address that is run a quick, easy survey, ask the right questions and get direct feedback from the consumer base, and let them speak for it. We do that all the time.

Describe your in-house team.

I created a team. I hired a social media marketing manager. It's a full-time position that a lot of companies have now, which is really exciting. Using social media is the best way to directly communicate with your consumer base. You have an audience of people who have voluntarily chosen to be

Figure 11.4

Dimensions of social currency. Image by Vivaldi Partners / Wikimedia Commons.

part of your community for whatever reason. But it's also a very serious position because, as we all know, you can also lose a lot of fans. It can go both ways. Whatever you put on the Internet—and this is a lesson a lot of people are learning the hard way—just because you delete it, it doesn't go away. Once you put something out on the Web, it's out there forever. That's a huge responsibility.

How has your content affected the brand and the community that is loyal to that brand?

We had a very distinct perception in the marketplace. Over the past couple of years we've changed that perception through the way we're marketing the brand to the public at large. And the response has been overwhelming. Mind you, there are some people who hate it. You can't please everyone. We know this. But our main goal is to constantly look forward while staying authentic and true to who we are. That's really all we're trying to do. We need to make sure that when our core expires, there's a new group of people who will become our core. It's what every brand goes through. You always have to gain and recruit new consumers who will become the loyalists. It's a never-ending process.

JOB DESCRIPTION: SOCIAL MEDIA COMMUNITY MANAGER

Non-newsroom and corporate editorial positions have evolved in recent years from strictly marketing jobs to a more nuanced kind of work that can be virtually indistinguishable from what is done at some traditional news outlets. For people who may be more interested in research, writing, and online community building, "social media community manager" could be a good fit. The job titles differ from company to company, and they are often housed in marketing departments, but the job can be quite similar to that of an editor of a magazine that serves a specific community. Martin & Co., a prestigious guitar manufacturer based in Nazareth, PA, has an almost 200-year history and a highly specialized community of devoted followers. You just read an interview with Amani Duncan, the company's Vice President of Brand Marketing. To help us clarify the role of community building as it is defined in her company, Duncan provided a job description for the Social Media Community Manager position at Martin. This is just one example of how the role is defined. Like most positions, job responsibilities vary and work is categorized a little differently, but there are likely many similarities between the description below and those you'll find for any number of other positions that may be loosely described as "social media manager."

POSITION DESCRIPTION

TITLE: Social Media Community Manager
FUNCTION: Marketing
REPORTS TO: Vice President, Brand Marketing

Summary description

The Social Media Community Manager will oversee the social media marketing efforts for the C. F. Martin & Co. brand and associated social media sites. This person will be responsible for leading digital strategy for actively engaging customers and influencers within social media channels, as well as, managing the day-to-day communications across all of the brand sites measuring and reporting on success of the program(s). Other responsibilities will include assessing and working with digital media solution providers that will help elevate brand conversations and engagements online, including, blogs, social media channels and networks, and our brand sites.

Specific duties and responsibilities

1. Strategize with and educate the management team and others across the organization on relevant social media techniques.
2. Experiment with new and alternative ways to leverage social media activities (marketing R&D).
3. Develops and assists in executing C. F. Martin & Co.'s Digital Marketing strategy across multiple platforms.
4. Works with various internal business units to help mold the content strategy.
5. Directly influences audience growth around the web.
6. Generates content on a daily basis for social media and blog using text, video, and graphics to engage audiences.
7. Oversees Martin Blog and e-Newsletter, managing all email lists and relevant segmentation.
8. Responsible for hitting online Martin Gear sales goals through active promotion.
9. Works with vendors to create, promote, and report on contests.
10. Maintains and reports on Facebook advertising.
11. Supports the generation and publication of content—implement and manage daily and weekly assignments to promote editorial features, posts, comments, video, and other content.
12. Researches and develops ongoing online partnerships, blogger relationships and social media tools.
13. Other assignments related to growing social media outlets members, loyalty and advocacy.
14. Measures and reports on the contributions of the individual tactical activities. Recommends improvements based on the results.
15. Provides competitive intelligence to Marketing department of competitors' activities.
16. Leads on developing relationships for all relevant social media sites.
17. Works with the marketing group on overall marketing plans for key initiatives and the categories.

18. Ensures consistency in design, timing and message with all other marketing disciplines.
19. Represents the social media efforts in strategic development discussions with entire brand team.
20. Researches opportunities to share content and provide digital guidelines and expectations.
21. Manages third-party agencies and vendors, including implementation, day-to-day operations and optimization.
22. Oversees resource to track results; data analytics.
23. Builds and maintains relationships and work with sponsors, media outlets and other business partners to create integrated marketing and promotional campaigns.
24. Conducts website usage and content research, audit competitive sites, and analyze site log and usage data to optimize the customer experience and to ensure that the company has the most effective site possible.
25. Perform all other duties or functions as assigned by the Vice President, Brand Marketing.
26. Select, promote, transfer and otherwise treat employees equally without regard to race, age, creed, color, sex, national origin, veteran status, mental/physical disability that can be reasonably accommodated, or any other characteristic protected by law.
27. Implement and assure adherence to governmental and company policies regarding Equal Employment Opportunity and Non-discrimination compliance in the incumbent's span of control.

Position requirements

- A relevant related Bachelor's degree is required, minimum of one–two years social media marketing experience.
- Experience with implementation of online ads, knowledge of search, online and social media application.
- Strong quantitative and analytical skills.
- Demonstrative creative and idea generation.
- Organized and detail-oriented.
- Outstanding verbal and written communication skills.
- Knowledge of media and digital media landscape with ability to translate to impact marketing opportunities.
- Ability to manage self and working environment.
- Ability to persuade and negotiate effectively.
- Planning and organizational skills.
- Ability to recognize critical problems and opportunities.
- Understanding of general media concept applications in the digital world.

- Ability to understand and create cross-platform media campaigns.
- General knowledge of all media types and their core attributes and measurement.
- Ability to work with multiple departments.
- Proficiency in the following:

 o HTML/CSS
 o Community Management
 o Google and Facebook Analytics
 o Copywriting
 o Adobe Photoshop
 o Adobe Illustrator
 o Adobe InDesign
 o Adobe Flash
 o Adobe Dreamweaver
 o WordPress, Blogger, Tumblr coding/updating
 o Microsoft Office Suite
 o Final Cut Pro preferred.

Core competencies
- Adaptability
- Building partnerships
- Building trust
- Communication
- Customer focus
- Decision-making
- Facilitating change
- Innovation
- Leading through vision and values
- Planning and organizing work
- Strategic planning
- Technical/professional
- Work standards.

Job description reprinted with permission of C. F. Martin & Co.

THE SOCIAL WEB

The Internet is a network of communities connected by common interests and motivations. Like terrestrial communities, virtual communities strongly identify with the community and each other. But in many cases they are stronger than terrestrial communities because they self-selected their community membership. For this reason, online communities tend

to be more diverse and more opinionated about their likes and dislikes. Communicating online often reinforces the community's similarities while reducing its differences. In early 2014, Facebook and researchers at the University of California San Diego and Yale announced the findings of research they had conducted secretly on Facebook users (who were anonymized in both data collection and reporting). The study concluded that emotions were contagious in online communities. By tracking the posts of 100 million Facebook users in the United States, the researchers determined that viewing positive posts (that contained positive words such as "happy") made users more likely to post their own positive messages. According to the research, negative posts (that contained negative words such as "sad") had a similar but less dramatic effect, slightly increasing the number of negative posts by those who received them.[3] The size of Facebook's community allows for research at a scale that was previously impossible, although some Facebook users were disturbed to learn that they had unwittingly taken part in a research study. A few months after Facebook's study on contagion of user emotions, the company's Chief Operating Officer Sheryl Sandburg admitted to other research Facebook had conducted on users, and said the company was looking into the way it conducts research with plans for improving the process.[4]

LEARNING FROM OKCUPID

Facebook is hardly the only social media company to conduct research on its users. The dating site OkCupid.com regularly conducts research on its users— and co-founder Christian Rudder has openly blogged about it using a style and tone that reinforces the company's fun, young, offbeat brand. In a July 28, 2014 blog entry, following the backlash against Facebook for conducting experiments on its users without their consent and before the imminent release of Rudder's new book on data called *Datacylsm*, Rudder addressed the Facebook backlash, then explained some of the research his company has conducted. From a public relations perspective, it was a very smart idea to get ahead of the news by framing, explaining, and contextualizing it before an angry public and a curious press defined OkCupid's problem for them. Rudder's entry on the OkCupid blog, called *OkTrends: Dating Research From OkCupid*, was frank, funny, and engaging. And for those otherwise not familiar with the company, it revealed, in an entertaining way, much more about the OkCupid community than any mission statement could (although an unofficial company motto that reads "We do math to get you dates" might as well be a mission statement).

Rudder wrote:

> We noticed recently that people didn't like it when Facebook "experimented" with their news feed. Even the FTC is getting involved. But guess what, everybody: if you use the Internet, you're the subject of hundreds of experiments at any given time, on every site. That's how websites work.[5]

Rudder went on to describe some of the other experiments OkCupid had conducted on its users. Most of the research cited was about how profile photos affect user interaction on the site. The research, while maybe not completely scientific, was entertaining and likely relevant to users, but discussing it was all about preventing the kind of backlash Facebook experienced when it experimented on its members. It was also about engaging the community in a personal way. For a young, fun, experimental community such as OkCupid, any other kind of communication—especially a faceless corporate message—would've shown a disconnect with members and a disrespect for what makes them special. Although Christian Rudder is a businessman, his entrepreneurial journalism skills have made him successful. Not only can he write engaging content for narrowly defined communities, but he understands social media and metrics, as well as good old fashioned marketing and public relations techniques. While few would call what Rudder does journalism, he is living evidence of the versatility of entrepreneurial journalism training today.

MARKET RESEARCH AND MEASUREMENT

In the not too distant past, advertising was advertising, and editorial was editorial. Neither ventured into each other's territory out of both tradition and ethical concerns. The worry was mostly on the editorial side, where, it was thought, if journalists were too aware of which advertisers were funding their paychecks, that knowledge may consciously or unconsciously affect the way they did their job. Maybe they'd be inclined to write favorably about an advertiser, for example. Although attitudes took several years to evolve, entrepreneurial journalists are often as involved in the business of their work as only advertising sales representatives once were.

While some entrepreneurial journalists may be hired to do the kind of work for news or commercial organizations that may have been done only by marketing specialists in the past, others will need to apply their marketing skills to their own research, and to their own branding and distribution campaigns. Whether they're working for themselves or for others—and particularly if they're trying to monetize a blog or other online endeavor—today's entrepreneurial journalists must understand how media metrics work.

Figure 11.5

OkCupid co-founder Christian Rudder performs with Bishop Allen in 2007. Photo by Mwadley / Wikimedia Commons.

Aside from the fun and gratification of assembling a large group of online followers, growing a huge readership for your website or blog can bring financial rewards. While revenue raised through online advertising is notoriously small, selling advertising may be just one of many ways you can monetize a strong online brand. That is the nature of the new Internet economy. Strong brands can be monetized in any number of ways. However, even today's strongest online brands (Amazon did not expect to turn a profit for years after its founding)[6] required years to achieve profitability.

ADS, ANALYTICS, AND OPTIMIZATION (SEO)

The more clicks, page views, and time spent on your site, the higher the site will rise in analytics trackers. But first you have to know how to attract visitors. Understanding search engine optimization (SEO) will help. Knowing how to tag your content with keywords that help it appear higher in searches will go a long way toward improving the searchability of your site. Make sure to submit your site to search engines such as Google, Yahoo!, and Bing to ensure it appears in searches as soon as possible. (Unless you restrict access to your pages, search engines will eventually find them.) If you host your own site and have access to its source code, you can register for Google AdWords or other services that drive traffic to your site through ads based on keywords you select. With AdWords, you create a daily budget that sets a top

limit on how much you're willing to pay for clicks to your site from Google searches using your selected keywords. Google Analytics or other Web analytics services (WordPress.com has its own) measure traffic to your site. As you build traffic, your site becomes more valuable to potential advertisers. If you host your own site and have access to its source code, you can create an AdSense account that lets Google place ads targeted to your content on your website. You collect a small fee from the highest bidder for the ad space on your site. (The revenue is small, and the bidding happens instantaneously.) Additionally, you can sign up for an affiliate program, like Amazon's, in which you get a small percentage of purchases that were made by people who clicked through to Amazon via an Amazon link on your site.

Most of the work you will do to improve traffic to your site will not be advertising. It will be search engine optimization (SEO), a term that encompasses small adjustments you can make to your site to maximize the amount of traffic it receives. Google offers users its own suggestions for improving SEO.[7] In addition to directing users to their Webmaster Tools, Google offers advice for writing clear HTML that will allow the search engine's tools to more easily find things like headlines. It also provides basic guidelines for writing headlines that can more easily be searched and for posting searchable images.

Text—especially in headlines—should be short, accurate, and, if possible, unique. When writing titles or headlines, consider the way you search for things online. When you search, you don't want to waste time looking at the wrong sites. You want to find the right content right away. A creative headline may draw some attention, but if it is misleading or vague, it will be less likely to appear high in searches. Make sure to include several accurate search tags for each post. These will also help more people find your content. Remember that long titles and headlines may not appear in their entirety on a Google search results page. Make sure the descriptions for each page are also accurate, short, and unique. Specificity here will help differentiate your pages from similar pages as well as from other pages on your site. Also make sure the structure of your site—pages and subpages—is clear and logical so that Google's bots can more easily find important content that will be relevant to Web searches. Use links instead of images, and make sure the anchor text (which readers click on to link) is clear and compelling so that both readers and Google bots can easily determine its importance. Avoid complicated navigation through multiple subpages. This will also make it easier for users to access your content with minimal clicking. Google makes some common-sense suggestions for increasing traffic to your site. Most important is posting useful content that is well organized and clearly written. Post fresh content frequently to keep visitors coming to your site while attracting new visitors.

Whether you're creating your own website from scratch or using a visual Web editor like the kind you'll find in WordPress.com and most blogging and Web development platforms, make sure your images have a clear file name as well as alternative text. The alternative text is also important from an accessibility standpoint. Visually impaired people who use screen readers rely on alternative text to "read" the images on the page. Without these, your site isn't fully accessible.

THE NATURE AND NEEDS OF ONLINE COMMUNITIES

In recent years online communities have increasingly become more involved in content curation than creation, as users engage in more linking, reposting, retweeting, and reblogging. This trend has emphasized the need for journalists to differentiate themselves by creating original content. Demand for content curation helped hasten the rise of online media communities several years ago, as the amount of online content being produced each day had grown to the point where daily users of the Web felt overwhelmed. They wanted to limit the number of Web pages they needed to visit each day in order to feel informed.

Content curation was a natural fit for a social medium that emphasized sharing and collaboration. However, in more recent years, even the curated content has begun to overwhelm as a number of free Web-based curation tools grew popular. The San Francisco-based Storify was developed in 2010 to "Make the Web tell a story,"[8] according to its home page. Storify is a free service that allows users to create and share stories by recombining bits and pieces of existing stories. At its best, Storify can be a way to collect a range of comments and points of view on particular topics, then to make meaningful connections with new text. However, far too many Storify stories tell no story at all. Rather, they are lists of tweets and other social media posts on the same issue. While countless journalism students have experimented with creating new "curated" content with Storify, the platform has failed to generate the buzz needed to become a journalism game changer. While journalists may want to assemble existing content to contextualize their stories, they need to provide more value to the community than simply assembling content, much of it from those without formal training. So while the need to make the ever expanding world of online content more manageable remains, it is also more critical than ever that those with journalism training and skills provide needed context to ensure that curated content is more than just collections and lists, but that it actually tells a story.

Despite Storify's limitations, it can be a great research tool, allowing journalists to easily find posts on a particular topic or by particular people. Other

social media platforms allow reporters to quickly conduct background research that can contribute to their reporting. Many publications have successfully used Storify to broadly and quickly survey public opinion on controversial topics or on election day. It is hardly scientific or in-depth, but a Storify report can produce a snapshot of public opinion that would otherwise take much more time and effort to gather.

SUMMARY

Developing, maintaining, and growing online communities are all key to forging strong brand relationships. The larger and more dedicated the community, the greater its value. Not only do individual journalists and bloggers want dedicated followers to consume their content, thereby increasing its value, but companies also want to keep and attract new users and subscribers who may ultimately buy and promote their products.

These days companies that produce branded content create and distribute their publications in much the same way traditional news organizations do. There is now a much larger overlap between the work of journalists and marketers than ever before. Journalists from the legacy press may find the idea of working closely with marketing staff professionally uncomfortable because of the latter field's strong association with sales. But if the content the marketing department creates does not uphold the highest standards of ethics and relevance, it will be useless to the company because the target audience won't consume it. Audiences demand content that is personally relevant and valuable, regardless of who produces it. To create anything less than that would not be sustainable to anyone interested in maintaining and building an audience.

Central to determining the success of a website, blog or online publication are analytics. Data assembled through analytics include the number, frequency, and duration of visits to a website or page, demographic information about those who visit, and the way visitors to a site interact with its pages and content. Much more detailed and accurate than traditional media audits that relied largely on self-reported information gathered in telephone interviews, Web analytics provide essential feedback to those who determine and direct online content. Analytics data can aid in deciding which content is appealing to visitors and should be promoted, and which content is not appealing and should be deleted. These decisions allow a site to better serve the interests of its key audiences while helping to meet the needs and serve the interests of more readers and viewers. Effective analytics tools now available to bloggers and journalists working online include Google Analytics, Quantcast, and Google Webmaster Tools.

JOURNALIST'S TOOLKIT

The mass media world is gone. Today we live in a global world composed of smaller self-selected communities, many of them online. Dedicated communities are valuable to any organization capable of commanding their attention. Not only do communities serve as a built-in audience for the journalist's and his company's messages, but they are also potential brand ambassadors that could help continue to grow and increase the community's value, and not just in terms of sales. From the journalist's standpoint, without community, no content can be disseminated or shared.

Skills

Writing

Editing

Basic layout skills

Web analytics.

Tools

Desktop or laptop computer

Web-based analytics software.

Sites

Angieslist.com: A subscription-based crowd-sourced review site for local businesses.

Epinions.com: A consumer review site.

Martinguitar.com: Online home of C. F. Martin & Co.

Okcupid: Free dating and social networking site that conducts research and uses personality tests to match people.

Opentable.com: Online network for restaurant reservations and reviews. Frequent users can earn points toward free meals.

Martinguitar.com/news/martin-the-journal-of-acoustic-guitars.html: Online home of *Martin: The Journal of Acoustic Guitars*

Tripadvisor.com: Crowd-sourced travel review site.

Yelp.com: Crowd-sourced review site for businesses and services in local markets across the United States, Europe, and Asia.

Application

1. Find a publication or website for a product or company that offers editorial (not just advertising or promotional) content. Write an analysis of the publication that describes its editorial features, as well as any advertising or promotional features. Try to contact a representative of the company behind the publication to determine its staff structure and the professional backgrounds of contributors. In your story, describe how closely the publication resembles a traditional editorial product and what, if anything, is unique about the publication. *Optional:* Pitch the story to your school's newspaper or another publication.
2. Find the *Martin Journal* online (martinguitar.com/news/martin-the-journal-of-acoustic-guitars.html), and compare its contents to those of the most similar magazine you can find at a newsstand or bookstore. Describe the similarities and differences. If you saw the *Martin Journal* on a newsstand, would you immediately know it was published by a guitar manufacturer? What details or information set it apart from other magazines?
3. Develop a pitch for a non-media news site for a company or organization that interests you. Include specific details about content, design, and distribution ideas.

Review Questions

1. Why would a non-media company decide to produce and distribute media?
2. Why are there so many different titles to describe employees who manage social media?
3. Why would a company need a social media manager?
4. Why is it important for a non-media company to build and maintain an online community?
5. Under what (if any) conditions would you work for a news site run by a company or sponsored by a product? What kind of research would you do before accepting a job with the company? What kinds of questions would you ask in employment interviews?

REFERENCES

1. "Social Media Job Descriptions," The Creative Group, http://www.roberthalf.com/creativegroup/social-media-job-descriptions.
2. "Market Research Analysts," *Occupational Outlook Handbook*, U.S. Bureau of Labor Statistics, http://www.bls.gov/ooh/business-and-financial/market-research-analysts.htm.
3. Hotz, Robert Lee. "Emotions Vented Online Are Contagious, Study Finds; Feelings Posted on Facebook Can Spread to Others, Research Shows," *Wall Street Journal*, March 12, 2014.
4. Reed, Albergotti. "Facebook Experiments Had Dew Limits; Data Science Lab Conducted Tests on Users With Little Oversight," *Wall Street Journal*, July 2, 2014.

5. "We Experiment on Human Beings," *OkTrends*, July 28, 2014, http://blog.okcupid.com/.

6. Saul, Hansell. "A Surprise from Amazon: Its First Profit," *New York Times*, January 23, 2002.

7. "Search Engine Optimization-Starter Guide," Google.com, http://static.googleusercontent.com/media/www.google.com/en/us/webmasters/docs/search-engine-optimization-starter-guide.pdf.

8. "Storify," https://storify.com/.

Strategic Planning and Management

One of the great things about managing and maintaining media organizations is that the tools most likely to grow a small business these days are the very means of communication that are the foundation of the business. Two of the business magazine *Fast Company*'s "five essential principles for growing your small business" are "brand, brand, brand" and "embrace technology." In its discussion of branding, the magazine includes suggestions to narrow your target audience and not "try to be all things to all people," to foster the community's emotional attachment to the brand, and to "inspire and influence your audience."[1] Happily, if you've followed the tips in this book, you're already quite focused on these objectives.

Fast Company's other three tips apply mostly to traditional brick-and-mortar companies that rely on conventional sales for growth. That your entrepreneurial business or enterprise is built on both branding and technology puts you that much further ahead. But the unconventional metrics by which technology businesses are assessed and measured can make it difficult to determine the relative health of a media business. This means traditional measures often don't quite work, and that entrepreneurial journalists who have launched their own businesses have to find new and different ways to measure success.

But where to start? The best way an entrepreneurial journalist—just like an entrepreneur in any field—can determine the success of his venture is to have established measureable objectives for himself in the first place. For most, this entails the creation of a strategic plan that outlines goals and measures of success for the enterprise's first year or two—or three, five or, really, any number of years, although a new business should be assessed more frequently than an established one. For online businesses, just like traditional brick-and-mortar businesses, it all comes down to return on investment, or ROI. Basically, you want to make sure that your investments (in both time and money) generate more revenue (or potential revenue—or, if you prefer, followers, subscribers or some other measure you find important) than they cost. Like with

any business, the goal is to get more out of the transaction than you put into it. While most people who start businesses create an ultimate goal of making money, your goals may differ depending on your values and timeframe. In the media business, the goals are often abstract, and may be longer-term than a typical business cycle.

In Chapter 6 we discussed developing a strategic plan. One of the main reasons for creating a strategic plan is to develop a plan for your business to become sustainable within a limited period of time. That doesn't necessarily mean it needs to turn a profit within one, two, three, five or whatever number of years, but it does mean that there needs to be a plan for the business to at least not exhaust its resources before it has a chance to meet its goals.

Savvy marketing may help you attract more subscribers, hits, page views or social media mentions. But none of these measures creates revenue in and of itself. Measures can provide evidence of your progress toward goals. They can even help you achieve your goals. But they aren't the ultimate goals of any enterprise.

Ask yourself: What are your ultimate goals? Would you like the business to be self-sustaining in five years? In three years? What would it take for your business to be self-sustaining? Be realistic. Stick to a budget. You should have addressed these questions when you first started planning for your business. Your initial strategic plan should have established timeframes or milestones when you would check the enterprise's progress toward its stated objectives. An honest assessment of progress is essential. The plan should have included means of assessment. Would you survey subscribers? Would you hold a focus group? Would you simply look at numbers—the number of visits or the number of subscribers?

Beyond the specifics of the strategic plan, a successful company also fosters and encourages constant self-evaluation and assessment. Especially in the media and communication fields where technology brings perpetual evolution and flux, companies and individuals can't afford to simply sit back and wait to see what happens next. Media companies in particular need to stay one step ahead, to respond proactively to trends and be ready for whatever tomorrow brings. Whether an entrepreneurial journalist is working for herself or for others, assessment—of herself, of her audiences or clients, of the marketplace—will help her stay sharp and relevant. A thorough and accurate assessment can help determine what an individual or organization is doing well, what it could be doing better, and what it shouldn't be doing at all. It can identify new opportunities that are not currently being considered. It can also identify threats that the organization may not currently recognize. You will remember these questions from SWOT (strengths, weaknesses, opportunities, and threats) analysis.

REVISITING THE STRATEGIC PLAN

Your strategic plan isn't just for starting your business or enterprise. You also need to review it at the milestones you established in the initial plan. Let's review the plan. There isn't one set format for a strategic plan. You should choose a format based on your needs and values, as well as your goals for the enterprise. There are lots of strategic plan templates available for free online, but not many of them are well suited to entrepreneurial journalism, where the goals will likely differ quite a bit from the sales goals of a typical business. There is no need to follow an existing template. You may actually want to create one yourself that is customized to your needs. It doesn't have to be complicated. The basic format can be a simple table.

Before you begin to construct the table, you need to conduct a comprehensive assessment of the environment, your audience and their needs, as well as your own abilities or deficiencies when it comes to serving those needs. Because individuals and organizations have a hard time honestly assessing themselves as they appear to others (and not just considering how they appear to themselves), Forbes suggests that those conducting a self-assessment undergo both internal and external audits.[2] Depending on the size and scope of the business, these could either be small and informal or large and extensive. You may, for instance, conduct a small focus group, then create a short survey to collect feedback from targeted audiences. Your research should be focused on determining your audience's perceptions of the marketplace, your competition, and yourself. Reconsider your mission (who you are) and vision (what you want to be). Are they both still right for the enterprise? Do you need to adjust them? Are you on track to achieve the goals you set for yourself at the beginning? Do you need to create new goals? What are the next most critical objectives for yourself or the organization?

Keep in mind that goals are broad ideas while objectives are measurable steps along the way toward achieving those goals. Make sure to list your organizational objectives, then designate a responsible party for ensuring they are achieved. Forbes also suggests that you return to the strategic plan frequently to remind yourself of your goals and to make adjustments as needed.[3]

CONDUCTING A SURVEY

Surveys are comparatively easy ways to collect information from targeted groups. Most surveys these days are conducted online, and they are inexpensive to administer. There are many Web-based tools now available to quickly and easily administer surveys to anyone with access to a computer with a high-speed Internet connection. Just like companies that sell goods or

offer services, media organizations may periodically want to know how they are performing in the eyes of their key audiences or markets. They may also want to know more about their key audiences—specifically, they may want to know more about the way readers, viewers or listeners live to better understand their needs and interests, and how they may best be able to serve those needs and interests.

While media organizations, like businesses in other marketplace sectors, want to know how they can better serve their customers, they also want to know how they can clarify or reinforce their brand. In general, surveys should be short (unless completers are offered incentives), well focused, and clear. Unless you are offering incentives, understand that long surveys are unlikely to be answered. No matter how well you target your potential survey respondents, you can expect only a fraction of recipients to respond. The popular online survey company SurveyMonkey explains that a good response rate is 20 to 30 percent.

Figure 12.1

A snapshot from a SurveyMonkey.com survey page.

TITLE	MODIFIED ▾	RESPONSES	ACTIONS	
Department Name Survey Created July, 29 2014	08/01/14	8		
JRN 301 at the Midterm Created November, 07 2010	03/19/14	8		
StratCom and Friends Created November, 04 2013	11/04/13	0		
COM 605 at the Midterm Created March, 16 2013	03/17/13	4		
COM 324 Work Style Preferenc... Created December, 30 2011	12/30/11	0		
COM 310 Mid-course Survey Created December, 05 2011	12/07/11	6		
Mobile Learning Survey Created November, 08 2011	11/08/11	0		
Group Work in Online Classes Created February, 25 2011	02/27/11	3		
Student Engagement in Online ... Created November, 30 2010	12/02/10	0		
Test Created June, 10 2010	06/10/10	0		

ALL SURVEYS ▾

Search titles

+ Create Survey

ALL SURVEYS: 1 - 10 of 17

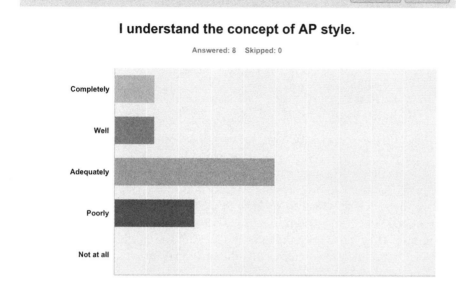

Figure 12.2
Keeping survey questions simple should increase response rate. This is one way SurveyMonkey.com lets even those with free accounts view their results.

Factors affecting response rate include: the target population (young people are unlikely to take the time to complete a survey), the relationship between the individual or organization sending the survey and the potential respondent, the degree of personalization of the survey invitation (are respondents addressed by name?), the length of the survey (always let potential respondents know how long it should take to complete the survey), the topic of the survey and complexity of the questions, and whether incentives are being offered. Sending reminder emails also helps increase response rate.[4]

To maximize response rate while minimizing frustration, questions should be unambiguous and well focused. Don't risk damaging your brand by frustrating your audience with complicated or time-consuming surveys. Let them know that their opinion is valuable and will help improve the product or service. In other words, let them know that answering the survey will make things better for everyone. Ask respondents a couple questions about their interests or needs. Ask them to rank or provide information about what is most important to them or how to best serve them. Here are a couple examples:

1. On what kind of device do you receive the most information about news and events?
 a. Desktop or laptop computer
 b. Smartphone

 c. Tablet computer
 d. Television or radio.

 2. Which of the following is most important to you when seeking
 information on a breaking news event?
 a. Timeliness of coverage
 b. Accuracy of coverage
 c. Personality of reporters
 d. In-depth analysis.

You may also want to include one or two questions that ask respondents to
compare your product (your magazine, your blog, etc.) to competing out-
lets. These kinds of questions have long been the basis of readership surveys.
You may, for instance, ask respondents to rank their preference for various
news outlets. You will likely also want to include a question or two that asks
respondents what they would like to see or in what areas their needs are not
being met. This will help you better understand the needs of your audience
while letting them know that meeting their needs is important to you.

CONDUCTING A FOCUS GROUP

Holding focus group can help organizations determine attitudes toward the
organization or brand in more detail and depth than a survey can reveal.
However, since a focus group is conducted in person, responses will be col-
lected from a smaller number of people. Depending on the organization,
there may or may not be enough members of your target community or audi-
ence available to meet with in person.

Focus groups can be conducted formally or informally. You can hold them
in your office or a rented hotel room. You could also hire an organization to
conduct the focus group for you at their location for a few thousand dollars.
Participants are usually also paid a small fee for their time.

Although focus group formats differ, most run for about an hour or two, and
include a manageable number of participants. Around ten is a good number—
enough people to ensure a diversity of opinions and not too many people
to allow everyone to be heard. Consumer research companies that regularly
run focus groups often make available rooms with one-way glass separating
the space from an observation area where the client (you or your organiza-
tion) can observe the interaction without being noticed or interfering with the
research. While some organizations or individuals conduct their own focus
groups, research results will be more accurate and useful if a professional mar-
ket researcher with no vested interest in the outcomes runs the show. There are
a number of reasons for hiring a professional to conduct any kind of market

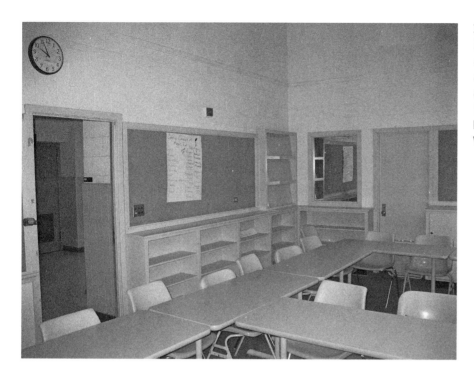

Figure 12.3
Focus groups are often conducted in rooms with one-way glass like this one at the University of Wisconsin Eau Claire.
Photo by Dale Mahalko / Wikimedia Commons.

research—particularly focus groups. If the focus group participants know that a representative of the organization is facilitating the discussion, they will not likely speak as freely. There is also the likelihood that someone involved with the organization would—often unconsciously—lead the discussion in a particular direction, thus skewing the results.

Focus group members can be recruited in any number of ways. Companies that routinely hold focus groups often have running advertisements and may have pools of hopeful volunteers who have signed up online or in their offices ready to be selected according to their demographic characteristics. Professionals usually hold more than one focus group to ensure that they are capturing a range of responses and attitudes. Although the exact makeup of the focus group may differ depending on the session's objectives, as a rule, groups should be largely homogeneous so that participants feel comfortable speaking freely to each other. If the study seeks the opinions of those in several demographic groups, a different focus group should be formed for each demographic.

A focus group's facilitator, often working with an assistant or co-facilitator, will likely ask ten or so questions to the group, in addition to the demographic questions group members may answer at the beginning of the

Figure 12.4

Focus groups should be relatively homogenous to ensure that participants are comfortable speaking honestly with each other. Photo by Mandi Lovasz, United States Army.

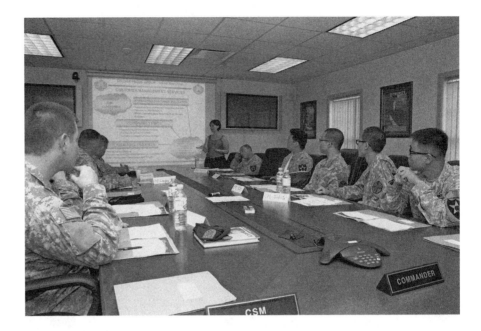

session, when they will also likely sign a legal form consenting to their participation in the study. The focus group questions should be open-ended and broad to elicit detail and depth. They should be questions that can't be answered with a simple "yes" or "no." They will differ depending on what the researcher or client wants to know. There will often be questions about the participants' perceptions of a product, service or brand. There will likely also be questions about the participants' habits, interests, and needs, as well as their interaction with the product, service or brand being studied. Often focus groups are held to more objectively determine brand perceptions in the marketplace outside of the organization, although focus groups may be held for other reasons too. While some may focus closely on the company or organization being studied, others will consider how the company compares to the competition in serving marketplace needs.

ANALYZING FINDINGS

Depending on your needs and goals, and the tools and techniques you used to collect data, analyzing findings can be either a fairly straightforward or a complicated task. With an adequate response rate, surveys will generate numerical data that can provide a quick snapshot of respondents' attitudes, interests, and needs. Tools like SurveyMonkey (surveymonkey.com) will present response data in simple charts, and users of even the free version of

the software get to choose whether to see findings presented in bar charts, pie charts or line charts. Like with any research, the greater the number of responses, the more reliable the findings.

Analyzing focus group data is a bit more complicated and less precise, although it could potentially reveal levels of depth and detail no survey could. With rare exception, focus group discussion is recorded for analysis after the session. It is also common for the co-facilitator or another member of the team to take notes during the session. A transcript of the focus group discussion should be made. As soon as possible after the focus group, researchers should isolate major themes from the discussion. Keywords should be selected for each theme for something called coding. Not to be confused with coding for the Web, language coding is a qualitative research tool that has long been used to determine a word's relative significance to an individual or group. In the old days, researchers would literally take a highlighter to the transcript and use different colors to quickly identify the words in context. These days the task can be easily performed on a computer.

Let's say one of the main themes of a focus group was smartphone accessibility. One keyword from the discussion could be "iPhone." Counting the number of times "iPhone" came up in the discussion could provide some insights into the importance of iPhones to the group. Similarly, other keywords would be isolated from the transcript, and a coding process would determine their relative importance to the group. In addition to general insights from the discussion, coding and keyword analysis can help uncover otherwise hidden themes and ideas from the discussion. If multiple focus groups are held, keyword analysis of the transcripts from all focus groups can be compared to determine the reliability of the data. The more similar the results from each session, the more meaningful the conclusions.

MAKING ADJUSTMENTS AND CHANGING COURSE

There is no set rule about when or how a company should change course in response to research findings, or to what degree change is necessary. Keep in mind that any organization or brand must evolve to stay relevant. That means ongoing adjustment and evolution. While some leaders base the ongoing process of adjustment and change only on gut feelings or hunches, drawing from research findings will ensure that the evolutionary process is based on real information and intelligent insights.

While research can help guide and justify changes, there is no exact science to adjusting a business model or strategic plan. If research has determined that change is needed, it may be time to revisit the strategic plan to re-evaluate

Figure 12.5

Despite appearances at Universal Studios Japan, no school will teach you what the future holds. But it is our job to be prepared for whatever comes our way. Photo by Jeremy Thompson / Wikimedia Commons.

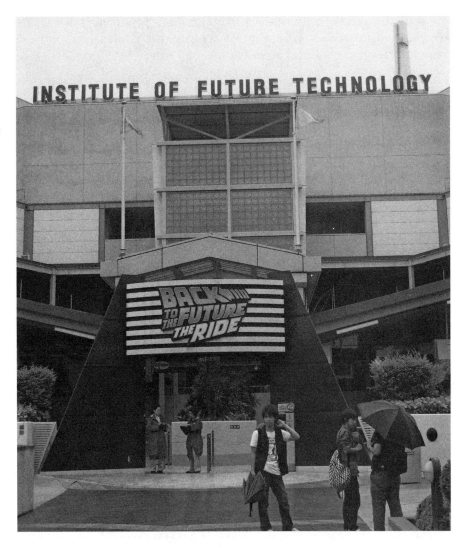

existing goals and possibly replace them with new ones that were identified in your research.

Now that you know what you are doing well and what areas of your business may need help, how do you determine a new set of goals for the next phase of your development? It's a great idea to start with key findings from your research. In technology-dependent fields such as media, environmental changes are likely to be a major driver of change. Organizations that are heavily reliant on technology should probably revisit their strategic plan every year.

Let's say your research has determined that most of your readers and followers access your content on a tablet computer. That's very good to know. Maybe your initial strategic plan included an assumption that most people accessing your content on a mobile device were using a smartphone. As your assumptions change, so should your plan. And as you set new goals for the next year or two, remember that changes in the environment in which the organization operates can render goals obsolete almost overnight. For instance, you forged a partnership with another media organization in another part of the world. Then a change in political leadership in your partner's country dramatically limits your access to audiences in that part of the world. That's something you probably can't plan for, and it may render part of your strategic plan obsolete. So remember that while it's important to have a plan, changing circumstances may require you to change your plan. As technology has taught us time and time again, one of the key skills for entrepreneurial journalists—and pretty much everyone in the workforce today—is flexibility. Keeping one eye always trained on the horizon for the next big thing is every bit as important. At no other time in human history have certain job skills become so relevant so fast. But people don't have to become irrelevant along with their aging skill sets. They simply need to keep up.

WHAT'S NEXT?

If we could know what the future held, we'd probably all be rich from playing the lottery. However, there are things all of us can do to be prepared for what's to come. The first, most important, thing—and this has always been the case for journalists—is to read, watch, listen, observe, always ask questions, and always make connections. As the world becomes more complex, and information becomes more ubiquitous and less organized, the journalist's job will only become more important. In the future, journalists may not be the gatekeepers to information they were in the analog age, but they will be the gatekeepers of knowledge and understanding. This is an essential role in the communities journalists serve, and the need will become even greater as time goes on and the world's people become more connected and potentially more overwhelmed by the virtual mountains of data and information multiplying by the day. It is up to journalists to make sense of it for everyone.

This book merges the work of journalists with the work of communications professionals from fields such as public relations and marketing that have traditionally worked in some degree of opposition. Applying terms traditionally reserved for marketing may rankle some traditionalists who may not like applying typically promotional concepts such as branding to human beings. For those of us who spent the majority of our journalism careers in a more

traditional era when the extent of personal branding consisted of running a columnist's grayscale headshot alongside his twenty inches of copy, the idea of selling ourselves in a way that shows our value without undermining our credibility can present a challenge. But it can be done. It has to be done. That's the way of the modern world. And it's actually not bad.

Look at the best branding efforts of our most successful peers. People like the *New York Times'* Nicholas Kristof and Thomas L. Friedman (who branded himself as a prognosticator with the 2005 publication of his *The World Is Flat*), have successfully branded themselves, telling the world who they are and what they do without ego or self-promotion. The concept can be confusing in an era when so many people promote themselves online for all kinds of things—few of them as useful to the common good as journalism. But personal branding, strategic planning, forming partnerships, and building businesses are all integral parts of the journalist's job today. The better you understand them, the better you'll be able to serve your community and the individuals who need you to help make sense of a world that grows more complicated by the day.

SUMMARY

Strategic planning is necessary to ensure the health and sustainability of any enterprise, particularly in the fast-changing fields of media and technology. Although Chapter 6 asked you to create a business plan and a strategic plan that provided a snapshot of market conditions at the time, a healthy, sustainable business requires periodic check-ins and reassessment. It is never a bad time to check in on the organization and its environment. If environmental conditions have changed, so should your assumptions. If the market has tanked or exploded, you can't afford to ignore that.

You also want to look at changes within your own business. Have your resource levels changed? Did you lose a critical staff person or leader? Was there another event that affected your company's ability to deliver on its promises? An event doesn't even need to be huge to have an impact on the company. Have your mission, vision or values changed?

While it's easy to check in on smaller matters—such as reaction to a new campaign—via social media, revisiting the strategic plan should provide the big picture of where your organization came from and whether it's on target to reach its goals.

Redo your SWOT analysis. Consider your mission, vision, and values. Change them if you need to. Replace one or more goals in your strategic plan. Reconsider the value you create as an organization or individual. In replacing your goals, look ahead to anticipate the future needs and interests of your target audiences.

JOURNALIST'S TOOLKIT

Research is key to sustainable enterprises. Any organization benefits from periodic assessment to ensure it stays on track to meet its goals. Entrepreneurial journalists need to learn how to conduct basic audience research to ensure they and their organizations continue to offer their target audiences what they need and demand. Without periodic research and the inevitable adjustments that follow, organizations become calcified. Instead of evolving and maturing, they stop growing and die. Happily, media organizations and those who work in them are particularly well equipped to research their effectiveness.

Skills

Basic research, including creating surveys and holding focus groups

Analytics interpretation

Reporting

Writing.

Tools

Desktop or laptop computer

Analytics software.

Sites

Entrepreneur.com: The online home of *Entrepreneur* magazine, which offers guidance to startups and other enterprising business ventures.

Fastcompany.com: The website for *Fast Company*, a business magazine that focuses on innovation and creativity.

Forbes.com: The online home of business magazine *Forbes*, a resource for business

Surveymonkey.com: An online survey tool that offers free and paid accounts.

Application

1. Solicit classmates to conduct a focus group on media use in your community. Follow this chapter's guidelines for conducting focus groups. Write no more than eight focused questions in advance, and record the group's answers to the questions. Transcribe and analyze the answers, then present your findings to your class.

2. Create an online survey on media use. Include no more than ten focused questions, and recruit classmates to take the survey. *Optional:* Compare the results of your focus group to the results of your survey.

Review Questions

1. What is SWOT analysis, and why is it done?
2. How often should a strategic plan for a media business be reconsidered and revised?
3. What is the difference between a survey and a focus group? When and why would you conduct each?

REFERENCES

1. Hoque, Faisal. "5 Essential Principles for Growing Your Small Business," *Fastcompany. com*, http://www.fastcompany.com/3004395/5-essential-principles-growing-your-small-business.
2. Aileron. "Five Steps to a Strategic Plan," *Forbes.com*, October 25, 2011, http://www.forbes.com/sites/aileron/2011/10/25/five-steps-to-a-strategic-plan/.
3. Ibid.
4. "Tips and Tricks to Improve Survey Response Rate," SurveyMonkey Blog, https://www.surveymonkey.com/blog/en/blog/2012/03/28/improve-survey-response-rate/.

Index

Page numbers in *italics* denotes an illustration/table/figure